DRIVE

DRIVE

JOURNEYS THROUGH FILM, CITIES AND LANDSCAPES

IAIN BORDEN

REAKTION BOOKS

For Claire

Published by
Reaktion Books Ltd
33 Great Sutton Street
London EC1V 0DX
www.reaktionbooks.co.uk

First published 2013
Copyright © Iain Borden 2013

The publishers gratefully acknowledge support for the publication of this book
by the Architecture Research Fund of the Bartlett School of Architecture, UCL

Printed and bound in China

British Library Cataloguing in Publication Data
Borden, Iain.
 Drive : automobile journeys through film, cities and landscapes.
 1. Automobile travel – Social aspects. 2. Automobiles in motion pictures.
 3. Travel in motion pictures. 4. Automobile travel in literature.
 5. Automobile driving – History.
 I. Title
 306.4'819-dc23
 ISBN 978 1 78023 026 9

CONTENTS

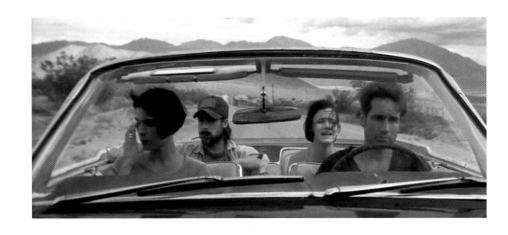

INTRODUCTION

> It is no longer the car's forms and functions that call forth human
> dreams but, rather, its handling, and before long, perhaps, we shall
> be writing not a mythology of the automobile but a mythology
> of driving.[1]
>
> Roland Barthes

The sheer quantitative presence of the automobile is astounding.
Some 1 billion cars were manufactured in the twentieth century, and
currently over 700 million are still operating, while some 1 billion
may be in use in 2030. Global car travel – the number of journeys
and miles undertaken – is estimated to triple between 1990 and
2050. And geographically, massive new economies and developing
countries – notably China – are now developing a new car culture.[2]

But as Roland Barthes' prediction above suggests, to under-
stand the history of the car and its role in our culture and cities
is not simply a question of the quantitative expansion of cars and
journeys. Driving is more than the car and the road, incorporating
also all manner of driving-related architectures, from petrol stations
to billboards, and, even more importantly, of people as drivers: the
thoughts we have, the actions we make, the images we consume
and imagine, the meanings we derive, the codes we observe and
the regulations we encounter. And driving is also the speeds we
move at, the spatial conditions we meet, the ways we look at and

Kalifornia
(Dominic Sena,
1993).

7

listen to the landscape, and the very emotions and attitudes we have towards this pursuit. Furthermore, this immense assemblage is made even more complex when we realize that there are differences of people, cars, speeds, roads, landscapes, historical periods and countries – all of which creates yet more variation.[3]

With this context firmly in mind, *Drive* is an exploration of cultural meanings, as visible and expressed through the real place of the car: on the road, being driven and operating as a dynamic machine. As one early motorist, A. B. Filson Young, whose *Complete Motorist* provides many illuminating insights into driving and to which I return many times in this study, stated, 'the true home of the motor-car is not in garage or workshop, showroom or factory, but on the open road. There it comes into its own, there it justifies itself, there it fulfils its true and appointed destiny'.[4]

In this age of urgent environmental concerns, it is also worth noting that some might be somewhat aghast at a study of car-driving cultures. Indeed, much of the most recent academic literature on car driving has tended to focus on the negative qualities and connotations of this practice, and to identify the various ways in which non-automotive living might be encouraged. For example, *Against Automobility* and several other publications all make substantial contributions to this necessary and important critique of automotive society.[5] By contrast, *Drive*, while certainly being aware of many of the negative qualities of car driving – alienation and placelessness, accidents and death, traffic jams and environmental impact all make an appearance – nonetheless explores just why it is that so many people choose to drive, seem to enjoy driving and even revel in doing so. In this sense I am following Ruth Brandon's salient remark in her excellent

social history of the car, *Auto Mobile: How the Car Changed Life*, that we must recognize 'the intoxicating pleasures of automobility' because 'we are all addicts now'.[6] In this context, a consideration of the cultural and experiential richness of driving seems a worthwhile trajectory to follow. Indeed, underlying *Drive* is an implicit engagement with current debates about car-usage – that is, it argues that the role of the private car cannot be simply replaced by improved forms of public transport without first understanding, and responding to, the various pleasures and experiences offered by automobile driving. In other words, why do people often seem to prefer their own car to the number 73 bus?

In this sense, this book is an exploration of the undeniable delight which many people – not all but many, not always but often – derive from driving. A primary concern here is the *pleasures* of driving, with such qualities, whether they be perceived and/or real, as liberation, fun, adventure, encounter, intimacy, visual stimulation, self-understanding, contemplation, pure speed, risk and danger. Such pleasures are not simple inventions of our most recent society. Even by the early 1900s, Filson Young foresaw that the automobile would not just be 'the rich man's toy, the idle man's excuses, the brutish man's weapon' but rather should be seen as 'good genius' that 'will make of poor men's wishes wings to carry them out of themselves and their surroundings, out of darkness into sunlight and the pure air'.[7] There is, therefore, a history to be told of how such driving-related perceptions have been borne, and how they have been carried through for over a century and into all corners of the world. We need to understand how we have come to love driving quite so much, while, conversely, it would be at our peril to simply

dismiss out of hand all automobile pleasures as being pure delusion, fantasy or selfishness.

Given how much many people undoubtedly enjoy driving, the enormous number of cars and road miles covered over the last century and more, and the vast literature available on cars, it is remarkable how relatively little thought has been given to the pleasures of driving. There is a plethora of studies of car design, car production, advertising and marketing, racing, maintenance, economics, highway and road design, traffic management and so forth, but very little on the actual experience of driving itself. Of those publications that do address the experience and pleasures of driving in some way, of particular note are Moran's *On Roads*, Seiler's *Republic of Drivers* and Vanderbilt's *Traffic*, all of which give valuable insights into driving experiences while framing these within much larger studies of social, cultural, political and techno-logical contexts. Similar clues to driving experiences are frequently provided by the many social and other contextual histories of the automobile.[8] Two edited collections – *The Car and the City* by Wachs and Crawford, and *Autopia* by Wollen and Kerr – similarly provide clues within their wide-ranging collections of essays to various aspects of automobile culture, as do a number of anthropology-, psychology- and culture-oriented studies.[9]

We can also find other fragmentary indications of the joys of automobility in accounts of particular roads, places and journeys.[10] Of particular note here is Merriman's *Driving Spaces*, which provides an exemplary and comprehensive account of the UK's M1 motorway in all of its economic, historical, geographic and aesthetic aspects, while the wide-ranging essays contained in the

excellent *Automobilities* edited by Featherstone, Thrift and Urry provide another exceptional overview of automobile driving through intersections of critical and cultural theory, urban geography and empirical data. Further indications of road visuality are provided by a diverse spectrum of anthropologists, architects, urban planners, philosophers, art theorists and critical commentators whose observations range from precise observations of driving to more speculative interpretations and theorizations.[11]

None of these studies, however, provides an overview of driving *experiences* in the last hundred years, and even when taken together they assemble, as might be expected, a somewhat patchy history and rather disparate methodological account of how people have engaged with and enjoyed automobile driving. This is a notable deficiency in our understanding of automobility, and instead we need here the kind of exploration proposed by Nigel Thrift through the notion of 'non-representational theory', that is an investigation of non-theorized, everyday practices, where people encounter, imagine and reproduce their lives in a non-academic manner.[12] We therefore need, perhaps, less highly detailed quantitative analysis and less complex theoretical constructions, and rather more reflection on the kinds of emotions invoked by Roland Barthes in his famous essay on the Citroën DS, describing how the car is an object of amorous attentions, that is being touched, caressed and fondled.[13] As Mimi Sheller has noted, such feelings and emotions are instinctual, but also bodily and collective: that is, they are not just to be dismissed as the feelings of one person but have real substance and historical worth.[14] Or, as Jean Baudrillard comments in relation to Los Angeles freeways, 'the point is not to write the sociology or the psychology of the car, the

point is to drive. That way you learn more about this society than all academia could ever tell you.'[15]

In order to undertake this kind of study, many writers and academics have commented on the need for interdisciplinary approaches, including, in particular, Merriman and the various contributors to *Automobilities*. So why then the particular interdisciplinary intersection of *Drive*, which here brings together concerns with driving experiences, social space and cinema? The need for a consideration of driving experience is already outlined above, and in terms of social space, this book forms part of my general concern with how architectural, urban and other forms of space are constructed socially, and how these are reproduced in different forms according to different people, practices, histories, times and cultures.[16] But why the additional element here of a particular (if not wholly exclusive) reference to cinema, movies and film?

There is of course the simple issue of the sheer extent of the subject-matter, whereby a vast number of primary sources of information, from personal diaries and government reports to enthusiast car magazines and specialist websites, combines with a wide geographical and historical range, as well as with a plethora of representational materials such as novels, films, animations, paintings, sculpture, music and poetry. My own bibliographic database has over 100,000 references to automobile-related materials in print-based form alone. A focus on film thus provides one way of filtering this material down to a manageable size.

But the concentration on film is far from being purely prosaic. First, cinema, more than any other representational form, provides the most direct sense of what it actually feels like to drive, its visual

qualities giving a substantive (if not always entirely accurate or complete) indication of how driving involves movement, bodies, thoughts, feelings, spaces, sights and sounds. In this sense, cinema helps articulate what it feels like to move and exist in urban space, and records this experience in a semi-historical manner from the time of a film's production or setting. Second, as director Cecil B. DeMille noted, the movie and automobile industries grew together because they both reflected 'the love of motion and speed, the restless urge toward improvement and expansion, the kinetic energy of a young, vigorous nation'.[17] As such, movies help us understand the experiential thrill of modernity not only through aesthetic experiences of space – through effects of framing, signs, mobility and so forth – but in transcending the rational and disciplined qualities of driving and moving into a realm of the comparatively irrational, into matters of non-codified thought, instinct and everyday behaviours. In short, film helps us understand that we often live dynamically and without the necessity of constant presence of self-reflective or rationalized thought. Third, movies do not stay on the cinema screen, but are constantly reproduced in the minds of those who have seen them. Driving in cinema is thus re-lived through the act of driving, and in turn re-represented through yet later films and other cultural imaginations. Movies are not, therefore, a simple reflection of driving, but instead an integral part of how we perceive, project, represent and engage in this practice. Driving embodies cinema, just as cinema visualizes driving. Fourth, nearly all movies contain some form of driving, just as nearly all drivers watch movies – and this ubiquitous commonality further strengthens the way in which films turn viewers into drivers, allowing them to move through spaces and cities while

watching films, and, conversely, to recall filmic depictions while
themselves driving. As the architectural writer Juhani Pallasmaa notes,
'experiential images of space and place are contained in practically all
films' such that 'the most powerful cinematic architecture is normally
concealed in the representation of normal events, not in the specific
exposition of buildings and spaces of exceptional architectural merit'.[18]
Thus in cinematic depictions, the 'normal' event of driving comes to
be expressed most substantively and significantly. Cinema helps to
lift driving out from our collective subconscious and makes it more
apparent and meaningful; movies act as a kind of hidden text, recov-
ering the implicit excitement, pleasures and themes which we all feel
when driving, but perhaps no longer consciously recognize. Fifth, as
Baudrillard has commented specifically in relation to America, the city
has seemingly stepped right out of the movies, and therefore, in order
to understand the city, we should not move inwards from the city to
the screen, but rather 'begin with the screen and move outwards to
the city'.[19] In other words, if we recognize that our subjectivities and
city spaces are not natural but constructed through diverse and dis-
persed cultures and technologies, then exploring cinematic depictions
of driving will help us to identify ways in which certain aspects of
driving culture and experiences have been expressed, encouraged
and heightened. Sixth, and last, a vast range of different driving
experiences are presented in movies, and so cinema helps debunk
any premise of there being a dominant unity or homogeneity of
driving; film shows driving as a mediated, provisional and differential
modern experience, a practice which varies according to road, speed,
car and landscape, as well as to specific life conditions, personalities
and narratives. Cinema shows driving as part of differential everyday

life, as something we all share but also undertake separately, which we nearly all do, yet in disparate and divergent ways.

It is also worth noting here that several books and articles deal with the road movie genre, from *Gun Crazy* and *Vanishing Point* to *Thelma & Louise* and *Kalifornia*.[20] However, even these road movie publications tend to avoid much of the actual experience of driving in terms of space, velocity and vision. They also, with a few notable exceptions, have a tendency to focus on films of the 1960s and '70s. Beyond these explorations of the road movie, considerations of driving in film are few and far between, and are largely restricted to occasional articles or chapters that make limited reference to this subject. A few publications do concentrate on cars as objects and on car chases – notably Buckley's *Cars in Films*, the Internet Movie Cars Database website at www.imcdb.org, and Crosse's *The Greatest Movie Car Chases of All Time* – but these enthusiast endeavours, while often highly informative in facts and data, are less concerned with wider cultural or contextual considerations. By contrast, this book focuses on the cultural and social qualities of automobilities in combination with a direct consideration of the experiential nature of driving. It also deals with far more than just the typical road movie fare of the open country, desert or rural road, extending its scope to include city streets, urban highways, freeways and motorways, as well as more imaginary speeds and forms of driving. Furthermore, it covers a much wider chronological range of films, extending from the earliest days of film in the 1900s right through to the 2000s – and consequently in researching this material I have reviewed over 450 different films, many if not all of which have found their way into the final text. Another concern here, therefore, is that some aspects of driving

experience have been around for decades or longer, and so can be seen as integral or endemic parts of modernity; thus, in our frequent contemporary concern to reduce or forego private automobile transport, we should recognize that these are qualities that are not likely to quickly disappear, be given up or be forgotten.

Drive consists of four main chapters, each of which deals with a particular intersection of speed, terrain and form of driving. Chapter One, 'Cities', therefore looks at the practice of urban driving at speeds of approximately 30 mph; key themes include those of democracy, social mobility, gender, alienation, adventure and the visuality of signs. In chapter Two, 'Journeys', the speed rises to around 55 mph, and the landscape shifts to the countryside, rural settings and the desert. Themes here cluster around the kinaesthetic qualities of vision and movement, and around existentialist concerns with the self. In chapter Three, 'Motopia', the focus is on the highly automobile-centred terrain of the freeway and motorway, where speeds of 70 mph or more are commonly maintained. This discussion addresses qualities of placelessness, new modernities, associations and temporality before reflecting briefly on some of the most distinctive cinematic approaches to representing driving. Chapter Four, 'Altered States', turns to actual and virtual speeds of 100 mph or more, where drivers variously encounter transcendental experiences, engage in transgressive acts, participate in dramatic car chases and, perhaps inevitably, frequently become involved in a crash, accident or other such sudden conclusion to their journey. Throughout these chapters, films form the primary (although not sole) focus of attention, while interpretations reflect on the wider experiential and cultural qualities of the kinds of driving these movies depict.

1 CITIES

The single most powerful idea attached to urban driving is that cars and driving are true harbingers of democracy, creating a world where all men and women are equal, where they can go anywhere, do anything, meet anyone. The road is 'the meeting place of democracy', asserted engineer Pedro Juan Larrañaga, a place where 'the Rolls-Royce limousine, the Ford tourer, the cycle and the donkey cart will learn to know and respect each other.'[1] Importantly it is not the car itself but the car journey that fulfils the promise of the city – as a place of work and creativity, anonymity and sociability, structure and adventure, history and progress, now liberated by the driving's propensity for communication, discovery and speed. 'The wheels move endlessly, always moving, always forward – and always lengthening the American road', proclaimed a Ford advertisement 1951. 'On that road the nation is steadily traveling beyond the troubles of this century, constantly heading towards finer tomorrows.'[2]

Getting On, Falling in Love

The association between urban car driving, freedom and democracy is predicated on a sense of social mobility: automobiles let people get on in life, furthering their economic, cultural and personal achievement. Thus

while early American documentary films such as *Automobile Parade* (1900) and *Boarding School Girls* (Edison, 1905) show automobiles as the preserve of the privileged, within a decade class-conscious films like *The Girl and the Chauffeur* (Yankee Film Company, 1911), *Putting the Bee in Herbert* (Floyd France, 1917) and *The Apple Tree Girl* (Alan Crosland, 1917) were depicting the car as a way for industrious working-class men to succeed, both economically and socially.[3] Other early films such as *The Elopement* (Billy Bitzer, 1907) and *A Change of Heart* (D. W. Griffith, 1909) similarly use the car to signify social freedom, class mobility, domestic rebellion and changing values.[4] Less dramatically, but nonetheless in an overt class setting, in *The Magnificent Ambersons* (Orson Welles, 1942) the status of the nouveau Morgan family, whose wealth has been founded on car manufacture, grows just as that of the old-moneyed and conservative Ambersons declines. In very different economic circumstances, *The Grapes of Wrath* (John Ford, 1940) shows how even destitute Oklahoma sharecroppers – the Joad family – possess a car, and indeed are wholly reliant on this 1926 Hudson Super Six on their desperate journey along Route 66 to California and during their subsequent shuttling from one migrant camp to another. As challenging as these times are, the family survives, and the film concludes in the front of the Hudson with Ma Joad asserting to her husband that 'We keepa comin', we're the people that live. They can't wipe us out, they can't lick us. We'll go on forever, because we're the people.' A final shot reveals a long line of similar vehicles, families and journeys being undertaken, emphasizing that these experiences were repeated across thousands of American lives, a condition which is also recorded by photographers like Walker Evans, Dorothea Lange, Russell Lee,

The final shot
from *The Grapes
of Wrath*
(John Ford, 1940).

Arthur Rothstein and John Vachon.[5] Also set in the Depression
era is *Paper Moon* (Peter Bogdanovich, 1973), this time in Kansas.
Although the gritty portrait of the robust Joads is replaced by a
much more whimsical study of selfish tricksters Moses Pray and
young Addie Loggins, the essential theme remains of getting on
through driving and staying one step ahead of dire poverty and
ruin, this time with the aid of a 1936 Ford v8 De Luxe.

In post-war America, and in a sensitive exploration of
respectable affluence, *Driving Miss Daisy* (Bruce Beresford, 1989)
shows how Daisy Werthan (Jessica Tandy), an aged Jewish widow
living in Atlanta, is reliant for her daily routines on a car driven by
chauffeur Hoke Colburn (Morgan Freeman). At one point, Hoke

leaves the state of Georgia for the very first time, crossing over into Alabama while driving Daisy to a family event in Mobile. Contemporary racism in America is also explored here, as when Hoke is stopped by Alabama highway patrolmen, who refer to Miss Daisy as an 'old Jew woman' and Hoke an 'old nigger'. Above all, the car interior becomes a space of class and ethnic negotiation, and although *Driving Miss Daisy* romanticizes racially constructed relationships of employment and servitude, it also displays considerable sensitivity to complex questions of multiculturalism, especially when Hoke gains Miss Daisy's grudging respect and friendship. Eventually Hoke – as with many Southern state African Americans who used cars to provide mobility and social status – manages to purchase his employer's Hudson Commodore.[6]

As *Driving Miss Daisy* suggests, the association between freedom and driving is particularly evident in prosperous everyday circumstances. Even before the Second World War, many Californian youngsters viewed a car as a social necessity, and from the 1950s onwards cars became an increasingly common purchase for the American urban as well as rural working classes.[7] Consequently in Nicholas Ray's *Rebel Without a Cause* (1955), automobiles like a 1941 Chevrolet Special De Luxe, 1946 Ford Super De Luxe and 1949 Mercury Coupe provide transport for teenagers; even the 15-year-old Plato has a 1940 Motor Glide motorized scooter. Similarly in George Lucas's nostalgic *American Graffiti* (1973), driving is the key for teenage transition to adulthood, granting young men the freedom to move across town, hook up with girls and generally fool around. An English exploration of similar themes occurs in *The Loneliness of the Long Distance Runner* (Tony Richardson, 1962) when bored

working-class Colin and Mike steal a Ford Consul Mk1 for a cheery joyride, during which they pick up Gladys and Audrey with promises of 'scooting up and down them hills' and 'round them bends'. The seduction works, and Colin loses his virginity with Audrey. Similar explorations of coming of age and youthful masculinity occur in more recent American settings like *Corvette Summer* (Matthew Robbins, 1978), *Boulevard Nights* (Michael Pressman, 1979) and John Hughes's massively popular *Ferris Bueller's Day Off* (1986), although in the latter the teenage frivolity of high-school seniors Ferris, Sloane and Cameron in a 1961 Ferrari GT California – which initially stimulates escapism, fantasy and teenage sexuality – eventually culminates in an emerging sense of responsibility after Cameron sends the car careening out of his father's glass-walled house into a ravine.

Many other 1960s films also returned to the kinds of class sensibility articulated in *The Magnificent Ambersons* and *The Grapes of Wrath* some twenty years earlier. For example, *Blow-Up* (1966), Michelangelo Antonioni's seminal study of media, aesthetics and morality in mod London, is partly based on the life of the working-class photographer David Bailey. As part of his glamorous life, Thomas (David Hemmings) guides his Rolls-Royce Silver Cloud III, replete with radio-telephone messaging, while scouring places for a shoot amid new housing, demolition sites, working-class streets and industrial areas. A year later, *Charlie Bubbles* (Albert Finney, 1967) also shows its eponymous character driving a Rolls-Royce Silver Cloud III as celebrated writer Charlie (Finney) returns to his native Manchester. This time, however, the car marks not a way of connecting but being distanced from working-class streets. Beginning his journey north in the golden limousine, Charlie and his young

assistant Eliza (Liza Minnelli) are stared at by the occupants of a small saloon with both fascination and resentment, while a petrol station attendant is wordless and surly. When Eliza takes photographs as they drive around the desolate streets of Salford, unlike similar scenes in *Blow-Up* which suggest creative engagement, this one serves simply to underline the socio-economic North–South divide of 1960s Britain, which Bubbles's driving of a Rolls still further expresses.

As *The Loneliness of the Long Distance Runner* suggests, another principal promise of the car has been increasing opportunity for sexual encounter. Although earlier horse-drawn buggies undoubtedly provided occasions for romance, in the twentieth century the car soon gave its users, and teenagers in particular, greater scope for

Thomas using the radio-telephone messaging service in his Rolls-Royce. *Blow-Up* (Michelangelo Antonioni, 1966).

passionate liaisons and other night-time fun.[8] As John Steinbeck wrote in *Cannery Row*, 'most of the babies of the period were conceived in Model T Fords', while early films such as *A Change of Heart* and *Sunshine Sue* (D. W. Griffith, 1910) portray the car as a device for the sophisticated to seduce the innocent.[9] But employing the car for passionate purposes can also lead to more positive emotions and heartfelt desires. One inventive take on 1950s teenage life is Gary Ross's *Pleasantville* (1988), set like *Rebel Without a Cause* and *American Graffiti* in the US of the 1950s. Finding himself transported into the ultra-conventional, black-and-white world of the fictional television town Pleasantville, Bud takes Margaret for a drive in a 1952 Buick Roadmaster. They and the other residents of Pleasantville now have their senses gradually awakened by music, fruits, rain and dawning sexuality, slowly moving from a local world of innocent family routines and naive emotions into a more modern and colourful realm of love, bodies, passions and new ideas – what Bud describes in court as the right to be 'silly, or sexy, or dangerous'.

The association of driving with passion is particularly strong in many films of the 1950s and '60s, and even appears in the dystopian setting of Godard's *Alphaville: A Strange Adventure of Lemmy Caution* (*Alphaville: Une étrange aventure de Lemmy Caution*, 1965). Here, the controlling Alpha 60 computer has banned free thought, love and emotion, and those few recidivists displaying such individualist traits are summarily executed. Yet even in Alphaville the promise of freedom can emerge, most dramatically at the movie's end when Natacha, riding in Caution's 1965 Ford Mustang as he leaves the city, manages to utter '*je vous aime*' – I love you. The ultimate freedom of self-expression and emotion thus takes place

in the liberatory space of the car and the highway. This should not be taken to be a particularly unusually setting for the declaration of love, for by 1967 around 40 per cent of marriage proposals in the u.s. were taking place in automobiles.[10] Sometimes love, with the aid of a car, can be found in the most unlikely of places.

Men and Women Drivers

Most of the films noted above identify their drivers as men, and indeed the connection between car ownership, driving and mas-culinity is one of the central themes of urban cinema. In particular, opportunist male lotharios frequently use cars to meet or escape female lovers. To cite but a few examples, in Jean Epstein's masterly *La Glace à trois faces* (1927), a wealthy businessman, rather than face up to his three different dates, takes his sports car from an ultra-modern garage and speeds to the fashionable beaches of Deauville, while in the original *Alfie* (Lewis Gilbert, 1966), Alfie relies on a 1957 Vauxhall Velox to conduct his affairs. Alternatively, masculinity as self-confident autonomy is evident in *Thunder Road* (Arthur Ripley, 1958), where war veteran Lucas Doolin (Robert Mitchum) maintains a reputation for robust bravado by delivering moonshine in modified Fords; as the theme song 'The Ballad of Thunder Road' describes, 'the mountain boy took roads that even angels feared to tread'.[11] Alternatively, in *White Lightning* (Joseph Sargent, 1973) Gator McKlusky (Burt Reynolds) announces his release from prison by noisily steering a Ford Custom around small-town Bogan County and then, in an astutely crafted scene shot from

the driver's viewpoint, engaging in a menacing confrontation with Sheriff J. C. Connors.

If male identity is frequently linked to car driving, then so too is female identity, and sometimes to even greater extent. While some motoring commentators have argued that technological and physiological demands rendered early driving a predominantly male preserve, in fact from the 1910s onwards car manufacturers from Ford to Cadillac actively targeted female consumers through advertisements in *Good Housekeeping, Vogue* and the *Ladies' Home Journal.* By the late 1920s manufacturers had realized that women (and, by substitution, men) desired overtly stylish cars that could supply some kind of psychological compensation for the rationalized, undignified and brutal nature of the modern workplace.[12] Above all, however, it is not the consumption of automobiles as objects but, as philosopher Loren E. Lomasky has argued, the correlation of the actual act of driving with the capacity for autonomy and self-direction that is most important here.[13] As Kate Dixon, a modern British mother and driver, asserted when filmed by the BBC in the 1990s, 'I want to be an independent person, I want to enjoy the driving I do, I want to enjoy myself.'[14] This kind of attitude affords women more relaxed family ties and increased opportunities for work, leisure, romance and general sociability.[15] In film, this is first reflected in early movies such as Man Ray's 16-minute cinépoème *Emak-Bakia* (1926), where Kiki of Montparnasse expertly propels an elegant two-seater sports car while wearing enigmatic goggles with masklike eyes for lenses. This sense of driving where a strong and adventurous female style is conjoined with determined separation from domesticity was

repeated many times over the next 40 years, as with two films from 1955: *To Catch a Thief* (Alfred Hitchcock), where Francie propels a Sunbeam Alpine around challenging Mediterranean roads, and *The Fast and the Furious* (John Ireland and Edward Sampson) in which Connie handles a speedy Jaguar XK120 in a purposefully energetic manner. 'I'd appreciate', Connie demands at one point to an assailant, 'you returning my car and my freedom'. During the 1960s, a decade when Ford was actively selling the sports 'pony car' Mustang to independent young women, such depictions became even more commonplace, ranging from the glamorous Ethel, who drives an Aston Martin DB3 drophead for a heist in *Two Way Stretch* (Robert Day, 1960), to the blowsy and adulterous Liz Gruffydd-Williams, who waywardly pilots an ostentatious Oldsmobile convertible around the Welsh town of Aberdarcy in *Only Two Can Play* (Sidney Gilliat, 1962). Even in the very epitome of male bravado and sexual prowess – 1960s Bond films starring

SPECTRE agent Fiona Volpe takes 007 for a ride. *Thunderball* (Terence Young, 1965).

Sean Connery – woman still appear as skilful drivers. Hence in *Goldfinger* (Guy Hamilton, 1964) Tilly Masterson steers her 1965 Ford Mustang with verve over alpine passes as she avenges the death of her sister Jill, while in *Thunderball* (Terence Young, 1965) SPECTRE agent Fiona Volpe forces another Ford Mustang along the palm-lined country roads of Nassau. As they screech to a halt outside a hotel, Volpe clearly has the confidence to match even the most daring of men. 'You look pale, Mr Bond', remarks the spy. 'I hope I didn't frighten you.'

In a less dramatic setting, the comedy *Carry on Cabby* (Gerald Thomas, 1963) has a whole army of women asserting their driving independence, this time through Peggy Hawkins (Hattie Jacques) and her Glamcab operation, launched in retaliation to work-obsessed husband Charlie (Sid James) and the anti-female employment practices of his Speedee Taxis outfit. Although quite prepared to use sexual innuendo as part of their service (each taxi flaunts a roof-mounted heart-shaped sign atop an illuminated 'I'm Free' signal), the Glamcab women are also more up-to-date than their male rivals. The cars they use, Ford Cortina Mk1s, are contemporary and American in style, while a similar modernity comes from their efficiency of service, smart uniforms, no-tipping rule and slick advertising – all in stark contrast to the ageing Austin FX3s, grubby rudeness and eccentric driving habits of the male Speedee Taxi drivers. In a more serious context, Agnès Varda's *Cléo from 5 to 7* (1962) details 90 minutes in the life of a singer, Cléo (Corinne Marchand), as she travels around Paris and contemplates cancer, death, friendships, loneliness and the substance of modern life. Taking a taxi across town, Cléo remarks to the female cabbie that

this is a 'tough job for a woman' and asks if she isn't afraid at night; the driver simply replies 'afraid of what?' Cléo, later called a 'spoiled child' for her endless cab rides, admires this taxi driver for her 'courage' and gutsy, street-smart attitude. Later, another of Cléo's friends has just gained her licence and determinedly comes to grips with an old open-topped Citroën 11 BL. Thus while Cléo, who cannot drive, is full of fears about her health and future, these two other women are making their way by car in the capital in an unashamedly independent manner.

During the 1960s it was increasingly the image of the energetic, independent female driver that came to the fore, someone like Claire Chingford (Julie Christie) in *The Fast Lady* (Ken Annakin, 1962), who is at once fashionably dressed and free-spirited, detailed in her knowledge of cars ('Red label Bentley. Late 27s. Three litre. Short chassis speed model with long stroke four cylinder engine fitted with single overhead camshaft') and exuberant in her driving of a 1962 Mini Cooper Mk1. This is not the pure invention of a film industry promoting an idealized version of the modern girl about town: in 1968, for example, English television star Cathy McGowan was actively promoted in photographs showing her smiling in the driving seat of her new Mini, having just passed her driving test, ready to take off around town. At a personal level, therefore, driving 1960s cars like the original Mini helped people to cross class and gender divides and to express their own liberation in the post-war metropolis.

Since the early 1990s, and particularly following the 1991 release of Ridley Scott's hugely successful *Thelma & Louise* (explored in the next chapter), many films have reinvested the theme of women's driving with new values. In Germany, for example, the

media-savvy *Bandits* (Katja von Garnier, 1997) portrays four misfit rock group prison-escapees as they move around the country, performing secret concerts and countering patriarchy while driving their vw Dormobile against oncoming autobahn cars and turning a traffic jam into an impromptu dance scene. In France, *Vendredi soir* (Claire Denis, 2003) echoes some of the sentiments of *Cléo from 5 to 7*. This time the central character, Laure (Valérie Lemercier), can drive, which she does to travel across a gridlocked Paris. Negotiating threatening evening streets in her Peugeot, Laure meets and spends the night with a stranger, Jean, before abruptly leaving the following morning. A kind of condensed urban road movie, *Vendredi soir* sensitively shows Laure contemplating not just the dangers and opportunities of the city but also an intersection in her life as she moves from youthful frivolity to more serious responsibilities. In all of this, the car interior is gloomy, confined and near invisible, yet Laure and Jean's body language is minutely tracked, rendering the car a time and space of intense yet tender communication. A sense of everyday dreaming is also apparent, as when a Volvo's rear badge dances to music on Laure's car radio. The kind of car journey explored in *Vendredi soir* is thus part of the uncertainty and myriad possibilities of city life – a place of occasional anxiety, constraint, conflict and fear, but also a place to be left alone, meet new people, have unexpected things happen, maybe fall in love and yet not be tied down.

More recently, and providing one of the most intensive movie explorations of women and car driving, comes Quentin Tarantino's slasher-exploitation *Death Proof* (2007). This film first shows three friends in Austin – Shanna, Arlene and radio DJ Julia – turning a 1996

Honda Civic into a space of friendship where they joke, celebrate and plan the evening ahead. Driving here is an accommodation of girl-talk, of friends bantering and kicking back. In spirit, the second part of *Death Proof* closely resembles Russ Meyer's sexploitation classic *Faster Pussycat Kill! Kill!* (1965) and its sports car-driving ball-busting go-go dancers. In Tarantino's film, a new group of women – this time Abernathy, Kim and Zoë in a white 1970 Dodge Challenger (a reference to the cult *Vanishing Point*) – survive a car-borne attack from psychopathic killer 'Stuntman' Mike (who has previously sadistically murdered Shanna, Arlene and Julia with his Chevrolet Nova) and then dispatch him in their own violent assault waged by car and physical combat. I return to this film in the final chapter, but suffice to note here that, as with actor Theron's stunt driving in the 2003 *The Italian Job*, in *Death Proof* the character Zoë is played by real-life stuntwoman Zoë Bell, and much of the movie's extremely dangerous fast driving is performed by Bell

Abernathy, Kim and Zoë deal with 'Stuntman' Mike. *Death Proof* (Quentin Tarantino, 2007).

herself. Indeed, as Tarantino has explained, one aim was simply to show 'real cars, real shit, at full fucking speed',[16] that is, genuine action in the manner of films like *Bullitt* (Peter Yates, 1968) and *Drive* (Nicolas Winding Refn, 2011), largely devoid of CGI, speeded up footage or other such trickery. As such, for all its tongue-in-cheek film genre knowingness, *Death Proof* displays female driving as a full-on assertion of women's ability not just to command a car skilfully at rapid velocities, or to be in control of their own lives, but to enact dire and vengeful retribution against anyone foolish enough to interfere with these freedoms.

Alienation and Negotiation

Not all films deal with car driving in an entirely celebratory manner. As many of the movies above indicate, the freedoms offered by city driving are not without complications and contradictions. Most obviously of all, car ownership and driving is not available to everyone, a fact made particularly explicit in a movie like *Borom Sarret*, the first film made by a black African and directed by the Senegalese Ousmane Sembene in 1963. This 18-minute short discloses how the political and social promises of the car and modernity are unequally dispersed, for the cart man of the title does not have access to the new houses, economy, automobiles or equality of nascent postcolonial Senegal. Indeed, when he takes a besuited customer to the non-native quarter of Dakar, his cart is confiscated by an over-officious policeman, who stands on the cart man's war medal and prevents him from taking his fare. Two decades later, *Down By Law* (Jim Jarmusch, 1986)

begins with a tracking shot from a slowly moving car showing the graveyard, houses, shacks and impoverished people of New Orleans, portraying the black and white city as listless and down-at-heel. The unseen automobile here is only a voyeur of poverty – never a means of escape from it.

Those who can drive are not immune to the effects of driving, and of course alienation of drivers and passengers through car driving and ownership has been a constant theme of much exploration, both sociological and cinematic, over the last century.[17] In movies, these range from the heartless and dysfunctional Alexander Joyce in *Journey to Italy* (*Viaggio in Italia*, Roberto Rossellini, 1953), to the comedic portrayals of *Playtime* (Jacques Tati, 1967), where city dwellers guide cars with robotic choreography and struggle with parking meters, to the innumerable transport tribulations of *Planes, Trains and Automobiles* (John Hughes, 1987). A decade later, *The Truman Show* (Peter Weir, 1998) implies that we are all controlled by the mind-numbing schedules, systems and regulations of the modern world. Unaware that his whole life is one giant media construct, Truman is allowed to drive by the television programme's controllers, but artificial routines, repetitive patterns and frequent radio messages prevent him from ever leaving his local world. At one point, sensing something is wrong with all this, Truman literally drives around in circles before eventually being blocked by stage-managed traffic.

It is, of course, not even necessary to drive to encounter alienation through the car. *Tobacco Road* (John Ford, 1941), for example, uses new automobiles as symbols of unnecessary commodity consumption, hostile modernity and personal narcissism.[18]

Many European films of the late 1950s and '60s make similar observations, notably at a drinks party in *Pierrot le fou* (Jean-Luc Godard, 1965), where husbands and wives eulogize about cars and beauty products in staggeringly banal tones:

> HUSBAND #1: An Alfa Romeo has great acceleration, powerful disk brakes, holds the road perfectly and is an exceptional touring car. It is safe, fast, pleasant to drive, responsive and stable.

> WIFE: It is easy to look fresh. Soap cleanses, cologne refreshes and scent perfumes. And to avoid perspiration, I use Printil, and feel fresh for the rest of the day. Printil is available as a stick deodorant, a roll-on or a spray.

> HUSBAND #2: But the Oldsmobile Rocket 88 is even better. Look at its rigorous design. Its powerful, sober lines show that elegance and exceptional performance can be combined.

Mon oncle (Jacques Tati, 1958) makes similar comments when M. Arpel takes delivery of a ghastly apple-green, pink and lilac 1956 Chevrolet Bel Air, as does *Les Tricheurs* (Marcel Carné, 1958) when carefree Mic rejects the Vespa scooters used by other Paris teenagers for a 1955 Jaguar XK140, a wonderful piece of style and technology that she has long coveted but which, she quickly discovers, cannot compensate for her unfulfilled love for Bob. In another popular

M. Arpel takes delivery of a multi-coloured Chevrolet Bel Air. *Mon oncle* (Jacques Tati, 1958).

French film of this period, *La Belle Americaine* (Jacques Dhéry, 1961), a working-class couple's chance acquisition of an enormously ostentatious 1959 Oldsmobile brings them not success or status but misfortune and envy. In the end, they regain their happiness by transforming the American convertible into an ice cream van, so serving their local community.[19] In a similarly light-hearted manner, Tati's *Trafic* (1971) uses a car show in Amsterdam to mock the ridiculous features of new cars, manufacturers' extravagant stands and the people who crowd around them. A slightly different take on alienation by car ownership is provided by *Yesterday, Today and Tomorrow* (*Ieri, oggi, domani*, Vittorio de Sica, 1963) when wealthy Anna of Milan drives herself and lover Renzo around in her husband's Rolls-Royce Silver Cloud III, while having several near misses and minor bumps. Seemingly indifferent to everyone around her, Anna remarks 'I've been living an empty life enclosed in an ivory tower, ignoring completely the rights of

others', while simultaneously beeping vigorously to eject smaller cars from her path. The gruff Bentley-driving Alexander in *Journey to Italy* is equally divorced from others. 'What noisy people', he snorts from his leather driving seat as a local blares past. 'I've never seen noise and boredom go so well together.' In such portrayals, drivers have become trapped as consumers and owners, seduced by the appearance, specifications and marketing of cars for which they have no significant use, knowledge or desire.

While these films tend to regard cars as objects, and driving as a condition of ownership, the first movie to undertake a sustained exploration of city driving as both dynamic performance and alienating practice arrived in 1976, in the form of Martin Scorsese's daunting *Taxi Driver* (1976). Robert de Niro's interpretation of former Marine and semi-fantasist Travis Bickle takes us on a journey through New York and into the mind of a paranoid psychotic. 'I go all over', Bickle declares, 'I take people to the Bronx, Brooklyn, I take them to Harlem. I don't care. Don't make no difference to me.' In this way, the taxi is at first an instrument of freedom for Bickle, and the opening slow-motion shots correspondingly peer through a rainy windscreen at beautiful city lights and artfully blurred views, accompanied by the atmospheric jazzy strains of Bernard Herrmann's 'Thank God for the Rain'. On one level, this is a highly aesthetic depiction of urban driving, suggesting Bickle's emergence from, or perhaps retreat into, a dreamlike state. As he cruises around, streets waver like a three-dimensional oscilloscope, light reflects off glass and bodywork, rain trickles down the overtaking mirror, traffic lights pulse strong circles of colour, and lamp-posts hover like guardian angels. Yet these same scenes also act as a

pornographic frame (like the adult movie theatres he frequents), forcing Bickle to encounter adulterers, suave politicians, abusive customers, prostitutes, vandals, drug-takers and other city lowlife. 'They're all animals anyway', Bickle declares. 'All the animals come out at night: whores, skunk pussies, buggers, queens, fairies, dopers, junkies.' Through such categorizations, Bickle largely sees rather than engages with the city, and it is therefore this visual mode of experience which constructs his reading of the city as a set of characters and vignettes, just like the temporary and disconnected encounters he has with his customers. The problem, of course, is not so much with anyone viewing the city in this way per se, but that this mode of seeing and understanding becomes Bickle's primary, indeed almost only, mode of experiencing urban life.

As Iva Pekárková's gritty novel *Gimme the Money: The Big Apple as Seen by a Czech Driver* and other New York cabbies affirm, 1970s and '80s Manhattan really was like this ('it looked like Dante's Inferno, it was hell'), the relentless pulse of the city and the exhilaration of driving making the drivers sleepless, lonely and necessarily thick-skinned. 'Drive a taxi cab in New York for one year', one driver declared, 'and learn what life is all about.'[20] Along with streets of peculiar atmospheric beauty, Bickle thus encounters kids throwing bottles at his taxi, drives through fire hydrants gushing water and generally is thrown amidst the 'sick, venal' world of prostitutes, drunkards and drug-takers; not only does Bickle have to deal with ill-behaved customers, but every night he must clean blood and semen off the rear seats. This is the driving condition Bickle has to face: one that is alternatively welcoming and hostile, seductive and repulsive, striking and menacing, colourful and dark, mobile and claustrophobic.

New York as seductive and hostile beauty. *Taxi Driver* (Martin Scorsese, 1976).

At the start of the script for *Taxi Driver*, writer Paul Schrader quotes Thomas Wolfe: 'The whole conviction of my life now rests upon the belief that loneliness, far from being a rare and curious phenomenon, is the central and inevitable fact of human existence.'[21] Bickle deals with this condition by inventing a new character for himself, fantasizing that he is involved in secret government work, while his inability to relate properly even to his parents is revealed by his sending a solitary card to cover a birthday, wedding anniversary and Father's Day. He turns inwards on himself, altering his haircut, physique and eating and drug-taking habits, and procuring four handguns. Manhattan is constantly exposed to Bickle during his taxi-driving, car-based observations, and he is gradually desensitized to the city, which is particularly apparent in the way he is able to relate to people.

Bickle wants to like people, but cannot seem to find a way of doing so; he takes the cultured Betsy (Cybill Shepherd) to a sex film on a first date, and eventually becomes what Scorsese has called an 'avenging angel': shooting a grocery store robber, trying to assassinate a politician, befriending the teenage prostitute Iris (Jodie Foster) and killing her pimp and clients. Despite this descent into what seems to be a bloody death away from the realm of taxi driving, the automobile reappears as Bickle's saviour when in the final scenes (much debated as representing either his actual future life, or showing his dying dreams) the taxi becomes a space of escape, with lights blurred in the driver's mirror, at once beautiful, transient, unstable and uncertain. Bickle's initial alienation – his inability to influence society, lack of appropriate beliefs, willingness to use illegitimate means, isolation from conventional norms and inability to be genuinely satisfied[22] – is now replaced by a sense of negotiation: that is, he has dealt with that alienation and, ultimately, created some kind of peace, both within the city and within himself.

A rather different conundrum faces another taxi driver, Max (Jamie Foxx) in *Collateral* (Michael Mann, 2004), who is forced to choose between driving hired assassin Vincent (Tom Cruise) across Los Angeles, or being himself murdered. As the night unfolds, the two characters' roles begin to subtly shift: Vincent comes to Max's aid both when the radio controller charges Max for cab damages, and when he supports Max's exaggerated self-descriptions when visiting his mother; and, in reverse, it is Max who enters a gangster-run Mexican club and starts to assume Vincent's persona. Above all, the taxi interior is where Vincent forces Max to reflect on his life,

and make him realize that his ambition to set up a cool high-end 'Island Limo' car service is still entirely unfulfilled. Aggravated by this goading, Max finally takes charge, speeding up the taxi, driving through red lights and deliberately crashing. The night's driving is thus ultimately a testing ground for Max where he is shaken out of his comfort zone and compelled finally to act in a decisive and dramatic fashion.

Leaving such dramatic events behind, a more everyday kind of conflict and self-negotiation is presented in Mike Leigh's *Happy-Go-Lucky* (2008). Scott (Eddie Marsan), a depressive, repressed and intolerant driving instructor, is surprised to find himself both encumbered with and attracted to the annoyingly upbeat Poppy (Sally Hawkins), whose frivolous attitude to driving, inappropriate footwear and constant innuendo-riddled chatter he mistakenly interprets as signs of flirting. At first Scott seeks to dominate Poppy in his role as instructor, berating her in a summary manner. 'You

Max confronts Los Angeles, an assassin and himself. *Collateral* (Michael Mann, 2004).

have no respect for order', Scott proclaims, 'You are arrogant, you are disruptive. And you celebrate chaos.' Yet as tensions escalate and Scott's barely expressed feelings for Poppy go unrequited, it is Poppy who, like Max in *Collateral*, takes the initiative, and in a concluding meeting between the two it is Poppy who throws back at Scott some of his favourite aphorisms regarding the responsibility and dangers of car driving, and who ultimately decides who will and will not drive. Rejecting Scott's style of aggressive, anger-fuelled driving, at the movie's end it is Poppy, for all her apparent childishness and flippancy, who is most in control of her own emotions, behaviour and wider social responsibilities.

Adventure and Fun

> Motion is a key to unravelling the city. When you're moving, and the world is around you, your energy gets matched. You're enacting a kind urban dance that no choreographer has scripted. Explore, team up, match. This place seems to go beyond the usual commercial libido. It responds and reacts.[23]

One of the most notable features of treatments of driving in films from *The Grapes of Wrath* to *Happy-Go-Lucky* is that much of the car-borne narrative takes place at comparatively slow speeds, cars being used as a mobile platform for social encounters as much as for the freedom of driving itself. However, if these kinds of filmic

depictions of driving recall sociologist Georg Simmel's contention that the modern world allows us to be anonymous and uncaring, and that in this kind of city we must negotiate our social relationships in a guarded, managed and even slow manner,[24] then, conversely, we should also consider that high-speed city driving allows urban dwellers to invoke experiences of adventure, exhilaration and even lack of control. Other films, therefore, emphasize a sense of freedom and openness to the city in a more dynamic way, exploring exhilaration in conjunction with social mobility, and, in particular, articulating urban driving as an activity filled with adventure and fun. This light-hearted and exuberant approach to driving has been central to a great number of films over the last century. To cite but a few of these, as early as 1905 Georges Méliès' *The Paris-Monte Carlo Run in Two Hours* (*Le Raid Paris Monte-Carlo en deux heures*, 1905) depicts King Leopold of Belgium playfully crashing into gateways, buildings and stalls, while a year later the fantastical journey followed in *The ? Motorist* (Walter Booth for R. W. Paul, 1906) imagines a car flying into the sky and beyond the moon. Films like *Man with a Movie Camera* (*Chelovek s kino-apparatom*, Dziga Vertov, 1929) later used the car to give a dynamic sense of getting out into the city, car-mounted cameras here being used to see and depict urban life, while the car-borne shots in *People on Sunday* (Robert Siodmak and Edgar G. Ulmer, 1929) also provide a strong sense of the city, this time Berlin, being opened up to its young residents.

By the post-war years, this theme had developed much further. As young lovers Bowie and Keechie flee the law in *They Live By Night* (Nicholas Ray, 1948), it is constant automobile-borne movement which secures their freedom from capture. Overhead airborne shots

DRIVE

– an innovative technique for the 1940s – emphasize a sense of
speeding around the landscape, creating a symbolic wind propelling
them along. Although set in the Depression era, *They Live By Night*
is very much future-facing, showing that even in adversity young
people can still find adventure, fall in love and move forward.

In the somewhat different setting of 1950s England, *Genevieve*
(Henry Cornelius, 1953) shows Alan and Ambrose competing with
each other on the London to Brighton Veteran Car Run in their
Darracq 10/12 hp Type O and Spyker 14/18 hp in order to flee their
boring worlds of law and advertising. Over the next decade, similar
scenes of swerving, speeding and generally good-humoured harmless
tom-foolery abounded in London, from the chaotic car chases of
The Wrong Arm of the Law (Cliff Owen, 1963) and the *Doctor in
the House* series of films (Ralph Thomas, 1954–70) to the cheeky
driving of Charlie Hawkins in *Carry on Cabby*. In an unusually
thoughtful variant on this theme, *Catch Us If You Can* (John
Boorman, 1965) – a promo for pop band The Dave Clark Five –
undertakes a surprisingly serious exploration into personal freedom
and relationships amid stage-managed events, images and contracts,
deploying exuberant dynamic blurs, tilts and fast edits as Steve
(Dave Clark) and Dinah (Barbara Ferris) evade their commitments
in a white Jaguar E-Type, enjoying the rush of London roads, the
Kingsway tunnel, lights and buildings. Similarly in Paris, teenagers
Louis (Georges Poujouly) and Véronique (Yori Bertin) steal a
1952 Chevrolet Styleline DeLuxe as a mischievous lark in *Lift to
the Scaffold* (*Ascenseur pour l'échafaud,* aka *Elevator to the Gallows,*
Louis Malle, 1957), with a Miles Davis jazz score adding to the sense
of free-form adventure. The Chevrolet has a stylish motorized roof,

which Véronique smilingly admires: 'Look, a push of a button and it's done! That's the kind of life I want.'

However, the movie which has undoubtedly done the most to establish the notion of urban driving as a practice filled with adventure, fun and joyful speed is the original version of *The Italian Job* (1969), written by Troy Kennedy and directed by Peter Collinson. In this humorous crime caper, a group of British criminals led by Charlie Croker (Michael Caine) attempt to steal a truckload of gold bullion from under the noses of the Turin police and Italian Mafia. To do so, they jam the computerized traffic control system to bring the city to a virtual standstill, ram an OM Leoncino bullion truck and force it into an inner courtyard, and then offload the gold into three Austin Mini Cooper S MkIs (painted red, white and blue in the colours of the British Union Jack). With Turin gridlocked and seemingly impassable, the Minis make their escape through the interiors of the Palazzo Carignano and down the steps of the Palazzo Madama, along the

The city as playground. *The Italian Job* (Peter Collinson, 1969).

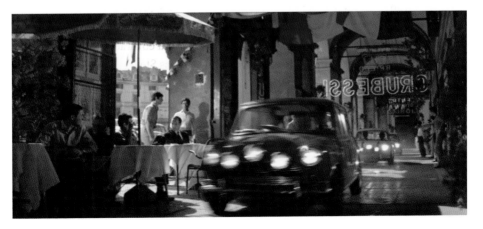

Galleria dell'Industria Subalpina and Galleria San Federico, and via
the various arcades, back alleys, courtyards and subway passages of
the city. They skip down the steps outside the Gran Madre di Dio
church, make high-level jumps between buildings, ride over the roof
of the 1961 Palavela (formerly Palazzo delle Mostre), race around the
famous rooftop track of the 1923 Fiat Lingotto factory, hide briefly in
a car park and finally flee the city across the weir of the River Po and
out via a sewer tunnel. In a deleted scene included in the DVD release,
the Minis and pursuing police Alfa Romeo Guilia TIs even come
together under the magnificent concrete vaulting of Pier Luigi
Nervi's 1949 Exhibition Building, where they perform an improbable
choreographed dance to the strains of Strauss's *The Blue Danube*.
At the end of the escapade, the gold-laden Minis disappear from
view when they are driven up into the back of a 1964 Bedford VAL
14 Harrington Legionnaire, using ramps trailed behind the coach as
it races along.[25]

The advanced stunt driving for the film was performed with
meticulous planning and precision by Rémy Julienne and his special-
ist équipe of drivers and mechanics. Nonetheless, it is not so much
the difficulty of the driving which makes *The Italian Job* so significant
or memorable as the character and personality of these antics. The
three childlike Minis bounce down steps, dart along gallerias, squeeze
through tunnels and cheekily play hide and seek with the chasing
police; the drivers grab food from pedestrians ('I could eat a horse!'),
shout 'good luck' at newly married couples, and bicker good-
naturedly with each other: 'Try putting your foot down Tony –
they're really getting rather close.' Here the streets of Turin become
a playground for driving, a scene of energy, pleasure and excitement,

a place where adults transcend the constraints of the city (traffic jams, regulations, signs, controls and procedures) and delight instead in unfettered velocities and trajectories let loose within unconventional and unusual locations. Indeed, if this seems like an overtly optimistic reading of the joys of urban driving, one could even go even further. In *Matter and Memory* (1896), the philosopher Henri Bergson contends that space is not static or pre-existent, but is born of motion, an unfolding and space of subjective perception that is revealed by a person's immediate experience of their world.[26] In this sense the urban space of Turin is not so much negotiated by the three Minis as created through their wayward trajectories, tight moves and hustling sprints; in this way, the city is rendered anew, brought into its very existence by dynamic city driving.

Given the starring role of the Mini in the original film, when the new *The Italian Job* (F. Gary Gray) was released in 2003, it was not surprising that the contemporary BMW-era Mini should enjoy a similarly prominent presence. In this version, written by Donna and Wayne Powers, the action is set predominantly in America, where Charlie Croker (Mark Wahlberg), Stella Bridger (Charlize Theron), Handsome Rob (Jason Statham), Left Ear (Mos Def) and Lyle (Seth Green) seek to avenge the death of Stella's father and steal back their gold bullion from double-crossing Steve (Edward Norton). As Steve transports the gold across Los Angeles in one of three International 4700 trucks, Lyle hacks into the city's computerized traffic system, isolates the gold truck and gridlocks the surrounding traffic. The team then blows up the road underneath the gold truck, dropping it down into a Metro tunnel and stealing the bullion in a trio of new Mini Coopers. As with the 1969 film, the red, white and blue cars

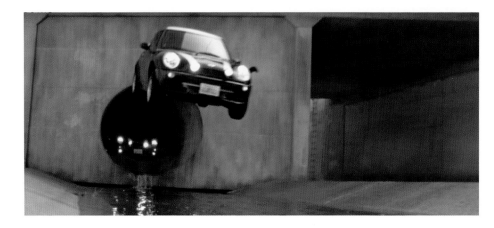

avoid seemingly impassable streets by using a sequence of tunnels and other short cuts, followed by some high-speed sequences through Los Angeles. At the end, they transfer the Minis onto another vehicle, a train at Union Station now replacing the earlier film's coach.

Unlike the more light-hearted tone of the 1969 movie, here the action is more dramatic in nature, involving precise driving with lots of tight turns and small jumps and a more spectacular and big-budget feel. One of the most significant changes is to the gender of the criminals, and in particular the prominence given to safe-cracker Stella. In the 2003 film, Stella zips her red Mini (a pre-BMW Mini Cooper Mk VII in homage to the 1969 original) through the streets of Philadelphia, squeezing at startling speed into a tiny parking slot between two enormous 4 x 4s. She later performs some equally remarkable driving (this time in the modern BMW-era Minis) when stealing back the gold bullion. A documentary included with the DVD version also reveals that during an intensive four weeks of driver training intended to allow them to perform as many stunts as possible, actors Charlize Theron (Stella) and Jason Statham (Handsome Rob) were intensely competitive with each other while undertaking complicated manoeuvres like 180-degree reverse handbrake turns in

extremely tight confines. As this suggests, no CGI effects (despite their ready availability) were used in the film's driving action scenes, the director being keen to preserve a strong sense of reality throughout the movie.

Gray's concern to maintain driving realism in what is essentially an improbable piece of Hollywood entertainment is highly significant, because at play in this meeting of the city, driving and film is a deliberate conjoining of the real and the imaginary, the everyday and the extraordinary, the conventional and the strange. For it is very much in normal people's quotidian lives that the city car operates, offering us not only a means of daily transport but also an important psychological and ideational sense of emancipation, pride, independence, autonomy and self-expression; the car allows us both to negotiate the conflicts we feel in our lives, and, to some extent, transcend them through newly constructed attitudes, aspirations, beliefs and perceptions. This is why automobile advertisements may focus on a range of different themes such as geographic escape, social status, individual freedom, gender and power, but in doing so nearly always go beyond matters of mundane function to incorporate elements of symbolic desire or even magical qualities.[27] Hence the UK BMW-era Mini was first launched in July 2001 with a highly sophisticated marketing campaign based on making the car seem as fresh and sexy as possible, proclaiming that 'It's a Mini Adventure'. Giant billboards included full-size 3D cars racing up the side of urban buildings ('New Mini attempts to drive up side of building. Succeeds. The End') while cinema advertisements parodied B-movies, showing the Mini saving the Earth from Zombies and invading Martians.[28] Similarly inventive marketing took place in the rest of

the world, an international 'Is It Love?' campaign focusing on emotionality, and running radio, television and print advertisements, mega-posters and special events across Asia, Europe, the Middle East, South Africa and the US. Over a decade later, and the new Mini is still being promoted as a sporty and adventurous automobile through such techniques as being the designated car for athletes during the London 2012 Olympics, as well as incorporating a special iPhone App to allow drivers to connect directly to Facebook and Twitter pages on the car's display screen, and automatically varying iPod music to match the car's speed.

Jim McDowell, vice-president of Mini USA, calls purchasers of the Mini and similar urban cars 'post-materialists', who buy an automobile because they perceive it to be exactly right for their own lives, and not because their neighbours have one. According to McDowell, these are drivers who are design-orientated, who prefer owning fewer and higher-quality objects and who have said 'I want to try a different path'; a car like the Mini helps them to redefine themselves as a person.[29] If they are to do so, of course, they cannot be told directly what they should think or purchase by marketeers. Hence the importance in the 2000s of films being increasingly used in conjunction with the Internet as a way of marketing cars virally, hoping that people will find and forward the films to their friends and colleagues through emails and social networking media. BMW were one of the first companies to succeed in this channel, particularly through the *The Hire* series of eight films produced in 2001–2. For the Mini, in 2007 BMW commissioned the *Hammer and Coop* series of six short films, created by Butler, Shine, Stern & Partners and directed by Todd Philips. Here, Hammer is a spoof of 1970s and

'80s television cops, and Coop is an independent-minded, irreverent and intelligent car which, in keeping with the spirit of the 1969 *The Italian Job*, speaks in an English accent, is argumentative and sarcastic, and performs numerous acts of precise urban driving such as spins, high-speed cornering and through pipes.

Sensing

As we have seen, filmic depictions of urban driving include such disparate notions as democracy and freedom, gender, alienation, negotiation, adventure and fun, thus constructing myriad correlations of the city, automobiles and social concerns. But what are some of the more visual, temporal and spatial aspects of these kinds of construction? In particular, what sensory experiences are involved in city driving, and how do films open these up?

Signs and Signals

> From speeding to walking, each rate of movement
> has generated a cinematic, constrained advertising
> language of icons and flags that address that motion
> and are probably invisible to others.[30]

One oft-cited aspect of urban driving is the reduction of city form to signs, signals, billboards and lights. That is, car driving tends to render the city as a matter of surface and the purely visual. Pre-eminent here is Robert Venturi, Denise Scott Brown and Stephen

Izenour's influential and partly film-based *Learning From Las Vegas* (1972), which celebrates roadside architectures of decorative symbolism, ordinary repetition and large-scale visibility. In this urbanism, signification triumphs over space and highway signs instantly communicate multifarious meanings.[31] This perspective resonates strongly with people's everyday urban experiences, for in the contemporary world of traffic management, where 'viewshed' design ensures landscapes are intelligible from moving cars, our city experiences are indeed highly semiotic, based to no small extent on a reading of signs and signals.[32]

Surprisingly, this aspect of urban driving is foregrounded relatively infrequently in film. Exceptions include the neon light sequences of *Piccadilly* (Ewald André Dupont, 1929) and other 1920s films such as *Berlin: Symphony of a Great City* (Walter Ruttmann, 1927) and *Man with a Movie Camera*, which take similar delight in the signs and reflections of the newly electrified metropolis. In the 1960s, movies like *Catch Us If You Can* used road signs and signals to highlight the dynamism of London, while one sequence in *Zabriskie Point* (Michelangelo Antonioni, 1969) similarly invokes a Venturi-esque series of signs, billboards and surfaces.[33] Some of the Japanese high-speed driving films from the 1990s onwards take particular delight in this kind of visual condition. For example, *Freeway Speedway 6* (Nikkatsu Corporation, 1996) turns the Japanese city into an assemblage of brake lights, headlights, tunnel lights, cornering arrows, overhead signs and other visual paraphernalia of night-time urban driving.

Other films, however, adopt a rather more critical attitude to signs, such as the propagandist documentary *The City* (Ralph Steiner

The Japanese city as lights, signs and signals. *Freeway Speedway 6* (Nikkatsu Corporation, 1996).

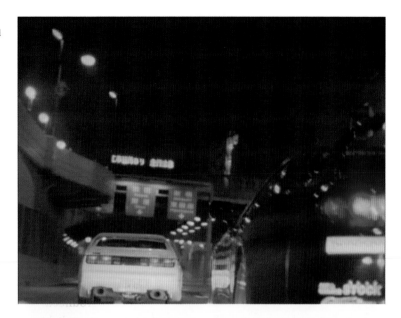

Montage of signals from the dystopian city of *Alphaville* (Jean-Luc Godard, 1965).

and Willard van Dyke, 1939), where constant instructions regarding 'no stopping' and 'no turning' indicate an intrusive, stressful and congested metropolis. As *The City* recognizes, city authorities often consider driving as a problem, and thus something to be controlled and rendered safe. In an overtly anti-signal and anti-governmental attitude, Godard first introduces the dystopian *Alphaville* as a city of flashing street lights, arrows, signs and equations, denoting the erasure of emotion and control of society by an unforgiving computer. In this kind of city, as French philosopher Henri Lefebvre noted a few years before Godard's film, signs are reduced to signals, directly issuing their instructions. 'I am conditioned by signals', wrote Lefebvre, perhaps recalling two years spent working as a Paris taxi driver, 'I behave as they tell me to behave.'[34] Similar connotations are felt by the cart man of *Borom Sarret* who reflects on how traffic lights control him as if he were in a prison. More prosaically, the kinds of sign-induced stress identified in *The City* are greatly intensified in the traffic jam at the start of *Falling Down* (Joel Schumacher, 1993), where William Foster (Michael Douglas) contends not only with roadwork lights flashing across his windscreen but also bumper stickers and license plates advertising everything from financial freedom and Christianity to downright abuse: 'How Am I Driving? Dial 1-800-EAT SHIT'. From this perspective, when we drive, the signs we see and must obey are not only a regulation of urban independence, but also a strong contributor to a mounting sense of urban frustration, alienation and malevolence.[35]

And yet, despite the kinds of argument made by *The City* and Lefebvre, stating that in a city of signals 'everything is trivial',[36] signs can also be much richer cultural entities, and indeed are capable of

speaking in multifarious ways. For example, even a single car journey in almost any city worldwide will provide not only signs for traffic management and control, but everyday clues to such things as power, servicing and communication networks, flora and fauna, corporations, historical traces, religion, international road haulage and so forth.[37] In film, these messages are often even more suggestive, providing another layer of meaning. Hence in *Saboteur* (Alfred Hitchcock, 1942), billboards seem to speak to Barry Kane of the dangers he is confronting, while neon ticker feeds in *Breathless* (*À bout de souffle*, Jean-Luc Godard, 1960) announce that Michel's arrest is imminent. At the start of *Sugarland Express* (Steven Spielberg, 1974), a stack of diverging highway numbers and directions indicates the uncertain future awaiting the Poplins. More subtly, in *Vendredi soir* Paris signs and lights provide the foil against which the slow-driving Laure rethinks her life. In these kinds of scene, signs add to the tapestry of the city, creating another layer of meaning among the many other such modes of communication present in urban life.

Time and Rhythms

Notions of time are central to urban driving experiences. Even in the early twentieth century, one of driving's great advantages was the freedom it gave from authoritarian train timetables. 'If I visit', wrote Rudyard Kipling of Edwardian motoring, 'I do so as a free agent, making my own arrangements for coming or going.'[38] Some indication of this can be seen in depictions of early motoring, notably in *The Open Road* (1925) where director Claude Friese-Greene's extended journeying around Britain is undertaken in a

Vauxhall D-type. Notably, Friese-Greene's route – from Lamorna Cove in the furthest southwest, through Plymouth, Cardiff and Glasgow en route to the north of Scotland, and then back south to London – would have been almost impossible via train, for only a car could readily accommodate his complex itinerary.

If the car promises to let the driver travel exactly where and when he or she wishes, of course in contemporary driving this does not always hold true: parking regulations, congestion and complex road systems mean the car is often no longer the most flexible form of urban transport, as is made evident in films from *The City* to *Falling Down*. But, for others, especially during non-rush hour traffic, it can still produce a peculiarly individual temporal experience. In city driving, as we have already seen with the Mini, this means a temporality of the ephemeral, darting and short-lived. Driving here creates a sense of communication that is curt and immediate, and which, again, is clearly evident in many films and exemplified by *Catch Us If You Can* and *The Italian Job*.

At other times, however, city driving is an amalgamation of different temporalities, from schedules and disruptions to free speeds and immediate movements. A notable version of this combination is provided by *Robbery* (1967), directed by Peter Yates who the following year would produce *Bullitt*'s seminal car chase. *Robbery* shows a group of London criminals planning and undertaking a jewel heist from a Vanden Plas 4 litre, the robbery being carried out with incredibly accurate timings and spatial choreography, including intricate surveillance, tracking, radio communications and a discreetly planted gassing device. After the heist, however, the robbers are rumbled by the police, leading to one of the longest

and most complex car chases ever undertaken in a British movie. Throughout this later sequence, it is the police who now adopt a highly measured and ordered operation, involving multiple cars, detailed written notes, radios, motorbikes, call signs, street names and directions. By contrast, the thieves resort to an increasingly desperate, high speed and instinct-driven attempt to escape in a silver Jaguar Mk2 in which they transgress various rules of the road, nearly hit a group of children crossing the street and get their windscreen smashed.

Unlike the fun-filled capers of *The Italian Job*'s Minis, all of this is shot in an extremely realistic and factual manner. Hence the streets are normal streets (not tunnels, weirs or arcades), the camera often takes the driver's view, and there is little dialogue to detract from what is essentially a neo-reportage piece of cinema, shot without official permission around London's Ladbroke Grove and including at least one real-life near miss.[39] Bereft of apparent emotion or other expressive theatricalities, the sense of frenzy as the robbers seek to escape is delivered instead by a sense of speed, risk, potential danger and exhilaration as factual, empirical experience – that is, as more like a high-speed game of chess against the clock than the playground-like antics of *The Italian Job*. Indeed, so matter-of-fact is the portrayal of these scenes that, despite their undoubted drama, one could read them as depictions of everyday driving, with all of its complex routes, manoeuvres, scrapes, timings, anticipation and decision-making, but now with the intensity dial turned up to max.

As *Robbery* therefore shows, driving adds another rhythm to the time and space of cities, one more pattern to the symphony of

melodies and beats created by urban life. In the early twentieth century, this was a common artistic theme, readily evident in Futurist paintings such as Giacomo Balla's *Velocità d'automobile + Luci* (*Speeding Automobile + Lights*, 1913), the films of Sergei Eisenstein and Fernand Léger's *Ballet mécanique* (1924), with its images of machines pistoning, rotating and gyrating. This is more explicit in films such as *Berlin: Symphony of a Great City* and *Man with a Movie Camera,* which montage car journeys and speeds against other scenes from daily life, and which use the rhythm editing of patterns, shapes and signs as well as of pedestrians, cars, trams and trains to portray the intensely pulsating quality of the city. Similar depictions occur in the first of the 1920s city symphony films, Alberto Calvacanti's oft-overlooked *Rien que les heures* (1926), which shows everyday events for lower-class Parisians through a series of multiple exposures, split screens, speeded-up action and frozen images as well as more prosaic images. 'We can fix a point in space to freeze a moment in time', proclaim intertitles, 'but space and time both elude our grasp.' A sense of rhythm is also to the fore in László Moholy-Nagy's *Dynamic of the Metropolis* film sketch (1921–2), and in Joris Ivens's *Regen* (1929), where the effects of rain on road surfaces, windscreens, wheels and car reflections are set within a delightful portrayal of downpours, splashes, patterns and puddles. Rhythm here is cast not just as the speeds but the changing light, textures and atmosphere of Amsterdam.

These avant-garde depictions of rhythms also appear in more conventional narrative movies. For example, early film-makers such as D. W. Griffith employed the fast speed of hurtling cars as an integral part of their cross-cutting and intercutting techniques

designed to increase narrative drama and tension,[40] while more
subtle depictions of automobile and urban rhythms soon appear
in the 1920s, as in *Piccadilly* when layers of space and reflections
infiltrate shots of a blurred bus moving across a static background.
Even more sophisticated games are played with the famous opening
sequence to *North by Northwest* (Alfred Hitchcock, 1959), where
Saul Bass's kinetic credits shift along the diagonal gridlines of an
office building, dissolving to reveal reflected views of taxis and
other cars of midtown Manhattan. All of this works to signify the
constantly conflicting rhythms and changing conditions of modern
city life.

Rhythms and
visual delights
of Amsterdam
rain. *Regen* (Joris
Ivens, 1929).

Not all rhythms are purely visual, as shown in *Genevieve*, where the sound of Edwardian wheels negotiating cobbles and tramlines is joined by judders, jolts, smells, beeps and burbling noises, while the belligerent blind passenger in the Paris episode of *Night on Earth* (Jim Jarmusch, 1991) recognizes from the sound of a tunnel that the cabbie has not followed her requested route. Another Paris setting provides a particularly modern formulation of rhythms in *Breathless*, including thoughts and complex conversation. In one sequence, Michel (Jean-Paul Belmondo) and Patricia (Jean Seberg) distractedly drive past blurred buildings while their disjointed dialogue collapses past, present and future, including a desire to caress, former marriage, their riding in a stolen car, a policeman's murder and a sense of fear – all while moving past some of the city's famous landmarks. 'Look', says Michel midway through their disparate exchange, 'Isn't Concorde gorgeous?' 'Yes', agrees Patricia, 'Mysterious with all the lights.' Director Godard explores this multi-cadenced urban experience again in *Pierrot le fou*, using the different coloured lights of night-time Paris not to depict some kind of actuality but as 'a sensation using the elements that compose it', as 'red stains, green, yellow gleams passing by' as they do in memory.[41]

A rather more cerebral depiction of rhythms is discernible in Wim Wenders's *Wings of Desire* (1987), in which angels' contemplations add temporal layers to the contemporary city they observe. In one scene the angel Cassiel journeys alongside the owner of a 1934 Mercedes 290, while views of war-torn Berlin are set against present streets. 'Germany has crumbled into as many small states as there are individuals', the narrative declares, 'and these small states are mobile.' Here rhythms are created through memories

and history, gently overlaid by driving through contemporary Berlin in a calmly measured manner. An equally thoughtful treatment of temporal rhythms appears in William Raban's *A13* (1994), where a day in the life of a major London highway is created through different driving speeds, traffic control systems, major tunnel construction, and incidental activities and objects like roadside workers, billboards, demolition works, street markets, artworks, financial exchanges, trains and light conditions. Influenced by *Man with a Movie Camera*, *A13* uses superimposition, mattes and other within-the-camera techniques and without recourse to post-production manipulations. Another psychogeographic film, *Robinson in Space* (Patrick Keiller, 1997), similarly conjoins times, ideas and places with the ambient details of city traffic. A more mainstream depiction of

the fluidity of time and space is the title sequence to *Changing Lanes* (Roger Michell, 2002), where traffic pulses dramatically: slow at intersections, speeded up down city streets, suddenly pulling up behind cars, fast when changing lanes, medium-paced on elevated freeways and so forth. All of this is shown at variable film speeds, angles and viewpoints, and an accompanying drum and bass score heightens a variable and discordant cadence in which the sense of a pulsating city rhythm comes from velocities, views and music rather than from montage or complex edits. Such filmic depictions emphasize the disparate temporal rhythms of cities, where the slow comes up against the fast, the speedy is interwoven with the plodding, hurried and rapid movement is punctuated by tedious waiting and stillness and, above all, the movement of cars adds its own distinct rhythm and speed to the city. This is faster, more dynamic and often more continuous than walking or cycling, at once creating barriers to and modulations of these slower activities. The sum total is indeed, as Ruttmann realized in the title of his *Berlin* film, a symphony of speeds and times, all coming together to create the complex, exhilarating and thought-provoking experience given to us by modern cities.

Anticipation and Mapping

For drivers, one of the dominant psychological states among these competing rhythms is that of anticipation: alertly reading the road ahead in order to predict what might be about to occur. A first-rate driver, declared pioneer motorist Filson Young, 'anticipates every variation, foreseeing and avoiding difficulties of traffic rather than

extricating himself from them'.[42] This is above all a mental process, involving instantaneous calculation of innumerable possibilities, and as such is embedded in nearly all filmic depictions of city driving, from the deliberate coasting of Scottie in *Vertigo* (Alfred Hitchcock, 1958) as he tracks Madeleine around San Francisco, to the constant awareness of New York traffic by Travis Bickle in *Taxi Driver*, to the frenetic computation made by the Mini drivers of *The Italian Job* as they negotiate London and Los Angeles. Occasionally, anticipation is even more explicit, as in *Breathless* when Michel instructs a Paris taxi driver: 'You're being overtaken by a scooter!', barks Michel. 'Take the next left! Overtake that 2CV! Eyes on the road!' More recently, the 'Follow' (Wong Kar-wai, 2001) episode of BMW's *The Hire* shows a driver (Clive Owen) recounting how to tail another car through traffic as a matter of 'distance, patterns, anticipation' involving alertness, precision, percentages, blind spots and understanding that 'distance is subjective'. Driving here is about a whole range of anticipatory and instinctive spatial tactics, such as short cuts, merging, overtaking, undertaking, accelerating, braking, cornering, reversing, rapidly parking and so on – all of which enables the driver be a truly metropolitan resident, someone who knows both the city and how to thrive within it. As driving specialists have described city driving, this practice not only requires considerable perceptual and information skills, including 'fast reactions' and 'the ability to concentrate and to anticipate other road users' moves', but also deep socio-psychological qualities of 'independence' as well as 'resourcefulness, calm behaviour under stressful conditions, cold-bloodedness'. Above all, drivers must 'develop human "nerves" to their fullest potential'.[43] More than a mere physiological skill,

driving involves the mental resilience and emotional depth to deal with all the city can throw up in terms of interweaving and fluctuating movements. In cities, driving goes far beyond being a mere skill: it is a registration of the driver's capacity to survive in the modern world.

As this suggests, the fast pace of much urban life is matched by the stop-start, ever alert and always impatient nature of urban driving. City driving produces, therefore, an experience of visual signs, but also of time, hearing, smelling, spatial judgment, danger, impatience and frustration – qualities which belie Lefebvre and others who see driving as a sensationless, culture-free zone. Instead, the very dynamic of urban driving creates cultural meanings or states, such as the condition of constant anticipation. Indeed, the situation is even more complicated in that urban driving sensibility is certainly dulled and routine, but is also hyperactive, always aware of the changing state of the surrounding city.[44] Driving is, therefore, an experience which represents the dual character of the city, being anonymous, repetitive and flat while simultaneously personal, rhythmical and variegated.

In another aspect of urban driving, knowing where to go (or not go) has always been part of automobile culture, ever since middle-class motoring pioneers put great effort into telling each other the best routes and hotels, or the worst garages to avoid.[45] As this suggests, mapping in driving – at least until the rise of GPS devices – has been primarily a cognitive activity, through which one knows the city less as an abstract map and more as a local experience. Hence in *Vertigo*, the seeming irrationality of Madeleine's convoluted routes boosts intrigue and mystery, reducing San Francisco to a

stage-set of impenetrable facades and meaningless surfaces. A similarly serious quality underlies Sherman and Maria's journey in *Bonfire of the Vanities* (Brian De Palma, 1990), when they take a wrong expressway exit into the 'war zone' of South Bronx. After hitting a black youth in their Mercedes 560 SEL, their lives rapidly become a maelstrom of ethical, judicial, journalistic, personal and political complications. 'A simple wrong turn, any one of us could have done it', explains the voiceover, 'suddenly you're off the track and moving relentlessly towards a destiny you could have never imagined.'

As all this suggests, mapping in driving is ultimately a matter of maintaining control over the city. Nowhere is this more evident than in heist and ambush situations, most explicitly in movies like *The Wrong Arm of the Law*, *Robbery* and, of course, the two versions of *The Italian Job*, in which the whole plot turns around the complications of conducting crime within complex city spaces. In *Payroll* (Sidney Hayers, 1961), a wages robbery is constructed as a complex mapping operation involving multifarious preparations, evasions, chases and eventual capture. Conducted amid gritty and industrial Newcastle upon Tyne, the action traverses central, wasteland and backstreet settings, thus increasing the sense of a whole city being mapped and controlled. A decade later, *Dirty Mary Crazy Larry* (John Hough, 1974) showed new mapping technologies as the police ensnare Larry, Deke and Mary in a large dragnet operation involving roadblocks, watch towers, sweep-searches and helicopter surveillance. The robbers counter with a radio scanner to eavesdrop and banter with the police, while also relying heavily on detailed knowledge of local territory. The 2003 *Italian Job* takes intricate mapping to even

more of an extreme. Initially, the gang hope to steal their target gold from a house interior, and so computer expert Lyle devises complex driving pathways via internal hallways, passages and steps. Later, he hacks the LA traffic system to gridlock streets and, by directing individual traffic lights, to manipulate a bullion truck within the ensuing chaos. Here, mapping comprises highly precise knowledge and control, and commands both large territories and micro-movements in time and space. This is not without some real-life parallel, for the Los Angeles Department of Transport undertakes a similar operation each year for the Academy Awards ceremony, precisely manipulating their computerized Automated Traffic Surveillance and Control (ATSAC) system to ensure the smooth cross-city running and timely arrival of 800 celebrity limousines in Hollywood.[46]

Mapping through driving is not always, however, simply about knowing where things are and how to get there. It is also

Lyle sends the bullion truck into a right-hand turn during a Los Angeles traffic jam of his own making. *The Italian Job.*

a matter of making mobile sense of the city even when that city resists conventional mapping. For example, the multiple car journeys of Quentin Tarantino's *Reservoir Dogs* (1992) and *Pulp Fiction* (1994) invoke a world of dislocated sensibilities and spaces in their depiction of postmodern Los Angeles, which, as urban geographer Edward Soja pointed out shortly before *Reservoir Dogs*, is the epitome of a fractured city, being at once profoundly conflictual in its history, limitless in its changing spatiality and appearing like an 'confusing collage of signs'.[47] A similar process occurs in an earlier Los Angeles movie, Roman Polanski's cinematic masterpiece *Chinatown* (1974). Within a plot based in part on the land and water disputes of inter-war California, the driving sequences in *Chinatown* disclose the essentially unknowable and unmappable nature of the modern city. In particular, a closing sequence shows detective Jake Gittes (Jack Nicholson) driving into the Chinatown area of Los Angeles. While we ride with the camera in the rear seat, city space is here both

Gittes drives into Chinatown. *Chinatown* (Roman Polanski, 1974).

observed from inside of the car (where it is partially obscured through reflections and movement) and accompanied by the tense and silent intimacy of the car interior. The result is a highly complex arrangement of views, searches and surfaces which renders Los Angeles less as a coherent urban or architectural space and more as a set of mysterious internalized and occasionally external spaces interconnected in some kind of as yet indecipherable manner. City driving here is at once mobile and static, revelatory and confusing, internal and external, physical and immaterial. It renders the city at once known and unknown, intelligible and irrational, certain and fragmented. And so in this dense spatio-visual construction, the experience of driving in cities attains what is perhaps one of its most significant attributes: not just being a way of travelling around or of discovering new places, but enabling the driver to confront the complexities of the city with all that it has to offer, and to try – without ever quite succeeding – to accommodate him- or herself within that complexity. *Chinatown* therefore serves as a reminder that our cities ultimately resist representation, comprehension and ordered understanding, and that, in turn, driving in them makes this even more apparent.[48]

2 JOURNEYS

In 1904, when the automobile was still the preserve of the wealthy, early motorist Filson Young was already speculating about the car's potential to enable the 'thousands who had otherwise been hopelessly engulfed in cities' to access 'the good life of the English country-side, its spaces and silences, its winding roads and peaceful landscapes'.[1] Henry Ford agreed when five years later he foresaw that his 'motor car for the great multitude' would allow any man with a good salary to 'enjoy with his family the blessings of hours of pleasure in God's great open spaces'.[2] Car manufacturer William Morris saw an equivalent market among the British middle classes,[3] while Adolf Hitler believed that a people's car would be of particular benefit to the less well-off as it would 'enhance their Sundays and holidays, giving them a great deal of future happiness'.[4]

During the interwar years these automobile visions became a common reality, either as a gentle Sunday drive in the countryside or as a more extended tourist drive, taking the motorist to exciting landscapes and distant sights. As Filson Young declared, 'the road sets us free [and] allows us to follow our own choice as to how fast and how far we shall go, permits us to tarry where and when we will.'[5] The car thus enabled the traveller to visit places unreachable by train, such as Raton Pass in America. 'Only by motor car can you climb such heights', exclaimed Dallas Lore Sharp, 'and halt

where you will and as long as you will.'[6] Unlike the train, which seemed to many travellers to be overly mechanistic in the way it passed places by, moving at a constant speed according to a pre-determined route and timetable, the automobile provided a more sociable way of travelling, hence restoring independence, intimacy and personal time.[7]

Above all, early motoring journeys were complex affairs of slowness, intimacy and unpredictability as well as of nature, land-scapes, pre-industrial society and generally of encountering a world which had recently become lost among the modern buildings and bustling commerce of the metropolis. They were, undoubtedly, also strewn with contradictions. For example, the 1920s American practice of relaxed and simplistic 'motor camping' increasingly relied on luxurious campsites and hotels, technological gadgetry, codified behaviour and even regimented timetables as motorists sought to 'make miles' between ever distant destinations.[8] Guide-books feverishly implored motorists to 'take time to see things',[9] disclosing the disappearance of slow, gypsy-like travels and the arrival instead of faster, view-at-a-glance tourism run according to a strict itinerary and a checklist of sights.

Glimpses of all this are supplied by biographies and memoirs, such as H. V. Morton's popular *In Search of England* and E. B. White's similarly influential account of American travels in *Farewell to Model T*.[10] But it is in film that the relatively innocent joys of early motoring really come alive, most notably in a documentary, Friese-Greene's *The Open Road*, made two years before Morton's famous literary work, where an expansive journey by Vauxhall D-type opens up Britain to both the driver and cinema audiences.

Claude Friese-
Greene passes
through an English
village. *The Open
Road* (1925).

An awful lot of Britain is on show here, from beautiful vistas, rural
hunts and agriculture to industrial manufacture, hydro-electric
power stations and coal mining, and from scenes of canals, roads
and trams to everyday routines such as craft activities, washing and
eating. So rich is the diversity on show that an intertitle asks 'why
travel abroad?' And when Friese-Greene comes across some other
motorists taking a roadside picnic, another intertitle declares: 'here,
indeed, was manifested the full joy of the Open Road'.

Suggestions of the camaraderie shared by early motorists
can also be seen in many other films. In *The Grapes of Wrath*, for
example, the extreme desperation of migrants en route to California
is mitigated by a campsite filled with shared food, personal tales and

melancholy, defiant singing. A similar Depression-era scene occurs in *Bonnie and Clyde* (Arthur Penn, 1967) when the injured fugitives receive food and water at another itinerant motorcamp. Even in the post-war setting of *Genevieve* it is clear that motoring was still connected with an older, less urban England, including forgiving policeman, helpful passers-by, traditional hostelries, local garages, gentle roads and country lanes blocked by sheep. Other incidental glimpses of driving as a carefree rural affair range from *Les Vacances de M. Hulot* (Jacques Tati, 1953), where holidaying children get their first sight of the seaside from a 1933 Renault Monaquatre 8cv, to the nostalgic portrayal of mid-twentieth-century motoring in the family animation *Cars* (John Lasseter and Joe Ranft, 2006). Here, the motoring town of 'Radiator Springs' is explicitly based on the gentle driving conditions which ran along Route 66 in pre-interstate America. 'Back then cars came across the country a whole different way', explains Sally, the Porsche 911 lawyer. 'The road didn't cut through the land like that interstate. It moved with the land, y'know, it rose, it fell, it curved. Cars didn't drive on it to make good time, they drove on it to have a great time.'

Kinaesthetics

'Sometimes, when I'm driving across the moors at dusk on a summer's night, there are moments when I'm going downhill and it feels like falling into the landscape. I feel as if I'm swooping down like a bird of prey, the moors coming up to meet me.'[11] As this quotation suggests, some countryside driving pleasures are less dependent

on seeing new places or people, and instead are embedded within the sensual pleasures of driving: what motoring journalist Steve Cropley aptly describes as the rich satisfaction derived from 'the rhythm, the absorption and the simple pleasure of motion'.[12] This condition of sensory experiences produced in motion – sometimes referred to as kinaesthetics – has been particularly explored in artistic and literary debates, notably by Sara Danius.[13] At first glance, this can be a complex conceptualization, and it is therefore worth recapitulating its main features here under three categories – the appearance of objects, ways of seeing and the intensification of these effects through speed – while also indicating how these three kinaesthetic conditions have been explored in film.

The Appearance of Objects

Driving can shock us out of our normal, unthinking and disconnected relationship with our surroundings, and instead inculcate a purely sensory encounter with the world around us. As a result, *objects appear differently*, rendering the familiar strange and out-of-place. In other words, trees, buildings, other vehicles and so on all look different from the car from how they do from the roadside; as Charles Bernard discovered during his first automobile drive in Ilya Ehrenburg's Futurist-Expressionist novel *The Life of the Automobile*, 'everything flashed by as in the movie-theater'.[14] In particular, objects can assume a 'purposeless beauty', being divorced from their original function, and so appearing as items of non-contextual contemplation. Filson Young described telegraph posts as no longer performing a task of communication, but beginning 'to crowd

together . . . flying in all directions over the ancient roofs of the
town and past the chimneys and weather-vanes like gathering
rumours or like flurried passengers'.[15]

Objects also appear differently in other ways. For example,
a dominant driving effect is that the mobile becomes immobile,
for drivers, their own cars and other mobile vehicles appear to be
stationary. Conversely, the immobile: becomes mobile – cars animate
landscapes so that stationary objects may appear to be moving. 'The
very mountains', wrote Filson Young, 'that in half a day's walk do
not seem to change their places, move and wheel and curtsey round
you in a stately dance.'[16] This effect is further intensified through
the phenomenon psychologists term 'motion parallax', whereby
nearby objects, such as trees and telegraph poles, seem to be moving
more rapidly than those that are more distant, such as hills and
mountains.[17] A great many writers have been struck by this kind
of visual experience, including the Belgian author Maurice Maeter-
linck, French writer Marcel Proust, Italian Futurist artist Filippo
Marinetti and French cultural theorist Paul Virilio. Maeterlinck's
essay 'In an Automobile' (1904) has driving speed increasing such
that the road 'grows frantic, springs forward, and throws itself
madly upon me, rushing under the car like a furious torrent',[18]
while, nearly a century later, Virilio remarks upon inanimate objects
that 'exhume themselves from the horizon and come bit by bit to
impregnate the sheen of the windshield', thus creating what he calls
'speed pictures'.[19]

In film, indications of these visual effects appear in documen-
taries like *Berlin: Symphony of a Great City*, where a mobile landscape
is contrasted with what appear to be stationary parts of a train, while

The mobile and the immobile. *Man with a Movie Camera* (Dziga Vertov, 1929).

Man with a Movie Camera provides a strong sense of the mobile and the immobile, particularly when a split screen has a static camera shot of trams crossing (where the trams are clearly moving) contrasted against a car-mounted image of trams moving (where the trams appear static in relation to the camera). From the 1950s onwards, these kinaesthetic games are more commonplace, and so in *Journey to Italy*, *Wild Strawberries* (*Smultronstället*, Ingmar Bergman, 1957), *Les Tricheurs* and *Breathless* we see blurred views of passing trees, trains, telegraph poles and buildings; while in *Duel* (1971), director Steven Spielberg engenders a great sense of speed through long-lens shots of the cliff walls flashing by on the inside of the demonic, chasing tanker.[20] In a similar manner, John Frankenheimer's *Grand Prix* (1966) emphasizes a tremendous sense of high-velocity driving at Monza with trees, bridges, hedges and signs all hurtling past the car-borne cameras. François Truffaut displayed

a particularly sophisticated awareness of kinaesthetics in the title
sequence to *The 400 Blows* (*Les Quatre Cents Coups*, 1959), which
intriguingly is an almost direct transposition of Proust's description
in *Swann's Way* (1913) of approaching the twin church steeple of
Martinville. 'The movement of the carriage and the windings of the
road seemed to keep them continually changing their position',
Proust writes. 'The steeples appeared so distant, and we ourselves
seemed to come so little nearer them, that I was astonished when, a
few minutes later, we drew up outside the church of Martinville.'[21]
In *The 400 Blows*, Martinville's church is now the Eiffel Tower, whose
lofty structure is first seen in the mid-distance from a car-mounted
camera, and then tracked as it continually disappears and reappears
from behind various buildings and trees. As the car circles, the tower
seemingly moves of its own accord while staying tantalizingly distant.
When the camera eventually gets near, the tower suddenly moves
faster, and the camera struggles to record the details of its iron

The Eiffel Tower
depicted in
Proustian terms.
The 400 Blows
(François Truffaut,
1959).

Montage of views of the American landscape from *Rain Man* (Barry Levinson, 1988).

structure; finally, the car departs down a straight boulevard, and the Eiffel Tower becomes more static before gradually receding into the distance.

In a more recent depiction of driving kinaesthetics, *Rain Man* (Barry Levinson, 1988) contains a highly perceptive sequence in which Charlie and his autistic brother Raymond experience a melody of speed effects, including glimpses of rushing yellow lines, road surfaces, trucks, bridge structures, fences, vegetation and open fields, along with such other impressions as mid-distance views of telegraph poles, wavering shadows, mirror reflections and mesmerizing single-point perspectives. In part this is a landscape being seen from the eyes of a childlike man, but the sequence also allows the audience itself to recover something of that initial newness of experience encountered by earlier motorists when driving in the countryside. These experiences can also be seen in many other road movies, particularly when characters are revelling in a sense of release from the city as they hit the open road. For example, in *The Adventures of Priscilla, Queen of the Desert* (Stephan Elliott,

1994), *To Wong Foo, Thanks for Everything, Julie Newmar* (Beeban
Kidron, 1995) and *Sideways* (Alexander Payne, 2004) we see wind,
shadows, rushing landscape, fresh air and sunshine all being enjoyed,
creating a sense not only of the kinaesthetics of driving but of life
being enjoyed afresh.

Ways of Seeing

As *Rain Man*, *To Wong Foo* and *Sideways* all suggest, another aspect
of kinaesthetics is that the *way we see* is changed by driving. By
releasing objects from their context, the process of seeing objects
is in turn freed from contextual knowledge; as a result, this seeing
process becomes a form of seeing 'in the first person'. In short,
driving helps us to forget what we know, and to focus instead on
what we simply see. This process is particularly attractive to artists,
writers, film-makers and other creative producers, providing them
with appropriate metaphors or other reflections on modern life.

Unsurprisingly, this aspect of driving kinaesthetics is frequently
apparent in avowedly experimental films. For example, *Man with
a Movie Camera* – introduced as 'a truly international absolute
language of cinema based on its total separation from the language
of theatre and literature' – is as much an analytical film about film-
making as it is a portrayal of urban life, thus leading to the kinds
of split-screen depiction of mobile and immobile trams described
above. Less self-referentially, *Emak-Bakia* clearly shows how moving,
changing and vibrating vision fashioned from a moving automobile
can help explore Dada-Surrealist concerns with dreams, sexuality
and the Freudian subconscious. As Kiki de Montparnasse propels

The journey between external and internal worlds. *Emak-Bakia* (Man Ray, 1926).

her car, angled views, movement blurs and juddering bumps infer a strange and uncontrolled journey into her deeper, uninhibited desires; driving here is a journey between the external world of physical pleasures and the inner world of thoughts, longings and yearnings. Similar depictions occur in Man Ray's *Les Mystères du château du dé* (1929), where fast and jerky windscreen shots reveal passing trains, telegraph poles, buildings, trees, village streets, slower traffic, signs and hedges in a highly uncertain and transitory manner – all of which indicates a concern with the role of chance and the fleeting nature of modern life. Equally experimental, albeit with the different concerns of an industrial documentary director, Geoffrey Jones's *Shell Spirit* (1962) also exploits kinaesthetic pleasures to reveal elusive meanings. This two-minute advertisement uses rhythm-edited and sun-drenched shots of road lines, houses, boats, pigs, a woman, the sky, wheels, patterns, textures and so forth, all set alongside South African *Kwela* pennywhistle street music. The overriding impression is of freedom to be gained

by driving out in the countryside and seeing new sights. Above all, *Shell Spirit* is a celebration of the joyful sensation of movement and a truly modern way of seeing.

Montage of rhythm edited shots from *Shell Spirit* (Geoffrey Jones, 1962).

Other forms of seeing are also implicated in the driving experience, notably the way the windscreen acts as a frame, limiting the landscape within a carefully prescribed boundary and hence converting it into an object of visual pleasure; as film historian Anne Friedberg summarily describes this condition, 'the visuality of driving is the visuality of the windshield, operating as a framing device.'[22] Through this frame, landscapes become fragmented into a series of discrete objects, vistas and markings, but are then recombined by the particular driver, car and journey. Examples of this in art are manifold, from academic painter Hubert von Herkomer's realization in 1905 that in his car 'one picture after another delights

my artistic eye', to Henri Matisse, whose *Le Parebrise, sur la route de Villacoublay* (1917) shows the view ahead framed into a triptych by his car's central windshield and side glass, as well as Stuart Davis's *Windshield Mirror* (1932), Edward Hopper's *Jo in Wyoming* (1946) and some of David Hockney's Mercedes-based Polaroid collages.[23] Sometimes artists look through the side windows, as in the photographs of Lee Friedlander's *America By Car* (1992–2009), Max Forsythe's *Drive By Shooting* (c. 2004) series, Ed Ruscha's *Every Building on the Sunset Strip* (1966), which depicts Los Angeles building facades in a continuous car-like journey, and Robbert Flick's similar video series *L.A. Documents* (1996–).[24] As these artworks suggest, such recombinations are near unique to driving. 'The opening of the cockpit is not a simple window', writes Virilio, 'it's a stage where signs of the places traversed animate themselves in a play of scenery changes composed of speed changes.'[25] Through driving, therefore, the landscape appears in cinematic terms – notably those of framing, sequencing, editing, unusual juxtapositions, montage, changing pace, unexplained events and unfamiliar sights, all of which are induced by the speeding, kinematic nature of driving.

Instances of this process occur in almost every scene of automobile driving in film, and I return to this aspect of kinaesthetics at the end of the following chapter. But to focus on just one movie here, a notable demonstration is provided by the much-maligned *The Brown Bunny* (Vincent Gallo, 2004), where motorcycle racer Bud Clay drives across the U.S. while recalling his ex-lover, Daisy. Throughout, Clay contemplates his life while viewing roads, traffic and landscape through the unrelenting frame of his 1994 Dodge Ram's dirty, fly-splattered windscreen. The effect is at once terminally banal – a

never-ending stream of everyday roadside paraphernalia – but also occasionally profound, for we see Clay suffer and contemplate loss, and eventually – and controversially – we come to understand his tortured mind when witnessing the two notorious scenes in which Clay (Gallo) and Daisy (Chloë Sevigny) have unsimulated sex and in which Daisy is gang-raped while Clay stands by. In this sense, the windscreen is cinematic in its portrayal both of America and of *The Brown Bunny* as a film; it offers at once a banal representation of a physically unyielding landscape, an effective insight into a challenging mental state, and a metaphor for a hugely uncompromising movie.

Intensification Through Speed

If speed changes how objects appear to us, and how we view these objects, then it also heightens our sense of these experiences. As has been noted for train travel, 'increased velocity calls forth a greater number of visual impressions for the sense of sight to deal with', a condition which equates with sociologist Georg Simmel's realization that modern life intensifies urban perceptions.[26] In automobiles, where the driver has even greater exposure to speed coming through the windscreen, this produces a correspondingly greater intensification, and in particular exacerbates a sense of strangeness, disconnection and velocity. In art we see this in early Futurist paintings such as Giacomo Balla's *Abstract Speed* series (1913–14) and Luigi Russolo's *Dynamism of a Car* (1912–13), while abstract films like Walter Ruttmann's *Opus 1* (1922) and Len Lye's *A Colour Box* (1935), *Kaleidoscope* (1936), *Swinging the Lambeth Walk* (1939) and *Particles in Space* (1967–71) similarly

Windscreen view as representation of landscape and metaphor for film. *The Brown Bunny* (Vincent Gallo, 2004).

use conditions of motion and speed to intensify their effects. For example, in *Opus 1* abstract forms move against a black background, creating raw rhythms and patterns in which shapes tumble, swerve, sweep, swing, fall, point, grow, avoid, occlude, follow, chase, bulge, drift, zigzag, wave, crest, swarm, oppose, stab and search – and in all of this speed heightens the effect on our eyes, creating a peculiarly hypnotic effect of pure movement, velocity and motion. In *La Glace à trois faces,* a businessman's flight from his complex love life is similarly centred on the mesmerizing velocity of his sports car: flying through villages, scaring pedestrians, overtaking other cars, flashing past trees and signs. Above all, speed defines both character – lonely, shallow, self-focused, cowardly – and fate as he hurtles

Abstracted movement intensifying the anticipation of a murderous act. *The Killers* (Robert Siodmak, 1946).

towards a final, lethal crash. Two decades later, Robert Siodmak's classic film noir *The Killers* (1946), in a near abstract opening sequence, almost directly translates the experimental depictions of motion by film-makers like Ruttmann and Lye. A highly minimalist windscreen view, shot while racing down a fast-moving country road at night, reveals only the road surface and lines as they are picked out by headlights. Patterns of light and shade rush towards the camera, the sheer speed at which they advance signifying the impending arrival of the two hit men at their destination in Brentwood.

Furthermore, it is not just viewing which is altered in this process, for the driver's body is also intensified by speed. Enthusiastic drivers will often travel great distances to experience the unique

sensation of driving on particularly sinuous, steep or otherwise challenging routes; the Stelvio Pass (Italian Alps), Iroha-zaka (Japan), Pacific Coast Highway (USA), Great Ocean Road (Australia), Pan American Highway (Mexico section), Transfăgărăşan/DN7C (Romania), Millau Viaduct (France), Hana Highway (Maui), Lysebotn Road (Norway), San Bernardino Pass (Switzerland), Guoliang Tunnel Road (China), unrestricted autobahns (Germany), 'Cat and Fiddle'/A537/A54 (UK) and the Jebel Hafeet Mountain Road (UAE), among many others, have all gained international reputations for being among the world's best driving roads.[27] 'There is no sensation so enjoyable', insisted Lady Mary Jeune in the 1900s, 'as driving in a fast motor. The endless variety of scenery; the keen whistle of the wind in one's face; the perpetual changing sunshine and shadow, create an indescribable feeling of exhilaration of excitement.'[28] These words could easily have been written for innumerable filmic depictions of driving as an enlivened bodily experience, but is particularly noticeable in scenes like one in *Dirty Mary Crazy Larry*, where Mary sticks her head out of window, enjoying both the onward rush of air and, therefore, a bodily manifestation of being on the run. Driving here creates a physical expression of a psychological condition. Indeed, in such conditions, a driver can feel that their body is no longer their own: 'it was as though I became the car, or the car became me, and which was which didn't matter anymore.'[29] More poetically, in the 1907 fantasy travelogue *La 628-E8*, Octave Mirbeau exhorts artists to devote themselves to the automobile, and describes a driver whose life is governed by speed. 'His brain is a racetrack, where thoughts, images and feelings roar along at

a hundred kilometers per hour', writes Mirbeau. 'Speed defines his life. He drives like the wind, thinks like the wind, feels like the wind, makes love like the wind, lives a whirlwind existence.' Mirbeau also extends this description in cinematic terms, noting how life rushes at the driver from all directions, only to then 'flicker away like a film'.[30] Movie depictions of such people abound, most recently in Ryan Gosling's portrayal of the anonymous avenger in Refn's *Drive*. But it is in the appropriately named *The Driver* (Walter Hill, 1978) that we find the figure of the driver-defined-by-driving in the most extreme form. Without a name, 'The Driver' is entirely circumscribed by his ability to control an automobile: to hotwire cars, drive fast, evade police, cause and avoid accidents, react to the visual conditions, keep calm (even under gunfire), navigate streets and traffic at high speed and even destroy a vehicle. Played by Ryan O'Neal, 'The Driver' says less than 400 words in the whole movie, and thus takes his whole raison d'être not from relationships with people or surroundings but from the act of driving itself, and in all of its possible variants.

In summary, the kinaesthetics of driving involves a substantial re-orientation of the experience of time and space, in which sight, senses, intellect, landscape, meaning, creativity and the human body are all potentially reconfigured. As Filson Young wrote, such driving 'flattens out the world, enlarges the horizon, loosens a little the bonds of time [and] sets back a little the barriers of space', while the driver simply 'lives more quickly'.[31] This is not an experience restricted to the world's best artists, race drivers or extreme thrill-seekers. Rather, such experiences are available to us all; indeed, they are often unavoidable whenever we drive or even passenger

in a car. They may be experiences which we have seemingly grown used to, and may not always have the shock of the new felt by the drivers depicted in early films like *Emak-Bakia* or *La Glace à trois faces*, but they are nonetheless essential and commonplace parts of modern driving.

Existential Self

Here we arrive at one of the most important aspects of automobile experience: driving as an existential condition whereby the driver seeks to confront, explore, express and produce the self through encountering the world around them – in other words where the driver reassesses their sense of autonomy, freedom and self-reliance. In particular, the 'road movie' of the 1950s and '60s, which often contains elements of social critique, later gave way, especially in the 1980s, to road movies where driving across a real landscape is used to indicate a psychological, emotional, philosophical or similar personal transformation.[32] Indeed, of all the ways in which driving has been represented in film, it is the road movie that, along with the car chase and the crash, has become particularly prevalent. It is also the area of cinematic driving that has been most analysed by critics and historians.[33] In order to navigate this range of movies and interpretations, I look here at three different themes: discovery, reconfiguration and nihilism.

Discovery

The literary world abounds with accounts of longer journeys,
adventures and philosophically oriented excursions in which drivers
discover something about themselves; such extended voyages trans-
port us out of familiar worlds, challenge our sense of security, open
up our minds and help explore those parts of ourselves usually
hidden within normal routines.[34]

Such dramatic accounts are similarly abundant in film, where
a narrative can be tightly wrought and intensely developed. *Easy
Rider* (Dennis Hopper, 1969), although a motorcycle rather than
an automobile film, is particularly worth recalling here. Essentially,
a journey is used to sound out America's contemporary condition,
especially differing attitudes to sexuality, transience, drug-taking,
personal appearance and politics. For the two riders, Wyatt and
Billy (Peter Fonda and Dennis Hopper), this drifting voyage is
less a discovery of the self than an attempted enactment of what
they already believe – as Wyatt muses, he 'never wanted to be
anyone else'. Instead, their true discovery is how hard it is to follow
their somewhat incoherent beliefs in the late 1960s; ultimately,
they fail to be properly countercultural – in Wyatt's famous line,
'you know, Billy – we blew it' – and, with their concluding death
by murderous hillbillies, they fail also to find a place where such
a project could be accommodated by mainstream America. As a
promotional poster declared, 'a man went looking for America
and couldn't find it anywhere'. Ultimately, therefore, *Easy Rider*
has no particular message, and is more about the search itself: the
importance of always moving and looking, even if no resolution
can be found.

If *Easy Rider* portrays two men who try to find something but fail to do so, then Spielberg's television movie *Duel* shows a driver who is in search of nothing but nonetheless discovers something about himself. In particular, *Duel* has inculcated audiences with the image of a solitary driver faced with unforeseen and mysterious challenges. The plot is extremely minimal. Based on a short story by Richard Matheson, businessman David Mann (Dennis Weaver) drives his Plymouth Valiant across the California desert, where he is constantly assailed by a grimy Peterbilt 281 truck – apparently for no reason, and by a driver whose face we never see.[35] In a psychological cat-and-mouse contest, Mann tries to outrun and outsmart the maniacal tanker driver. Minor crashes and near misses intercut heart-stopping sequences, as when Mann is rear-shunted into a passing locomotive while waiting at a train crossing. In turns curious, paranoid, bewildered, angry and desperate, Mann eventually outwits the tanker driver by playing a game of chicken on a cliff-top plateau – Mann jumps unhurt from his Plymouth at the last moment, while his adversary fatally plummets into a canyon, with a roaring, slow-motion dive signifying the end of both tanker and driver. Mann is initially jubilant, dancing in a manic, chimpanzee-like manner; a series of sharp yelps, half-cries and half-laughs reveal that he has been brought to a primitive inner self. Finally, Mann contemplates the sunset, the intelligent modern man within returning as he throws stones over the cliff edge.

Duel has been interpreted as being representative of U.S. class war, largely through white-collar Mann being attacked by a blue-collar tanker driver.[36] It also shares with many road movies a condition whereby objects and events encountered along the road

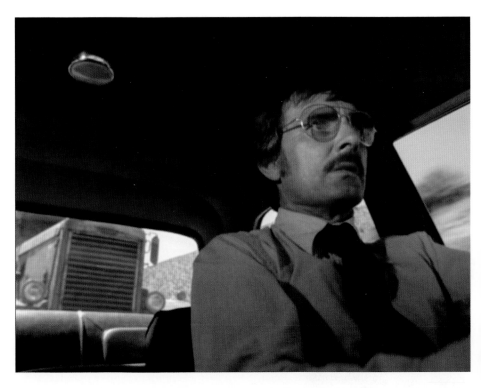

are threatening and invasive, thus indicating that the external world is pressing menacingly inward on the driver.[37] More fundamentally, however, *Duel* portrays one man's struggle against the unknown and the irrational, his fight against the fear (turned reality) that something dreadful might happen for no reason. This also differentiates *Duel* from some of the later films influenced by it, such as *Roadkill* (aka *Joy Ride*, John Dahl, 2001), in which a psychopathic truck driver has at least some reason to pursue his taunting victims. In

David Mann pursued by a Peterbilt 281 tanker. *Duel* (Steven Spielberg, 1971).

Duel, however, the assault comes out of nowhere. Above all, in his celebrations, at once childlike in unfettered jubilation and terrible in emotional intensity, Mann discovers qualities until now hidden, even from himself. 'It was a primeval tumult in his mind', ends Matheson in the original story, 'The cry of some ancestral beast above the body of its vanquished foe.'[38] So although the film ends with nothing being explained or made clear, the true meaning lies in Mann's discovery of his own resoluteness and determination, as well as his unearthing of other qualities that he has yet to comprehend, and perhaps, as night falls, has already once again buried. The other suggestion is of course that if this most un-macho of men, one who bears the universal moniker of 'Mann', carries within him such emotions and capacities, then so might all drivers, all people.

After *Duel*, Spielberg returned to the theme of a journey filled with increasing stress. Based on a true story, in *Sugarland Express* Lou Jean Poplin (Goldie Hawn) helps her husband Clovis (William

Lou Jean Poplin helped by ordinary Americans at a gas station. *Sugarland Express* (Steven Spielberg, 1974).

Atherton) to escape prison; they then try to collect their son Langston from a foster home, along the way kidnapping patrolman Maxwell Slide. Over days of slow-moving driving, a massive police and media presence tracks their every move. Eventually the Poplins reach the foster home, where Clovis is shot, though, credits inform us, Lou Jean later gains back Langston. Like *Duel*, the physical journey depicted is also intensely psychological, passing from desperation, surprise, denial and determination to changes in the Poplins' relations with Slide, the public, the media, the police and each other. As with Mann in *Duel*, the Poplins also discover an inner determination to face the challenges presented by the external world. However, unlike in *Duel*, whose story is predicated on unprovoked external violence, here the context is more clearly internalized – the Poplins' illegal actions, their focus on family reunion and the support they receive from sympathetic members of the police and public. 'It's your baby', a woman says to Lou Jean at a gas station. 'Don't let no one take him away from you.' The discovery made is of the prevalence of normative social standards – the Poplins' hopes for family life, the police's reliability and sensitivity, and the public's capacity to empathize.[39] *Sugarland Express* does not seek to portray any flight from, alteration to or philosophical meditation on life but rather to represent the conformative principles at the heart of American society. This journey at once discovers and reaffirms conventional values.

A similarly conservative approach to America values pervades films like *Planes, Trains and Automobiles*, *Rain Man* and *Lost in America* (Albert Brooks, 1985). In the last of these, David and Linda Howard (Albert Brooks and Julie Hagerty) leave New York for Connecticut in a Winnebago motorhome. Inspired by Hopper's

classic film ('this is just like *Easy Rider* – except now it's our turn') the couple are also lured by cheaper property and the chance to spend time writing and painting. *Lost in America* thus exemplifies a common road movie theme, whereby the escapist fantasy of the open road made accessible via automotive technology challenges, but is simultaneously constrained by, responsibilities for domestic life, personal relationships and gainful employment.[40] Underscoring this contradiction, the Winnebago boasts all the accoutrements of a normal home, including a microwave, a television and a comfy bed. When the Howards do live life on the edge, it is by playing roulette in Las Vegas, where Linda loses their life savings. The motorhome thereafter becomes a mobile space of domestic spats and silences, eventually returning the Howards to Manhattan. Postmodern in its ironic critique of countercultural movies like *Easy Rider*, *Lost in America* has been described as conformist, de-politicized and reliant on in-jokes for effect[41] – and certainly the Howards make little attempt radically to alter their lives. But this is also the very point of the film, which ultimately charts the condition in which many middle-aged people find themselves – stuck in a routine and chasing property and other materialist goals, while simultaneously bearing some allegiance to the more rebellious and open-minded years of their youth. In this sense *Lost in America* is a darkly depressing journey of discovery – the difficulty of amending one's life, but also the lack of desire to do so in any meaningful manner. At the start of the film, David says being an advertising executive is a road to nowhere: 'You're on it, you don't know it. It's a nowhere road, it just goes around in a circle', he declares. 'It's the carrot on the stick and the watch when you're seventy.' By the end of their

Walt begins his journey back towards normality. *Paris, Texas* (Wim Wenders, 1984).

journey, David and his wife are right back on this nowhere road, and little, if anything, has changed.

An overtly European take on the American road movie is provided by Wim Wenders's imposing *Paris, Texas* (1984), which builds upon his German films of the 1970s – *Alice in the Cities* (*Alice in den Städten*, 1974), *The Wrong Move* (*Falsche Bewegung*, 1975) and *Kings of the Road* (1976) – to create a haunting set of physical and mental journeys through America.[42] To begin with, Travis (Harry Dean Stanton) rides with his brother Walt (Dean Stockwell) in a 1984 Oldsmobile Cutlass, a journey which, unlike many road movies, is not into danger or desperation but in the reverse direction: back from being deranged, a return to something approaching normality. In short, Travis rediscovers himself. Initially, Travis can neither communicate with Walt nor engage with the surrounding landscape in any normal manner, sometimes walking

down railway tracks and straight across deserts. But as he recuperates, Travis even starts driving himself, although, as he explains, it is his body rather than his mind that remembers how to drive. Although now almost back in control, some disorientation remains in time as well as in space. Travis asks at one point, 'How long have I been gone, do you know?' Walt: 'Four years.' Travis: 'Is four years a long time?'

The second journey, with Walt reunited with his son Hunter (Hunter Carson), is a search for Jane, Travis's lost wife and Hunter's mother (Nastassja Kinski). Hunter bonds with his father in a 1959 Ford Ranchero, turning the car into a space of intimate communication where relationships gently unfold and strengthen. After finding Jane working in a Houston peepshow, Travis explains, via a one-way screen and telephone, that he was too in love, found her too beautiful, to contemplate that one day he might lose her. Hugely cinematic with its systems of glass, lights, reflections and views, this interior arrangement is in many ways like a car journey, with two people within a contained space considering their inner thoughts and conversing over time while a windscreen-like sheet of glass acts as a kind of mutual mirror. Walt and Jane then modify the set-up to make it even more like a car space, turning off the light in her part of the room, thus removing the screen opacity and unifying the space into one. The conversations here are like those between Travis and Hunter, now more painful and difficult but also part of a journey into some kind of understanding, reconciliation and way forward.

The final journey takes another direction, as Travis departs once again and leaves Jane with Hunter. In part, this is standard road movie fare: setting out alone into the wilderness and an unknown future, with Travis fleeing that which dominates him –

his love for Jane – except that Travis has already recreated some sense of solidity and conclusion through his own recuperated psychology, reconnection with Hunter and reunion of mother and son. Moreover, Travis's flight is not desperate but deliberate and controlled. When Jane is finally reunited with Hunter in a hotel, Travis watches from a car park, checking the reunion has occurred while mysterious green lighting indicates the strange nature of his decision to rekindle his family and then promptly leave. As Travis takes a freeway out of Houston, it is with a mixture of stability, having brought Hunter and Jane back together, and uncertainty, travelling the open road alone and at night. Ultimately, therefore, *Paris, Texas* offers a road movie voyage not as escape, fear or confusion, but as a drive towards constancy, direction and understanding, albeit in a world where this equation is always difficult to maintain.

Reconfiguration

In *Duel*, Mann survives and learns something about himself. But has he changed? Similar uncertainties occur in *Paris, Texas*, where Travis rediscovers something of an older, more settled self. Will he maintain the new balance he has constructed? Have Mann and Travis remained the same, or in some way been reconfigured?

We have already noted films in which people are challenged severely and frequently altered during the course of their automobile journeys. In particular, many movies focus on reconfiguration within relationships of friends, families and lovers – just a few of these are *Boys on the Side, Cold Fever, Crossroads, Double-Blind/ No Sex Last Night, Driving Miss Daisy, Familia Rodante, Five Easy*

Pieces, Genevieve, The Getaway, The Graduate, Le Grand voyage, Jízda, Journey to Italy, Kikujiro, Last Orders, Lolita, A Man and a Woman, Marnie, Midnight Run, National Lampoon's Vacation, Pierrot le fou, Rain Man, The Rain People, Red Lights, Riding Alone for Thousands of Miles, Soft Top Hard Shoulder, Stranger than Paradise, The Sure Thing, Two for the Road, The Vanishing, Vozvrashcheniye, When Harry Met Sally and *You Only Live Once.* Above all, the car interior during these long drives lies in between pleasures and conflict – a place of joys, emotions and loves but also of troubles, trials and stresses, of challenges and transformation both within and without. In particular, as film historian Tim Corrigan observes, the road movie often uses the car interior and the narrative of a long journey to track the breakdown of the post-war family and, in particular, challenges to male subjectivity and empowerment – so that the reconfiguration disclosed is not just of individual characters but, by extension, of social conditions and society as a whole.[43]

Frequently, such individuals are cast into a maelstrom of personal decisions and fortune, where reconfiguration becomes a fatalistic journey towards death. Consider, for example, Al and Vera in Edgar G. Ulmer's classic film noir *Detour* (1945); cast adrift from any social stability of families, locality, community and certainty, they contend instead with distant destinations, ethical dilemmas, forced relationships and (for Vera) a grisly end. Or consider the sense of chance and personal decision-making which similarly guide Marion's journey in *Psycho* (Alfred Hitchcock, 1960). At first, Marion's drive out of Phoenix in a 1956 Ford Fairlane (and later a 1957 Ford Custom 300) marks her transformation from law-abiding citizen to criminal, someone who has reacted instinctively

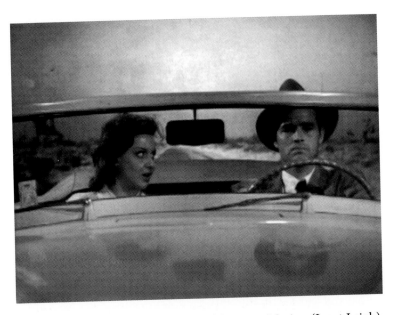

Vera and Al face personal and ethical dilemmas in *Detour* (Edgar G. Ulmer, 1945).

to an unexpected opportunity to steal $40,000. Marion (Janet Leigh) has her first doubts about stealing the money when seeing her boss at an intersection in Phoenix, fears which intensify as she travels nervously towards a rendezvous with her boyfriend Sam, during which time she imagines people talking about her crime. Marion's drive here is thus part of a deeper journey into herself, trying to come to terms with what she has done and who she is becoming. In this respect, Marion's journey is akin to Al's in *Detour*, an almost imaginary world in which the driver attempts to make some kind of sense out of a highly unreal situation. The other trajectory in *Psycho*, however, is of course Marion's impending arrival at the Bates Motel, shortly followed by the infamous shower murder. In this way, Marion's driving in *Psycho* exists as a suspended interlude, at first as a transition from one life to another, over which Marion tries to gain control, but ultimately becoming a deliverance by fate, over which she has no control at all. Marion's drive away from Phoenix is therefore like the final journey by boat across the River

Styx in Greek mythology, an in-between state when Marion is almost dead herself but is yet to reach the Underworld. Indeed, the boatman Charon is also present in the form of the mysterious highway patrol-man (Mort Mills) who wears ultra-black mirrored sunglasses and keeps watch as Marion drives to her bloody end; as is the watery Styx, in the form of the torrential rain that descends as she approaches the Bates Motel.

In other journeys, the reconfiguration is more mental and philosophical in nature, such as the gradual transformation of John and Gerry confronting failure, masculinity, sex and responsibility in *Goodbye Pork Pie* (Geoff Murphy, 1981), the transgressive sexual explorations of Julio, Tenoch and Luisa travelling in a 1980 Dodge Dart in Alfonso Cuarón's perceptive *Y tu mamá también* (2001), and the tentative friendships and kindnesses between people of different ages and families in Carlos Sorín's eloquent *Historias mínimas* (2002). Also worth noting here are the peculiarly strange yet everyday observations of Jim White in the documentary *Searching for the Wrong-Eyed Jesus* (Jim White, 2003); White drives a 1970 Chevrolet Impala in his search to understand the American South, trying to 'become a Southerner' and getting 'closer to God'.

A particularly prevalent form of philosophical road movie concerns the search not for an answer but for an attitude to life. This is evident most explicitly in Jack Kerouac's *On the Road* (1957; film version, Walter Salles, 2012), where mobility expresses resistance to social conventions,[44] and, more subtly, in Wim Wenders's 1970s road trilogy, most notably *Kings of the Road*, as well as in the Wenders-esque *Radio On* (Chris Petit, 1979). Indeed, here driving goes beyond providing a mobile stage to become central

to the philosophical impetus being followed. A case in point is the
trajectory of Ferdinand (Jean-Paul Belmondo) and Marianne (Anna
Karina) in *Pierrot le fou*, where Ferdinand, having left his wife and
children for Marianne, sees their journey as a progression from
captivity to freedom. 'Ten minutes ago, I saw death everywhere',
he declares. 'And now look, the sea, the waves, the sky. Life may be
sad, but it's still beautiful. I suddenly feel free.' To emphasize this
point, Ferdinand flicks the steering wheel ('right, left, right, left')
and then, rather than mindlessly following the 'little fool' ahead
along a straight road, impetuously turns their stolen 1957 Ford
Fairlane 500 Sunliner straight into a lake. Similarly thoughtful, if less
dramatic, concerns underlie *The Passenger* (Michelangelo Antonioni,
1975) when David Locke (Jack Nicholson) explains to his female

Rushing away
from the past.
The Passenger
(Michelangelo
Antonioni, 1975).

passenger (Maria Schneider as the nameless 'Girl') what he is running away from. 'Turn around with your back to the front seat', he requests, and so the Girl stands with arms outstretched above the red leather rear seats of their 1966 Mercury Comet convertible to see the past rushing by in the form of a straight countryside road bounded by even-spaced trees, each painted with a white horizontal stripe. This journeying scene is at once meaningless in its lack of specific places or commentary, but rich in Antonioni's typical speculation on conditions of journeying, estrangement, detachment, isolation, adventure, escape and the search for identity.[45] In such automobile moments, we see ideas, personal change, movement and the unfolding journey all collapse into one.

The other dominant variant of the philosophical road movie is often emotional, passionate and violent in nature, a kind of mad love where an outlaw couple descend into an inner self-centred world of sex, desire and mutual encouragement, just as their relations to the external world become increasingly reliant on fast driving, blazing guns, wanton bloodshed and heartless terror. And while some of these films let their main characters survive (*The Getaway*, *Wild at Heart* and *Natural Born Killers*), in many cases (*You Only Live Once*, *They Live by Night*, *Gun Crazy*, *Pierrot le fou*, *Badlands*, *Thieves Like Us*, *The Passenger*, *Bonnie and Clyde*, *Kalifornia*, *Thelma & Louise*, *Bandits*) the result is a gruesome end for at least one person.[46]

Joseph H. Lewis's B-movie *Gun Crazy* (1949), much admired by film aficionados and surrealists alike, sets the early standard for this genre. Gun-obsessed Bart Tare (John Dall) falls in love with trick-shooter Annie Laurie Starr (Peggy Cummins), the couple then moving quickly to a furious series of robberies, deepening their

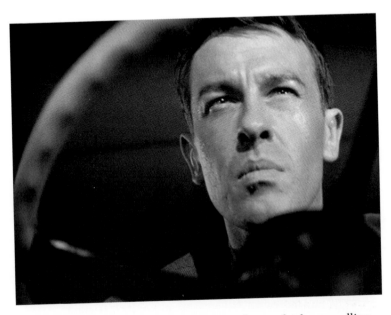

Propelled by his love of femme fatale Laurie, Bart drives to their death. *Gun Crazy* (Joseph H. Lewis, 1949).

affection as they go. While Laurie is a true femme fatale, propelling the relationship through eroticism and a ruthless desire for excitement, Bart has more doubts, particularly when they start to shoot their victims and pursuers. 'I don't know. It's just that everything is going so fast, it's all in such high gear', Bart announces while driving a stolen car. 'It sometimes doesn't feel like me. It's as if none of it really happened, as if nothing were real any more.' Prompted by Laurie, Bart agrees that she at least is 'real' but that 'the rest is a nightmare'. As the police close in, Bart begins to mesh with the car – for example, in a view from low down, through the steering wheel and up at his face while frantically driving a 1938 Plymouth Road-king through the Californian mountains – before they are finally

both gunned down by the police. Reconfiguration here is a journey into Bart and Laurie's dark private world, a life constructed from thrills, ammunition and disguises, in opposition to the conventions of post-war consumerist and domestic society.

If *Gun Crazy* provides the basic genre of the outlaw couple who are madly in love, then *Bonnie and Clyde* develops its most extreme form. Set in the Depression, Penn's depiction of real-life bank robbers Bonnie Parker and Clyde Barrow is gory and violent, but also frequently comic and even slapstick. The tenets of the relationship are quickly set up when Clyde tries to steal Bonnie's mother's car; they introduce themselves while he hotwires a 1930 Willys-Knight for a getaway, kiss in the car and then flee the scene. Driving at speed, sexuality, crime and exhilaration are all introduced here, as is a sense that Bonnie (Faye Dunaway) immediately becomes a different person, leaving behind her home physically and emotionally the moment she gets into the car with Clyde (Warren Beatty). Automobiles are now used to move between towns, each drive providing a calm interlude before a robbery, allowing expectation, tension and contemplation to develop. Alternatively, after each robbery, each drive is highly animated – infused with speed, risk and hysterical arguments. The cars themselves are stolen, adding to the frisson of an illicit life, while also supplying a cloak of unidentifiable anonymity. Throughout, the automobile is the important third partner in Bonnie and Clyde's lunatic life, providing an alternative utopia of mobility, exhilaration and transgression.

However, after a police raid, a frenzied scene in the back of their 1932 Nash 970 sees Buck Barrow (Clyde's brother) die from gunshots and Blanche Barrow (Buck's wife) blinded. Car chases are

now no longer exciting and fun, but violent and desperate. The end comes for Bonnie and Clyde at a roadside trap where their 1934 Ford v8 is strafed with police gunfire. Bonnie's demise is especially graphic as she snakes and recoils from the riddling bullets; this multi-camera, multi-speed, multi-angle and complexly edited depiction is simultaneously technically advanced, voyeuristic and sexual, conveying full-body spasms and involuntary death-throe twitching. The final shot is simpler but equally sophisticated, looking through and out of the Ford's windows at the gunmen. The car, once Bonnie and Clyde's partner in crime, is now an implicit witness to their death, framing the killers' sombre faces as they stare at the outlaws' bodies, noting the immediate present (Bonnie and Clyde are dead) but also contemplating how the couple have come to this end. Some see this scene as portraying the victory of conservative values over rebellious actions, but to my mind the look on the gunmen's faces, far from being triumphant, is more ambivalent and uncertain, and as such is entirely in keeping with the film's ambiguous ethical portrayal of Bonnie and Clyde as unruly working-class anti-heroes.

The lives of Bonnie Parker and Clyde Barrow, reflected in the faces of their killers, and seen through the frame of a 1934 Ford v8. *Bonnie and Clyde* (Arthur Penn, 1967).

Reconfiguration here is a reflective view, encompassing all that has gone before, relevant not just to Bonnie and Clyde but to all of us who have been along for the ride. Ultimately, little has changed for Bonnie and Clyde, for their flight to freedom has been filled with only short-lived joys cut short by a more permanent demise, but their furious automobile-charged story has perhaps changed the audience (and even possibly their killers), and given us insights into such tensions as those between consumerist objects and exhilarating experience, restless mobility and static domesticity, countercultural lifestyles and conservative American values, individual choices and corporate logic, and between self-conscious image-aware spectacle and more straightforward narrative story telling. Despite a tendency to light-hearted banjo car chases and comic characterizations, *Bonnie and Clyde* asks far more than might initially appear, and its deliberate contemporary relevance to 1960s consumerism and countercultural alternatives continues to stimulate audiences today.

Terrence Malick's *Badlands* (1973) is also based on real-life murders. James Dean look-alike Kit (Martin Sheen), an arrogant garbage man, shoots the disapproving father of teenage girlfriend Holly (Sissy Spacek), and then takes her on a Dakota-wide killing spree. However, where *Bonnie and Clyde* – a film *Badlands* references and mimics – uses driving to generate urgent momentum, Malick's movie rests on aimless and imaginary voyages placed in, but nonetheless outside, real space and time. Two trajectories are present: the first is Kit's, who fixates on his media image, while spinning ridiculous lies and making illogical choices; the second is Holly's, whose obsession with celebrity magazines renders her detached from the world around yet wholly surrendered to life with

Kit. 'Our time with each other was limited, and each lived for the precious hours when he or she could be with the other, away from all the cares of the world', explains Holly in a languid and strangely disinterested voiceover. 'He wanted to die with me, and I dreamed of being lost forever in his arms.' As the young couple survive in a 1959 Cadillac Coupe DeVille amid endless flat plains – 'we lived in utter loneliness, neither here nor there' – driving creates not a velocity nor an impetus, nor a direction nor adventure, but rather a world of small-scale intimacies, kissing and talking as if Kit and Holly are children playing at families. The car also provides subtle predictions, and at one point, as their time together closes in, they dance in the headlights to the radio refrains of Nat King Cole's end-of-love 'A Blossom Fell'. The Cadillac is here a substitute for the domestic home, and driving summons up a personal world apart, a dream, a fantasy, a reverie.

Although *Badlands* reveals an implicit political sensibility through its observations of teenage life, media and ethical boundaries, the cultural and political premises which infuse *Bonnie and Clyde* are more evident in another killer-on-the-run movie, Dominic Sena's *Kalifornia* (1993). This thematic comes largely from the play-off, as they drive from Kentucky to California in a 1963 Lincoln Continental, between four very different ride-sharers: murderer and psychotic white-trash Early (Brad Pitt), his simple-minded girlfriend Adele (Juliette Lewis), graduate psychology journalist Brian (David Duchovny) and his photographer girlfriend Carrie (Michelle Forbes). As the journey unfolds, and Early's predilection for violence becomes explicit, contrasts emerge between the two couples, notably intellect against ignorance, middle against working class, passivity against

violence, sophistication against crudity, analysis against instinct, consideration against brutality and lovemaking against animalistic sex. In particular, Brian first becomes enthralled with Early's rough-and-ready manner, and then has to confront his own engagement with violence, first in refusing Early's demands that he kill a police officer and subsequently in striking Early with a shovel before finishing him off with a gun. Throughout, the Lincoln forms a shared space which constrains these wholly different couples in a collective nightmare from which there is no escape. Driving is also a movement through landscape, and the geography the Lincoln traverses – notably the post-apocalyptic nuclear testing site where Brian kills Early as well as the other derelict industrial terrains through which they pass – provides a coded reference to the violence and desolation of post-war American life.[47] Driving here is both the site of an unfolding personal event and a witness to a wider social malaise. Similar themes emerge again a year later in Oliver Stone's overtly postmodern *Natural Born Killers* (1994), and I return to this film in the last chapter.

One of the most prominent of the road movies that track a couple on a journey of reconfiguration is Ridley Scott's *Thelma & Louise*, which has led to numerous other road movies as diverse as *The Living End* (Greg Araki, 1992), *Boys on the Side* (Herbert Ross, 1995) and *Bandits*. Scripted by Callie Khouri, the story begins with Thelma (Geena Davis) and Louise (Susan Sarandon) taking a 1966 Ford Thunderbird on a fishing trip out of Arkansas. Thelma is seeking temporary escape from her domineering husband, and Louise is looking for release from her routine waitressing job. After Thelma is nearly raped outside a bar, Louise loses her cool and shoots the assailant dead. Fleeing to Mexico but avoiding Texas

(where Louise may herself have been previously raped), the two women journey west through Oklahoma. They pick up a hitchhiker, JD (Brad Pitt), who sleeps with Thelma and steals Louise's life savings. Events now spiral out of control, with the pair robbing a store, assaulting a state trooper and exploding an obscene driver's tanker. Chased by the police to the edge of the Grand Canyon, they decide to avoid capture and incarceration by accelerating off the cliff edge. Numerous reconfigurations run through all of this, notably Thelma's transition from passive and foolish housewife to hard-headed, hard-drinking and ruthless woman, Louise's similar determination to exact revenge on male violence past and present, a refusal to tolerate male abuse, and an ultimate decision not to end their journey together in jail.

Thelma & Louise's neo-feminist trajectory initially articulates a world of women seeking freedom from male patriarchy, but ultimately penalizes them for every attempt they make at emancipation – Thelma

Reconfiguration in a Ford Thunderbird. *Thelma & Louise* (Ridley Scott, 1991).

Flying off the
Grand Canyon.
Thelma & Louise.

and Louise encounter attempted rape when they dance and drink, obscenities when they talk back, theft when they offer trust, and finally a stark choice between what Louise sees as 'incarceration, cavity search, life imprisonment, death by electrocution' or suicide. On the one hand, the movie is therefore a stark warning to women about what will happen should they stray from patriarchal conventions. On the other, it not only shows two women who refuse and retaliate against male abuse, but also portrays a range of speeds, emotions and actions that are open to women and not just men. Above all, throughout the movie it is car driving that provides not only the essential stage but also a forcefully intensifying experience, allowing the women to live the lawless world of robbery and self-defined morality previously set up in *Gun Crazy* and *Bonnie and Clyde*. Moreover, in *Thelma & Louise*, this automobile-based existence is even more intense, providing, in sequence, a space for release (liberation on leaving town), violence (attempted rape and initial

murder), flight, re-grouping and thinking, decision and determination, and the possibility for random meetings (JD), as well as mapping and spatial tactics (choosing a route), release (singing together in car), sexuality (Thelma flirting with JD), despair (after JD has stolen Louise's saving), disbelief (Louise after Thelma has robbed a store), laughter and exhilaration, wonder at landscape, retribution, resilience and their final determination and imagination (to conclude their lives together).

In the end, therefore, the emancipatory content of *Thelma & Louise* is located not within a grand narrative but in raising matters of rape, patriarchy, suicide and domestic abuse – in putting these issues on the screen – and in the courage Thelma and Louise show in confronting these issues in various mobile moments. In short, the political imperative resides in the enjoyment, pleasures, difficulties and challenges thrown up by driving a Thunderbird across the American landscape, and the ways in which the two women confront these trials and tribulations. Above all, it is through driving the Ford – through feeling the wind in their hair, contemplating the past rushing by in the rear-view mirror, watching the permanence of the landscape, singing under the beating sun, bouncing along dusky roads, picking up hitch-hikers, being mesmerized by the desert horizon, outrunning police cars and smashing blockades, joking, kissing, laughing, scheming, smoking, sleeping and talking along with the rhythms of the car's engine and transportation through a strangely beautiful yet alien landscape – that Thelma and Louise feel liberation, affirm their friendship and reconfigure their sense of who they are. The film itself recognizes this much in its final moment, freezing the

Thunderbird while still horizontal and moving forward, and then showing a brief reprise of some of the women's most positive car-bound moments. As Thelma says as they set off on the final stage of their journey, 'something has crossed over in me'.

Nihilism

Although *Thelma & Louise* ends in the death of its central characters, there is much that is positive in their journey of reconfiguration. Indeed, the writer Khouri does not see the ending as being about Thelma and Louise's suicide, the drive off the cliff being more meta-phorical, and the film's final shot showing that they 'flew away, out of this world, into the mass unconscious'.[48] By contrast, many other films follow a much more nihilistic arc where despair, dejection and detachment are matched with resignation, passivity and blankness.

Many indications of nihilism are of course possible during the complex and variable moods of long automobile journeys, from the hopelessness of achieving love in *Detour*, to the existentialist anomie of *L'Avventura* (Michelangelo Antonioni, 1959), the sense of impending fate in *The Hit* (Stephen Frears, 1984), *The Texas Chainsaw Massacre* (Tobe Hooper, 1974) and *Wolf Creek* (Greg McLean, 2005), or the despair of Andrew Kötting's 18-minute short *Smart Alek* (1993). Particularly telling is the philosophical attitude of *Journey to Italy* which, although ending with Katherine and Alexander Joyce reconciled to another attempt at being together, nonetheless tracks a post-war world in which men are repressed emotionally and alienated socially. 'Are you suddenly getting senti-mental?', asks Alexander as they discuss divorce in their Bentley Mk

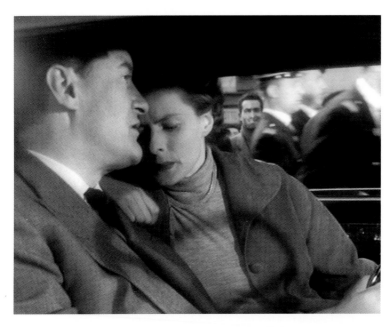

'Don't let's spoil
everything'. *Journey
to Italy* (Roberto
Rossellini, 1953).

vi. 'Listen, Kathy, we've been honest with each other up to now.
Don't let's spoil everything.' In all of these films, a sense of nihilism
pervades, but to find a true existential nihilism – viewing life as
without purpose or meaning, and morality as a purely artificial or
personal construction – we turn to two of the most seminal road
movies of the 1970s, *Two-Lane Blacktop* and *Vanishing Point.*

Monte Hellman's *Two-Lane Blacktop* (1971) follows two hot
rod racers known only as 'The Driver' (songwriter James Taylor)
and 'The Mechanic' (Beach Boys drummer Dennis Wilson) as they
travel east along Route 66, making money by pitting their highly
modified 1955 Chevrolet 150 against other street racers. Along the
way they pick up 'The Girl' (Laurie Bird) and become involved in
a race to Washington, betting the Chevy against the gaudy yellow
1970 Pontiac GTO of 'GTO' (Warren Oates). Less of a race than a
disjointed battle – with both sides taking plenty of time to rest, pick
up hitchhikers, enter races and even converse with other – the film

culminates without either side reaching Washington. The last scene takes place at an airfield drag race, deploying a famous piece of cinematic conceit where, as The Driver takes off on his run, the sound first fades away, the film itself slows down and finally a static frame burns out on screen.

Throughout the film, little is said and none of the characters take much interest in the world around them or their own place within it. In particular, The Driver and The Mechanic are apathetic in the extreme – and although *Two-Lane Blacktop* is conventionally read as an existentialist search for an identity and purpose which are never found, their disinterest in actually doing any searching at first sight renders the movie tedious and aimless. This flatness is emphatically presented through the driving sequences, most of which are confined to the front of the Chevy, showing the uncommunicative faces of its occupants, while the infrequent action scenes are similarly devoid of exhilaration or suspense. Night-time shots are extremely dark, with tail-lights and other illuminations only occasionally visible; *Two-Lane Blacktop* displays none of the fascination with multi-coloured electric luminescence evident in some other driving films. Even the depictions of speed from inside the car are rendered curiously velocity-free by the deafening roar of the 454 Chevy engine and by the impairment to forward vision caused by the dashtop Sun Super Tach rev counter and the massive hood-mounted air intake. The immensely accelerative Chevy itself, on which much time and money has clearly been expended, is dull grey in colour, and The Driver and The Mechanic appear interested only in its capacity to go fast and generate income, taking little or no delight in the vehicle's menacing aesthetics or explosive kinaesthetic potential. Thus when

The Driver famously retorts to GTO that 'you can never go fast enough', it seems more a statement of fact than an indication of any sense of excitement; one of the rare times The Driver gets at all animated is when laying a $300 bet with the owner of a candy-apple 1932 Ford hot rod – 'make it three yards motherfucker and we'll have an automobile race'. By contrast, the outwardly brash and boastful GTO is the only character with whom we can have much empathy because, for all his lying and unstable superficiality, he at least drives his Pontiac with some kind of energy and also tries to articulate something about being alive. 'I get to one end of the country', boasts GTO, 'and I bounce off like a rubber ball'. Ultimately, of course, such bravado only serves to highlight The Driver and The Mechanic's utter disinterest in anything so animated, aspirational or expressive, and it is around their mindset, not GTO's, which *Two-Lane Blacktop* revolves.

This, however, is of course the whole point of *Two-Lane Blacktop*, whose very flatness and sense of ennui, delicately nurtured by the director, Hellman, provides its essential meaning: a refusal by the two young men even to be seen to be trying, yet alone actually endeavouring, to realize some kind of achievement or pleasure. The final moment, when the celluloid flares up as if jammed within the projector, makes this particularly clear: the result of this particular race does not matter, and nor does that of the race to Washington. Instead, as Adam Webb has pointed out, *Two-Lane Blacktop* is less a film about nihilism than a film which actually is nihilism.[49] Once you give yourself over to the movie, and accept it in these terms, it becomes a cold yet compelling journey in which the beauty of the drive comes not from its kinaesthetics but

Film and journey
as existential
nihilism. The
concluding shot of
Two-Lane Blacktop
(Monte Hellman,
1971).

from the sheer relentlessness of an intricately nuanced, austere and abstract message.

Much more energized than *Two-Lane Blacktop* is another film from 1971, *Vanishing Point*, directed by Richard C. Sarafian, in which car delivery driver Kowalski (Barry Newman) takes a white 1970 Dodge Challenger R/T on an amphetamine-fuelled police-pursued sprint from Denver to San Francisco. A former policeman, Vietnam veteran, race driver and a man who has lost his much-loved Vera to a surfing accident, Kowalski epitomizes, according to the blind DJ 'Super Soul' (Cleavon Little) who guides Kowalski via Nevada-based radio broadcasts, 'the last great American hero to whom speed means freedom of the soul'. In the end, and having raced across Colorado, Utah and Nevada into California, rather than give himself up Kowalski chooses to plunge headlong into a pair of yellow bulldozers at the small Californian town of Cisco.

In part, this is a story of one man's rebellion against the
forces of police and state – and as such reaches back to the 1900s
when motorists like Filson Young were already complaining of the
'persecution of motorists' by such police tactics as speed traps.[50] But
the depiction in *Vanishing Point* runs much deeper; nihilistic and
desolate rather than triumphalist, the film portrays a narrowing of
the human condition, whereby people like Kowalski can no longer
express freedom, take risks or confront personal demons. Kowalski
undoubtedly revels in outrunning police officers, racing against a
Jaguar E-Type and taking to the desert, while we enjoy the sight of
the flat sands, dust billowing from the speeding Dodge, extensive
tracks being cut along the earth's surface, and vast blue sky hovering
over a distant horizon – and in this sense *Vanishing Point* concurs
with a frequent road movie thematic, whereby the driver identifies
the technology of the car as offering the only possibility of the self in
the modern world.[51] Yet in contrast to *Thelma & Louise*, *Vanishing
Point* takes no fundamental pleasure from the wondrous landscape
in which these driving sequences take place, Kowalski simply passing
by a series of fleeting visions and temporary exposures rather than
encountering fresh revelations or constructing new memories. As the
film unfolds, we therefore sense that the net is closing in, and what-
ever Kowalski is now enjoying – if indeed he is enjoying anything at
all – is exactly that which is no longer possible, in the same way that,
as flashbacks explain, he could not fit in with either his police job or
the world of motor-racing. Kowalski is also unable to desire sex or
hold any kind of sustained conversation. Like a 1970s truck driver,
he takes amphetamines to stay awake and largely travels alone; he
later has to fight off a pair of hitchhikers, and even turns off the

radio to silence Super Soul. Similarly, Super Soul himself is prevented from helping Kowalski when a police officer and other racist assailants beat him up. More generally, in the two years between *Easy Rider* and *Vanishing Point*, events like the Manson Family murders and court trials in Los Angeles, a death at the Rolling Stones' Altamont Speedway Free Festival concert, the brutal violence of the Weathermen terrorists and the general dissipation of the student protest movement meant that, by 1971, any remaining vestiges of 1960s countercultural optimism had all but disappeared. In this context, *Vanishing Point* does not open up the delights of driving but instead highlights their closure, the end arriving not just for Kowalski but for all those who might wish for a freedom of the road, personal emotion, satisfaction and other everyday pleasures; in *Vanishing Point* we find not democracy, fulfilment, love or connection, or even much by way of a phenomenological thrill of driving, but instead a more abstract sense of movement, one without content or meaning, which traverses a landscape populated only by dispersed, damaged and abandoned individuals.[52]

In contrast to the listless ennui of The Driver and The Mechanic, Kowalski's character is certainly more developed, for he has a back-story and shows concern for others. *Vanishing Point* also offers a greater sense of driving kinaesthetics than does *Two-Lane Blacktop*, with an extended portrayal of driving experience as rushing road surfaces, squealing cornering, dramatic overtakes and near misses, flashing road signs and fragmentary glances in rear-view mirrors, as well as, of course, the bewitching vanishing point of the driver's single-point perspective vision. *Vanishing Point* particularly succeeds in portraying the ethereal and shimmering visual and mental condition

which prevails when driving across deserts or other expansive landscapes, immersing both Kowalski and audience alike in an immaterial condition of velocity, horizon and light. Until, that is, we are shaken from the reverie, remembering that there is no reason for Kowalski to be driving at such a rate to San Francisco; instead, we must accept, Kowalski's high-speed desert driving is a deepening realization of the impossibility of being allowed to exist in such a manner and, furthermore, the lack of any sense of fulfilling reward even when one is temporarily able to do so.

Kowalski reaches the end of his journey. *Vanishing Point* (Richard C. Sarafian, 1971).

As with *Thelma & Louise*, there has been much discussion over the ending of *Vanishing Point*, including why Kowalski smiles as he plunges into the bulldozers. Barry Newman has even stated that Kowalski thought he was going to get through unscathed.[53] This, however, seems highly unlikely, and instead any escape, as

in *Thelma & Louise*, must be considered metaphorical rather than literal; as the director, Sarafian, has explained, his intention was to make Kowalski seem 'otherworldly', and his death was simply a transition from one existence into another.[54] Unlike the two women in Scott's film, however, Kowalski's suicide is not a positive action in the sense of being a continuation of the journey or a refusal to give up on passionate beliefs and intense experiences. Kowalski is neither searching for nor holding on to anything, and if there are any pleasures to be had in the present then these are, for him, so challenged by external forces and tainted by personal memories that they are simply not worth living for. Whenever he occasionally seeks escape in the desert, Kowalski simply gets lost, and so he returns to the road because he must. Driving on the open road, which initially seems to offer exhilaration and freedom, now supplies only the requirements of the police and the state, a world of federal discipline and corporate direction. And so in Kowalski's choosing death over a fettered and unrequited life, *Vanishing Point* shows driving as the ultimate nihilistic existentialist experience, a test for the driver's sense not so much of who they are, or even of who they choose not to be, but of who they cannot be. Kowalski's death-driven high-velocity journey in the famous white Dodge Challenger is an act of passive rejection, an acceptance of the impossibility of there being a fulfilling life either now or in the future.

3 MOTOPIA

In 1961 the British architect and landscape designer Geoffrey Jellicoe published *Motopia*, an extreme proposition for a future city to be built from the perspective of the automobile.[1] Motopia places 30,000 residents within an entirely gridded layout, where drivers traverse rooftop elevated motorways beneath which rest enormous 'Terrace' blocks containing 'Mews Road' parking, all knitted together by giant roundabout-style 'Circle' intersections. Offering a strict geometry so as to be comprehensible 'at a single glance', while accommodating usage rates of just one occupant per vehicle, Motopia is an automobile-friendly environment par excellence.

Many other designers, planners, artists and film-makers have also enthusiastically imagined cities based around cars and freeways.[2] Le Corbusier, for example, formulated the centre of his 'Ville Contemporaine' scheme (1922) as a vast transport interchange of aircraft, runways, cars and roads. Indeed, so emphatically did Corbusier connect the modernity of architecture with that of the automobile that he frequently staged photographs of his buildings with a new car placed directly in front, while in the short film *L'Architecture d'aujourd'hui* (Pierre Chenal and Le Corbusier, 1930), Corbusier himself drives up the driveway to the Villa Stein at Garches. Although different in style and layout, the overall modernistic scale, ambition and transport thematic of Corbusier's urban visions are

Highway system imagined in *Metropolis* (Fritz Lang, 1927).

recalled in the contemporaneous *Metropolis* (Fritz Lang, 1927). Here
Freder, son of the autocratic city leader, travels in a white limousine
along a network of high-rise highways, his progress marked by
powerful searchlights. In later scenes, other high-level routes include
a layered system of three- to six-lane pedestrian-free roads along which
traffic moves in a highly ordered fashion. Similarly grandiose systems
appear as the vast underground highways of the 2036 city Everytown
in the science fiction film *Things to Come* (William Cameron Menzies,
1936), as well as, more recently, the automated cars and 'San Angeles'
freeway of *Demolition Man* (Marco Brambilla, 1993), the futuristic
horizontal and vertical freeways of 2054 Washington, DC, in *Minority
Report* (Steven Spielberg, 2002) and the elevated and tunnelled free-
ways of 2035 Chicago in *I, Robot* (Alex Proyas, 2004).

Most notable of all in its depictions of a freeway-centred
Corbusier-inspired urbanism, rivalling even Motopia in this respect,
is the cinematically arranged exhibition 'Futurama'. Created a few
years after the release of *Metropolis*, Futurama was the brainchild
of designer Norman Bel Geddes who, along with the architect and
model-maker Adolph Witchard, fashioned the most popular attrac-
tion at the 1939 New York World's Fair. An enormous 3500m²
scale model, Futurama populated its grand series of bright dioramas
with thousands of trees, buildings and automobiles. Millions of
visitors enjoyed this vision of utopian urbanism within a darkened
pavilion, taking a 16-minute 'carry-go-round' on a chain of 552
elevated chairs while listening to a synchronized narration, and
thus enjoying an experience akin to that of seeing a movie, except
now more mobile and three-dimensional. Futurama was located
in General Motors' 'Highways and Horizons' exhibition, and it

appropriately extolled a comprehensive system of personal automobile transportation that was efficient, fast and modern, promoting the interchange of people and ideas, encouraging unity and diversity, and even aiding national defence.[3] 'The road itself seems to glow', enthused Bel Geddes, noting how the visitor 'hears the rush of the car's slipstream' and 'has a sense of smooth running power, high speed'.[4]

Just how Bel Geddes could be so enthusiastic is evident from the 1940 documentary *To New Horizons* (Jam Handy Organization/ General Motors), a movie which makes explicit the convergence of film and reality in the various dioramas and moving displays of Futurama itself. *To New Horizons* begins with footage of real roads, which the voiceover describes as central to scientific and economic progress. A colour sequence then turns to the 1960 'wonderworld'

Views of 'Futurama' from *To New Horizons* (Jam Handy Organization / General Motors, 1940).

of Futurama, depicting the 'lovely and unchanging' landscape of sunshine, trees, valleys and rivers inhabited by new industry, modern farms and carefully zoned cities – a world of education, research, electrification, short working hours and constant progress. Through all this, a grandiose network of seven-lane highways allows cars to travel at velocities of 50, 75 and 100 mph, facilitating 'safety with increased speed'. These highways are also equipped with 'spectacular' elevated intersections, lookout towers every five miles, automated curbside lighting, curved lane channels to keep drivers on track, and even 'automatic radio control' to maintain safe distances between cars. When Roland Barthes famously compared the Citroën DS automobile to a Gothic cathedral as being a 'supreme creation of an era', this was because they were both 'conceived with passion by unknown artists, and consumed in image if not in usage by a whole population which appropriates them as a purely magical object'. Furthermore, the Citroën was often consumed by the public not through driving but at motor exhibitions, where it was 'explored with an intense, amorous studiousness'. This was exactly how the freeway became consumed by the American public at Futurama and in *To New Horizons*: that is, as collective production, wondered at as model and film, and imagined as a magical object which repre- sents, to use Barthes concluding words, 'the very essence of petit- bourgeois advancement'.[5] And unlike the aestheticized politics and muscular construction of the German autobahns discussed below, the logic here is about circulation, exchange and consumption, a world where big business and the state subtly collude to create a world of technological glamour, sweat-free achievement and easy consumerist living.[6]

On leaving Futurama, visitors were presented with a pin proclaiming 'I Have Seen the Future'. As this prophetically suggests, Bel Geddes's vision of freeway-centric urbanism did not remain for long on architects' drawing boards or in sci-fi film fantasies, and freeways (also variously known as autobahns, autostrada, autoroutes and motorways) soon became commonplace worldwide. Indeed, Germany had already begun constructing its autobahn system in 1929 – from 1933 to 1935, road construction consumed 60 per cent of all public investment in work projects, and by September 1939 some 2,400 miles of autobahn had been completed.[7] Today, the *Bundesautobahnen* (BAB) system has over 7,500 miles of road, some of it with unrestricted speed limits. Over in America, in 1940 and while Futurama was still on show, the Arroyo Seco Parkway (later Pasadena Freeway) connecting Pasadena with downtown Los Angeles became the first Californian freeway and within 20 years was already operating at over 150 per cent of designed capacity.[8] Across the U.S., the Interstate Highway System was begun in 1956, leading to freeways totalling 41,000 miles by 1961 and nearly 47,000 miles by 2010. This Cold War-era development was an integral part of U.S. urban growth, aimed at governing the American economy, citizens and nation alike; it helped people to spread into areas without public transport, creating greater demand for cars and car-related products like fuel and mechanical services, fostering a sense of national and individual American character, as well as increasing the mobility of the U.S. military.[9] Through this freeway system, drivers enjoyed the freedom of the road, but in the context of a technological system wherein, as with Futurama, independent individuals cooperate with the requirements of the state.[10] Back in Europe, the UK's first

long-distance motorway, the M1 from London to Birmingham, opened in 1959. Today, it carries 140,000 vehicles per day, while a 2,200-mile network of 35 motorways covers the rest of the country.[11] Similar constructions have taken place in every other developed nation. To cite a few examples, Italy was the first to build a freeway with its Milan to Varese road (completed 1926) and today has 4,000 miles of autostrada system; France has around 7,500 miles in its autoroute network of toll roads; Japan has a highly developed network of national highways and urban expressways; Australia has a motorway system focused around major cities; and Taiwan inaugurated its system of national expressways and freeways with the Sun Yat-sen National Freeway in 1978.[12] Lastly, despite not beginning construction of its National Trunk Highway System (NTHS) until 1988, China already has, after the USA, the world's second-largest freeway system, with over 40,000 miles completed by 2010 and another 69,000 miles projected over the next 40 years. Parts of this system directly emulate American precedents, as with one 1994 Chinese expressway being inspired by the New Jersey Turnpike and built by a Princeton-educated Hong Kong engineer.[13]

Much of this can be seen in many films from the 1930s onwards. In Germany, the birth of the autobahn was accompanied by a series of National Socialist films with enthusiastic titles such as *Bahn Frei!* (Open Road!), *Strassen der Zukunft* (Roads of the Future) and *Strassen machen Freude* (Roads Make Happiness), and can also be seen in Hartmut Bitomsky's poetic documentary *Reichsautobahn* (1986), which discloses these new roads to be an amalgam of cultural, aesthetic, functional and political practices.[14] In America, mainstream movies give frequent illustrations of these new road spaces. For

Aesthetic beauty of night-time freeway signs. *Cars* (John Lasseter and Joe Ranft, 2006).

example, the opening title sequence of *Duel* gives a clear depiction of the Pasadena and Santa Ana freeways as Mann heads out of Los Angeles, while *Gone in 60 Seconds* (H. B. 'Toby' Halicki, 1974), set in and around Long Beach, is one of the first films to celebrate the sheer scale and elegance of the new road constructions, including the Vincent Thomas Bridge on State Route 47 en route to the Harbor Freeway. Somewhat unexpectedly for a family-oriented movie, *Who Framed Roger Rabbit?* (Robert Zemeckis, 1988) includes a fictionalized account of how the Los Angeles streetcars came to be replaced by freeways, a story that has consequently gained considerable public acceptance despite some serious historical inaccuracies.[15] Also of note here are the everyday portrayals of American freeways in the Disney educational shorts *Freewayphobia* and *Goofy's Freeway Troubles* (Les Clark, 1965), the highly aestheticized views of freeways in *Kalifornia*, *Collateral*, *Cars* and *Little Miss Sunshine* (Jonathan Dayton and Valerie Faris, 2006), and the freeway-based action of *The Blues Brothers* (John Landis, 1980), *Speed* (Jan de Bont, 1994), *Matrix*

Reloaded (Larry and Andy Wachowski, 2003) and *Taxi* (Tim Story, 2004). Particularly sophisticated in their depictions of American freeways are two films by Wim Wenders: *Paris, Texas*, which uses freeways to indicate various moments of separation, decision-making, arrival and departure, and *The End of Violence* (1997), where a vertiginous view over an expansive Californian interchange serves as a metaphor both for the difficulty of the crime which the police are investigating and for the constant movement, exchanges, complexity and anonymity of the city as a whole; the freeway interchange here indicates that there is far more going on than might be immediately discernible, as well as suggesting a city where people often seem to intersect without ever making any real connections or communicating any substantive meanings.

Freeway interchange as indication of movement, complexity and a lack of communication. *The End of Violence* (Wim Wenders, 1997).

As these Wenders films reveal, cinematic depictions of freeways can be subtly complex endeavours. This is understandable if we consider the peculiarly distinct yet generally uniform character

of freeways. Such roads offer a limited-access dual carriageway solely for high-speed traffic, and are equipped with continuous grade-separated intersections. They are typically characterized by strict rules regarding speeds, stopping and lane behaviour, by comprehensive signage systems, and by bespoke service facilities to eat, rest and refuel. Furthermore, at 55–80 mph freeways offer higher speeds than most other roads, velocities which are frequently held for continuous periods lasting from several minutes to several hours. Freeway driving thus creates vastly different experiences to, for example, the discordant and stop-start city traffic, or the winding and variegated landscapes of country driving, with their multiple crossings, changes of direction and places to stop. Freeways are what Edward Dimendberg has termed 'centrifugal spaces', which, through unique conditions of territory, communication and speed, elude commonplace understandings of architectural space and construction.[16] It is therefore unsurprising that many films, and often those made in Europe, have gone out of their way to interpret freeways in a highly diverse manner.

Placelessness

More than any other kind of driving experience, the freeway and motorway environment has produced a hostile reaction among those who have encountered it. Particularly critical interpretations have come from the geographer Edward Relph and the social theorists Marc Augé, Jean Baudrillard and Henri Lefebvre, who all contend that driving in general and the freeway in particular offer a placeless

world, an abstract and flattened terrain, a destination-focused and overtly functional activity, as well as a driving experience devoid of consciousness or bodily senses. 'The driver', wrote Lefebvre in 1974, 'is concerned only with steering himself to his destination'; he is someone who 'perceives only his route' and does so via the reductive terms of 'speed, readability, facility'.[17] Many other French intellectuals have concurred, such as Guy Debord and the Situationists, who attacked the car for reducing workers' free time – 'as supreme good of an alienated life and as essential product of the capitalist market'.[18] Alan Touraine similarly castigated the automobile for its central role in the 'programmed society' of the technocratic state and invidious consumerism, while American academics like Richard Sennett have decried cars for making us believe that city streets are 'meaningless or even maddening' unless we can drive down them unimpeded, such that 'the driver wants to go through the space, not to be aroused by it'.[19]

To some extent this is undoubtedly true, and many films show an alienating freeway environment which could be anywhere, such as the vacant spaces of *Plunder Road* (Hubert Cornfield, 1957),[20] the traffic jams of *Five Easy Pieces* and *Falling Down*, the blank emptiness of a new industrial estate in *Villain* (Michael Tuchner, 1971), the sprawling Thames corridor in *Essex Boys* (Terry Winsor, 2000), the anonymous New Jersey turnpike in *Being John Malkovich* (Spike Jonze, 1999), the bleak autobahns of *The Wrong Move*, motorists speeding along a straight-line interstate in blind ignorance of a majestically beautiful landscape in *Cars*, or the repetitive landscape of 'motel signs, café signs, one way signs, do not enter signs, every other kind of sign' which cause one bored

The generic, standardized architecture of the petrol station. *Butterfly Kiss* (Michael Winterbottom, 1995).

competitor in *The Gumball Rally* (Chuck Bail, 1976) to declare that 'it all looks the same to me'. Or, as a Wichita taxi driver comments in *Planes, Trains and Automobiles*, 'you don't see nothing on the interstate but the interstate'. The same kind of repetition appears in *Butterfly Kiss* (Michael Winterbottom, 1995), this time in the guise of the UK's generic service stations, standardized petrol stations and faceless motels. Another British film of the mid-1990s, *Robinson in Space*, extends its scope into the wider automobile-scapes of motorways, trunk roads, suburbs, car parks, industrial estates and distribution centres, and yet even here, despite this variegation of function, we see only a curiously flattened world of massive shedlike service facilities, pseudo-historic housing and blank research establishments all draped in banal industrialized architecture and labelled with sans serif graphics. As described by architectural critic Martin Pawley, this is the kind of 'Shedland' found 'anywhere there is a motorway'.[21] There is seemingly no escape from this unvarying environment. Even *Trafic*, which like many of Jacques Tati's films searches for the comic possibilities

Charlie and Eliza enter the placeless world of Newport Pagnell service station. *Charlie Bubbles* (Albert Finney, 1967).

of modernism, comments on the homogeneous and directionless nature of automobile environments.[22] *Trafic* thus pokes fun at fuel-less motorists who walk past each other on opposite sides of the road, a petrol station offering customers superfluous gifts, motorists who pick fights on the basis of mistaken identity, and others who just yawn, smoke and pick their noses in a highly bored and remote manner.

Much of this is portrayed as early as 1967 in *Charlie Bubbles*, in which writer Charlie drives his Rolls-Royce Silver Cloud III from London to his native Manchester accompanied by his assistant, Eliza. Along the way, the Newport Pagnell service station on the M1 looms up as a series of illuminated signs, offering little more visually than a hovering rank of corporate logos. But it is the service station's internal architecture which has the greatest impact. By 1965, a study by the Bartlett School of Architecture at University College London had noted that the novelty of the new service stations was

already beginning to wear thin,[23] and *Charlie Bubbles* reflects this change with deadpan accuracy. Here, rather than the glamorous Continental life enjoyed by teenagers described later in this chapter, the Newport Pagnell service station, with its pedestrian bridge illuminated by fluorescent panels and a near-empty cafeteria staffed by an unfriendly waitress, further isolates Charlie and Eliza from their journey, their immediate location and each other. After the chance arrival of some of Charlie's acquaintances – a wealthy couple and family – a highly stilted and cursory conversation ensues about other friends, hunting, yachts and work projects, and Charlie then quickly makes excuses to leave. Besides inferences that Charlie has had some kind of affair with the wife, it is never explained who the other couple are, and when they later pass by silently on the M1 in their own limousine the meaning is clear: Charlie's life is dislocated, shallow and empty of long-lasting emotion, being a network of associations and encounters rather than a community of friends and lovers. Above all, it is the motorway architectures which here impart Charlie's social world with a telling spatial and visual aes-thetic, with separate signs, faceless buildings and vacant internal spaces – which harshly echo from hard metallic and shiny plastic surfaces and subtly shimmer with the even radiance of ubiquitous fluorescent lighting – creating a world of isolated individuals pass-ing through places of exchange, where they might meet but never really communicate or connect.

 In *Charlie Bubbles* and many other films noted above, motor-way spaces and signs are infused with placelessness, but this quality is largely restricted to matters of symbolism, expression or aesthetics. By contrast, *London Orbital* (2002) focuses on the nature of motorway

driving, exploring placelessness as a truly immersive experience –
a world of endless physical spaces and times, explicit thoughts,
potential actions and failed projects. Directed by film-maker and
critic Chris Petit with psychogeographic writer Iain Sinclair, *London
Orbital* is part-documentary, part-experimental journey along the
M25 motorway, which circumnavigates London in an almost
unbroken path of 117 miles (*London Orbital* is also accompanied
by Sinclair's book, describing exploratory walks around the same
road).[24] While Sinclair divines the M25's meaning by foot and
through art, literature and culture, it is Petit, aided by another
film-maker, John Sergeant, who provides most of the driving-based
footage and commentary. Circumnavigating the motorway for days
on end – a 'drive in pursuit of nothing' – Petit interprets both the
experience of driving the M25 and, alongside single- and split-screen
imagery, the filmic challenge of capturing this strange reality. The
result is a curious collage of thoughts and views, avoiding both
the normal narrative development of a mainstream movie and
the explanatory impulse of a conventional documentary; what is
clear, however, is that for Petit the M25 wins, and that any attempt
to defeat the 'dead time', 'negative space' or 'energy drain' of the
motorway is doomed to failure. Instead, the M25 'eliminates any
romantic notion of boredom', for more than other motorway it
tests the thresholds of extreme ennui. 'It is mainline boredom, it is
true boredom, a quest for transcendental boredom', suggests Petit,
'a state that offers nothing except itself, resisting any promise of
breakthrough or story. The road becomes a tunnelled landscape. A
perfect kind of amnesia.' And so the M25 is inescapable, providing
the driver with nothing other than the physicality of the endless

motorway and traffic, with no chance of creating other social connections, cultural associations, memories or mental abstractions. This kind of driving environment is truly placeless, offering only its own reality of vehicles, tarmac, signs, lights and directions, all held together in a single, gigantic and unending circular movement.

In *London Orbital*, the M25's wider connotations are found not through experiencing the motorway but, as an interview with the novelist of dystopian modernity J. G. Ballard suggests, in its helping to render English society a world composed solely of video rentals, low-cost executive housing, easy airport access and constant transience. As for driving, Petit discovers that the 'senseless repetition' can create anxiety or rage, for which 'only psychosis can break the spell'. Having started off hoping that viewing the M25 as an alien landscape would lead to a transformative experience, perhaps anticipating the kinds of dreamlike car-free motorways envisaged by painter Julian Opie in his *Imagine You Are Driving* series (1993–4),[25] Petit's endlessly orbiting journey is instead dominated by the intensive and unavoidable normalcy of the M25. 'Road is nightmare, road is purgatory, road is hell', states Petit towards the end, and ultimately he is left with nothing but 'inertia and dissolution'. As he realizes, 'after running too long on empty, everything stops – boredom, like rust, becomes entropy.' In this kind of world, we find not freedom but a 'loss of privacy and individuality as previously understood' as well as 'new, unsuspected kinds of boredom', and so the only option is to yield entirely to the motorway's placeless quality. 'We are Stoker's undead, see nothing of ourselves in the rear view mirror', Petit finally accepts, for 'memory recedes, we become cosmonauts, we become lost'. Placelessness in the M25 defeats everything else, and the sole

choice is to keep moving onwards, knowing neither past route, present location nor future destination.

The kinds of placelessness depicted by *London Orbital* are, of course, intensely worrying in the kind of world they suggest we now inhabit. And in many ways these warnings are worth receiving, for if our world was indeed devoid of resonant location, active bodies, historical memory, creative thoughts, cultural depth, visual stimulation or social connections then our lives would be all the poorer. However, there are three main objections to the way in which *London Orbital* and other films depict the freeway as sites of placelessness, amnesia or permanent boredom. First, there is the simple observation that almost any activity, if it were carried out for many hours, days and nights, would lead to some of the profound disorientation of *London Orbital*. The very depth of immersion which Petit undertook into the M25 is very different to typical weekday journeys on this motorway, which are on average only 20–40 minutes in duration.[26] Rather than seeing the freeway as a totalizing world, therefore, we might accept it as one of the many different kinds of environment within modern urban life, offering experiences which are undoubtedly distinct but not entirely dominant. Second, some aspects of placelessness are not therefore to be entirely rejected but can even be welcomed, for sometimes it is advantageous or even desirable to feel isolated from others and freed from the intense diversity, immediacy and mutability of urban culture in all its myriad forms. To cite but one example, many African Americans welcomed the limited access, neutrality and anonymity of 1950s and 1960s American highways, finding there a degree of mobility and freedom from the violence, humiliation and prejudice that would often be encountered along

local roads and in small towns.[27] Third, and more fundamentally, many of the social theorists and film-makers noted previously tend to make their negative critique of the freeway by comparing it, implicitly at least, with a version of public life that is centred on busy urban squares and other local foci, where people converse face-to-face and create closely knit communities. As Ruth Brandon explains in her excellent social history of the car, *Auto Mobile: How the Car Changed Life*, public life has until now been predominantly understood, both spatially and psychologically, as an 'essentially pedestrian concept'.[28] But is public life really based to such an overriding extent on walking and communications conducted in person? If we move away from such presumptions, we discover that the freeway can also offer various forms of social exchange, cultural richness and aesthetic delight.

A World Apart

More than anything else, drivers of freeways and motorways found themselves far removed from other forms of twentieth-century urban environment. Hence the Nazi propaganda movie *Schnelle Strassen* (*Fast Roads*, 1937) portrays British tourists as entirely captivated by that most extraordinary of new constructions, the autobahn.[29] The world apart offered by this improbable and artificial landscape was wholly, self-evidently and undeniably new – new in terms of concrete construction, minimal design, gentle curvatures, continuous intersections, startling signage and standardized services, and also enhanced car performance, higher speeds and different

attitudes to driving. New, that is, in terms of modern buildings, cars, spaces and graphics, a true modernity of experiences, designs and velocities. Some found this environment alien to the point of terror; for example, many first-time users of the British M1 would drive on to the motorway, instantly panic and then attempt to reverse off or perform a U-turn.[30] But many others found the motorway more seductive and, in particular, several commentators remarked on how it offered a foreign, youthful and exotic lifestyle. For example, in the 1960s the M1 found young drivers 'eating up the miles at incredible speeds in search of the bright lights' and so allowed a 'concrete escape to a new kind of excitement'. The bright yellow Newport Pagnell service station, one of the first to open on the 1960s M1 and the location of the episode in *Charlie Bubbles* described earlier, was a favourite 'place of pilgrimage for teenagers hoping for instant glamour', savouring the cosmopolitan delights of bar counters, high stools and Italian coffee, or even the *Grill & Griddle* restaurant frequented by The Beatles and other pop stars.[31] Others, too, recognized the distinctively modern nature of this new architecture. 'To drive up M1 is to feel as if the England of one's childhood is no more', wrote English racing driver Tony Brooks six days after the M1 opened. 'This broad six-lane through-way, divorced from the countryside, divorced from towns and villages, kills the image of a tight little island full of hamlets and lanes and pubs. More than anything – more than Espresso bars, jeans, rock 'n' roll, the smell of French cigarettes on the underground, white lipstick – it is of the twentieth century.'[32] Or as the motoring correspondent for the *Daily Mirror* reported, this 'space-age highway' was 'so strange it was hard to believe that I was still in England'.[33]

Véronique and Louis encounter a world apart – the autoroute. *Lift to the Scaffold* (Louis Malle, 1957).

A decade later, London's elevated freeway-style road, the Westway, was similarly viewed as a place of progressive modernity, worthy of comparison with the Continental lifestyle offered by Paris' Boulevard Périphérique.[34]

Depictions of these themes of modernity, glamour and otherwise inaccessible worlds occur in numerous films of the 1950s and '60s. As early as 1957, for example, *Lift to the Scaffold* shows the entirely new spaces of the French autoroute, where dual carriageways, serried lighting and curving roads allow uninterrupted, high-speed progress. The young Véronique is particularly excited by this novel terrain, encouraging boyfriend Louis to drive faster in their stolen American convertible (a 1952 Chevrolet Styleline DeLuxe) while following a fashionable German couple in a prestigious Mercedes 300SL gullwing. This is the alternative world celebrated by writer

Françoise Sagan. 'The plane trees at the side of the road seem to lie flat; at night the neon lights of gas stations are lengthened and distorted', muses Sagan. 'Your tires no longer screech but are muffled and quietly attentive: however madly and hopelessly in love you may be, at 120 miles an hour you are less so.'[35] This kind of environment is also politically inflected, being exactly the world desired by many European politicians and the International Road Federation (IRF) in the 1950s: a place of open and fast movement which, in contrast to the bureaucratized and scheduled train systems associated with dictatorships and state intervention, leads to personal freedom, liberal European citizens and a peaceful and free continent.[36] And so, joyfully participating in this new realm, Véronique persuades Louis to try another kind of innovative architecture, a modernist white motel. 'Let's stay here', she implores, 'I read about them. They have separate cabins, garages.' Like the teenagers of the M1, Véronique desires the alluring, foreign and above all modern world that this new automobile environment uniquely offers, and when she and Louis raise a glass of champagne at the motel with the Mercedes-driving Germans, the toast is suitably international and forward-facing – 'to Europe'.

Other European films have similarly commented on freeways as alternative worlds, such as, for example, Steven and Dinah's flight along a dual carriageway in *Catch Us If You Can*, the use of west Berlin's elevated freeway-like roads in *The Quiller Memorandum* (Michael Anderson, 1966) as a space of Cold War intrigue and subtle pursuit, and the freeway-like A4 in *The Man Who Haunted Himself* (Basil Dearden, 1970) as a realm of inexplicable psychological happenings, where Harold Pelham mutates from a staid

Rover P5-driving company director into a ruthless, womanizing and Lamborghini Islero-driving version of himself. In *Withnail and I* (Bruce Robinson, 1986), the modern, clean and ordered M1 sharply contrasts with the filthy domesticity and decay of 1960s London. In all these films, the motorway proffers a new realm, separated from the city both spatially and culturally, where drivers gain release and excitement, or occasionally uncertainty and even fear, as they move from one world into another. Sometimes it is enough just to join a motorway to gain this sense of liberation: in *Soft Top Hard Shoulder* (Stefan Schwartz, 1993), Gavin feels intense exhilaration as he escapes central London traffic and joins the M1 in his 1971 Triumph Herald 13/60 convertible. 'I was born of the wind, I don't care, fourth gear!', he laughs, accelerating forward, 'Hyperspace! Let's eat tar. C'mon, c'mon, rock n roll!'

But the most prevalent experience of freeways and motorways is of their distinctive visual regime. While earlier mobile experiences must be understood from the perspective of people moving through landscape by foot, horse, carriage and train,[37] the motorway must be understood as being both designed for, and perceived from, high velocity automobiles. Many motorways, of course, have been carefully designed, as with the advertising-free and scenic routes of early German autobahns, all of which, as Bitomsky's *Reichsautobahn* comments, introduced a sense of landscape perspective where new views, open roads and high speeds expressed progress into a modern German future. Indeed, as Dimendberg has argued, the National Socialist autobahn must be understood as a representation as much as a functional transport system, and, furthermore, must be comprehended in predominantly cinematic terms.[38] Although constructed

in very different political contexts, the UK's M1 introduced similar aesthetic conditions. Here, politicians and designers (including Motopia's Jellicoe) combined landscaping, bridges, service stations, views, signage and graphics in a manner conducive to continuous high-speed driving, allowing for a sense of legibility, flow and, above all, an efficient and contemporary realm.[39] Over in 1960s America, urban designers Donald Appleyard, Kevin Lynch and John R. Myer codified the visual experience of freeway driving into a series of events, including cinematic conditions such as sequencing, forward-facing vision, transitions, overlapping and layering of spaces, recalls of the past, glimpses of the future, contrasting views and apparent motion. Based on an analysis of freeways in Hartford, New York, Philadelphia, Cleveland and Boston, their book *The View from the Road* provides a notational system for a driver's passage down a road, creating 'sequence' and 'orientation' diagrams which identify various paths, edges, nodes, landmarks, districts and different kinds of view. Through such an approach, highways can become 'conscious works of art' and so render driving – through rhythms, views, landmarks, vista recalls and so on – a more 'coherent and delightful esthetic experience'. A filmic storyboard sequence is even used to depict the driving experience along their proposed design for an inner belt freeway in Boston.[40]

Although neither Appleyard, Lynch and Myer's cinematic notation system nor their inherently filmic sensitivity to freeway design was widely adopted, many American freeways – most of which demonstrate haphazard visual and spatial attributes – have nonetheless been widely recognized for their aesthetic, architectural and experiential qualities.[41] In the early 1970s, for example, architects

Robert Venturi, Denise Scott Brown and Stephen Izenour undertook their influential study of Las Vegas' roadside architecture, including an analysis of how buildings, signs and spaces of different sizes and scales appear to the driver at different speeds.[42] Around the same time, Reyner Banham, an English advocate of architectural modernism, was doing something similar for Los Angeles, whose freeways he described as having 'canonical and monumental form' equivalent to the streets of Baroque Rome or the boulevards of Haussmann's Paris. Banham singled out the intersection of the Santa Monica and San Diego freeways as 'one of the greater works of Man', a complex piece of art which must be appreciated not only 'as a pattern on the map' and a 'monument against the sky' but also 'as a kinetic experience as one sweeps through it'.[43]

As Banham's last comment suggests, the freeway's mobile visual character is most distinctive here, something described by landscape designer Lawrence Halprin as 'a new form of urban sculpture for motion',[44] while architecture critic Rowan Moore has similarly extolled driving along London's Westway in cinematic terms. 'The bright, smooth openness of its top deck is counterpoised by its sinuous undercroft', enthuses Moore, 'where light and shadow flicker between the columns as you plunge in and out of tunnels, and glimpses of tree, sky and street, or a canal, flash by like snatches of film.'[45] Thus while some might debate the heritage value of constructions like the concrete Pennine Tower restaurant at the Forton/Lancaster M6 services, or the M1's two-span over-bridges designed in a modernist-Doric style by Owen Williams, it is the high-speed encounter with the freeway or motorway which sets these constructions apart, through which, as Halprin explains, 'the

qualities of change are not mere abstract conceptions but a vital part of our everyday experiences'.[46] As Banham noted of Los Angeles, its freeways offer a 'coherent state of mind, a complete way of life' and the 'fourth ecology' of the city where residents find 'a special way of being alive'; he himself, in order to 'read Los Angeles in the original', had to learn to drive. Los Angeles will 'never be fully understood by those who cannot move fluently through its urban texture', argued Banham, nor by those 'who cannot go with the flow of its unprecedented life.'[47] Similar reactions abound, such as modernist American artist Tony Smith who, after an enlightening night-time drive along the New Jersey Turnpike in the 1950s, where there were 'no lights or shoulder markers, lines, railings or anything at all except the dark pavement moving through the landscape of the flats', felt himself liberated from many of his views on art, and indeed considered that the 'end of art' might have now arrived.[48] Banham's friend and modernist architect Alison Smithson describes journeys along the UK's M3, M4 and M6 in comparable terms in her unusual travelogue AS in DS: an Eye on the Road. Smithson here remarks how motorways uniquely offer surprising landscape views of 'freshly presented clearly defined compositions', 'greater spaciousness' and 'swathe-spaces', while she could experience a 'miracle in the movement' as her Citroën DS ploughed through a storm. Aesthetically, Smithson observes the graphic effects of motorways in motion, ranging from 'triangles that could be Klee's' and 'dotty winking lights' to seeing a distant town 'spread out in the atmosphere tonight like scattered foam on a pool of darkness', as well as noting the 'peaceful, anonymous world of motorway embankments' or a 'golden-barred ceiling echoing the light spread on the surface of night-wet-road'. Such an

automobile-centred world, Smithson muses, generates a 'place of possibilities' and indicates a 'new aspect of England'.[49]

This novel world is exactly the one represented in many films of the 1950s and '60s, notably in the atmospheric night-time minimalism of the autoroute in *Lift to the Scaffold*. Yet where Malle's movie portrays its autoroute as an otherworldly terrain, later films find even richer delights in the visual pluralism of the freeway. In freeway driving in particular, the landscape often appears to the driver in cinematic terms and so is very different to the experience of, for example, a train passenger. In a train carriage, the traveller is fundamentally detached from the view, which unfolds from side to side, but for the automobile driver the frontal windscreen means that views are framed head-on, and are also sequenced, juxtaposed and speeded up by the effect of rushing up to the windscreen, all of which is further intensified by the dynamic participation of the driver in the act of driving the car.[50] Cultural theorist Paul Virilio calls this 'dromoscopy', where, 'with the help of the steering wheel and the accelerator pedal, the author-composer of the trip will in effect arrange a series of speed pictures', these 'speed pictures' being images which line up with the windscreen, playfully sneaking up on the driver, then suicidally accelerating as they get close, and finally, at the last instant, fleeing down the side windows. Virilio describes this as a 'cinematic hallucination', a reversal of viewing a movie in a darkened theatre, where the driver now has the impression of being constantly thrown forward into the windscreen and 'projected' onwards to their destination.[51] This is, of course, a universal condition of driving in general and of freeway driving in particular, and even 'how-to-drive' guides as prosaic as the British

police *Roadcraft* of 1960 describe how these effects are visible to any fast-moving driver.[52]

Beyond these general effects of motorway driving, specific films modulate dromoscopic viewing into subtle variations of seeing and of meaning. Tati's *Playtime*, for example, finds joy in the road markings and lamp-posts of city roads, while his later *Trafic* makes even more of the visual qualities of autoroutes. As various drivers approach Amsterdam, *Trafic* shows a multitude of visual effects involving moving lines, reflections, rhythms and layers extending across air, glass, tarmac and metal. We see white lines dart along car sides, mutate into psychedelic patterns on complex metal shapes, oscillate across lanes, beat out staccato rhythms along road surfaces, waver in long ribbons and conjoin in abstract patterns, only to

separate in divergent patterns; static views are enlivened by speeding cars and moving reflections; and glass surfaces fracture into kaleidoscopic panels, while the sun glints off chrome bumpers and hubcaps. The overall effect is a dazzling arrangement of visual amusements, at once dynamic, rhythmic and hypnotic, and unique to the expansive terrain of the mobile automobile landscape.

As might be expected after the shock of freeway landscapes started to wear off in the 1970s, concentrated cinematic attention on freeway visuality occurs less frequently after *Trafic*. Nonetheless, many views still occur, ranging from the extended depictions of the M25 in *London Orbital* to the beautified digital renditions of signs and truck lights as Mack the truck heads west in *Cars*. Also frequently apparent is the drama of freeway infrastructure, such as the photographs of intersections Carrie takes in *Kalifornia*, the scenes in *Paris, Texas* and *The End of Violence* noted above, or overhead views of Pittsburgh freeways in *Boys on the Side*. Especially dramatic are the lingering and experiential shots of freeways framed against a blue

Experiential view of a freeway intersection. *Little Miss Sunshine* (Jonathan Dayton and Valerie Faris, 2006).

sky in *Little Miss Sunshine,* where clean and minimal concrete form is played out alongside young Olive's questions about her recently deceased grandfather. These views are therefore at once formal, showing the scale and complexity of the intersection; experiential, with an upward-titled camera revealing the changing shapes and directions of freeways as the family's vw Microbus passes underneath; and psychological, a foil to considerations of continuity, death and afterlife.

The most intriguing of all post-*Trafic* depictions of freeway visuality comes via the black-and-white cinematography of *Radio On*. The first film by Chris Petit, this atmospheric road movie traces the listless journey of Robert (David Beames) as he drives to Bristol after the death of his brother. Driving around London and then

Robert experiences visual minimalism and Kraftwerk's 'Radioactivity'. *Radio On* (Chris Petit, 1979).

onwards to Bristol, the film alternatively portrays rushing buildings as Robert guides his Rover P4 along London's Westway, a slow parallax effect while passing residential towers besides the elevated A4, a wistful appreciation of electricity pylons when meandering around Bristol and, most strikingly of all, the hypnotic effect of a forward-facing and long-held single-point perspective as Robert coasts down the M4. Significantly, this last scene is accompanied by the electronic Morse-code beat of Kraftwerk's 'Radioactivity' playing on the in-car cassette, thus connecting the reductive view ahead with Petit's contention, earlier seen scrawled on a note, that 'we are the children of Fritz Lang and Werner von Braun' and that 'our reality is an electronic reality'. The audio-visual environment of the M4 thus stands as a supremely distinctive aesthetic experience in its own right, but also as an expression of a modern life that, for Petit, combined 'drift and boredom, jukeboxes, *Alphaville*, J. G. Ballard and Kraftwerk'.[53] In this scene from *Radio On*, the motorway, forward sight, inexorable motion, minimalist music and modern cultural life all come together in a single haunting vision.

Associations and Connections

Beyond these highly visual experiences, freeways also allow for all manner of different associations and connections to be made between people. In *Charlie Bubbles*, for example, the only real relationship Charlie has is with his assistant Eliza, which begins while they drive along the M1 in his Rolls-Royce. Similarly, much of the bonding between Travis and Hunter in *Paris, Texas* is conducted while resting

underneath intersections or travelling along freeways, and numerous other such relationships are developed in many of the journeys described in the previous chapter. Other films, however, use the peculiar detachment of the freeway from normal urban realities to establish alternative social connections: these range from the sexually and violently charged encounters engineered by Eunice in *Butterfly Kiss*, which take place across a network of Lancastrian dual carriage-ways, motorways, service stations and car parks, to the extended journey along Los Angeles' Interstate 5 in *Freeway* (Matthew Bright, 1996), which allows Bob to subtly manipulate Vanessa into revealing personal details of her difficult life.

Besides these kinds of social connection, freeway driving, if undertaken in a certain manner, also allows for modes of thoughtful understanding. In contrast to the kind of placeless nowhere described by Lefebvre and others, freeways offer all kinds of objects and associations, ranging from scenes of landscape, flora, fauna and service networks to clues to such things as accidents (the inevitable roadside emergency), forms of protest and political opinion (bumper stickers), everyday lives (views into fellow drivers' cars) and international connections (overseas trucks pounding across Europe).[54] Motorway verges and adjacent land also create an eco-haven of car-borne cross-pollination, fungi and algae, wild flowers, trees and shrubs, voles and mice, and rare birds such as kestrels, hawks and red kite.[55] In particular, for the motorist, motorway driving involves a constant oscillation from the detail to the territorial, from the local to the national and global: here a kestrel, there an eco-system; here a truck, there a transport network; here a service station, there a global energy supply; here a bilingual sign, there a tension between regional

identities. 'The geography was different', reflects journalist Suzanne Greaves of her early UK motorway journeys, 'you heard these regional accents, which showed the foreign-ness but also the availability of travelling to these bits of the country.'[56] Or as the popular children's book *I-Spy: On the Motorway* put it, 'think of your car as a magic carpet, taking you to explore new country which you would not otherwise see'; it encouraged youngsters to spot such sights as a church, a country house, topiary, 70 mph signs, Continental lorries, viaducts and railways.[57] Motorway travel thus allows people to contemplate things that are both distant and close to hand, and in some ways it finally meets the desires of nineteenth-century figures such as Honoré de Balzac, who would no doubt have delighted in this manner of travel. 'If only you knew how strongly I aspire to seize hold of nature by means of a long high-speed race across Europe', wrote Balzac, 'how strongly my soul thirsts for that which is vast, infinite, for nature seized as a whole and not in its details . . . in the course of traversing spaces and seeing countries rather than villages.'[58]

High-speed inter-regional motoring can, therefore, offer a valuable understanding of place: comprehending place at a scale beyond locality and immediacy, and within a wider context and time. As early motorist Filson Young describes driving across Europe, through such journeys 'we lose the extremely minute detail of the road' but also 'cover it in spans so much greater that the sense of passage is so vastly increased'; in this way, for example, 'the pageant of Rome, of the Middle Ages, pass before your wondering eyes'. As Filson Young continues, 'this is the supreme charm of this kind of travel; that it takes us from one world to another, open to and conscious of the things that connect those worlds with each other,

so that we see the change coming and know how it has come.' In short, through such journeys we witness 'history and geography at a glance', not just seeing land and terrain change but also witnessing the 'life and history' unfold over large distances.[59]

Of course, it might well be objected that Filson Young's early twentieth-century journeys might not be readily experienced today, when freeways and service stations have replaced B-roads and roadside hostelries, and fractured society has replaced Filson Young's families at dinner, children at play, tired labourers and stabled horses. Yet when considered in a certain way, history is still visible, geography is still variable and life is still rich along motorways. Indeed, in recent years many have emphasized exactly these characteristics of motorways, citing, for example, the many sights visible along the UK's motorways, allowing the driver to 'find out about everything you can see from your vehicle'. For the M4, this includes over 500 sites ranging from industrial ruins, churches, country homes and other places of historical interest to artworks, bridges, technology centres, signage systems and power stations, and includes such gems as the Membury Mast, an elegant television aerial first built in 1965.[60] Other guides give details about the M25, including information on its construction, route, intersections and geology, as well as historical sites, art galleries, churches, flora, waterways and agricultural produce, or even providing a detailed account of the 'social arena' and 'community apart' located at the South Mimms service station.[61]

Even *London Orbital* finds all manner of curious social and historical layering, once, that is, cultural associations beyond the immediate confines of the M25 are brought into play, encompassing everything from boarding kennels and Christopher Wren's displaced

Part of psycho-
geographer
Iain Sinclair's
M25 project
of restitution.
London Orbital
(Chris Petit and
Iain Sinclair, 2002).

Temple Bar to Heathrow airport and Bram Stoker's *Dracula*. Indeed, in *London Orbital* we even see indications of this on the M25 itself, as Sinclair attempts a 'project of restitution' by conjuring up memories at strategic points along the motorway: photographer Effie Paleo- logou logging traffic from a roadside West Thurrock hotel as a device for meditation; writer and artist Rachel Lichtenstein in the Jewish cemetery at Waltham Abbey, rescuing 'shards of biography that had drifted away from the ghetto'; architect Liat Uziel, searching for a site for a 'museum of memory' for 'all the lost voices of London'; and artist Renchi Bicknell constructing with Sinclair a 'mad encyclo- pedia' map of 'all the M25's secrets', such as logging the literary and historical presence of the U.S. presidential Bush family, Nicholas Hawksmoor's grave, H. G. Wells, Aldous Huxley, J. G. Ballard, petro-chemical works, Martian landing sites, lunatic asylums, lost hospitals, 'acoustic footstep' planning regulations and the mystical visions of artist Samuel Palmer. Once read or reconfigured in a certain way, even the M25, 'the world's biggest bypass', can thus offer a dreamlike interweaving of imagination and facts, paranoia and calmness, conjectures and knowledge; in this way, as Sinclair finally concludes, the M25 'had lost meaning and acquired a soul'.

Endless Time and Contemplation

Another of the discoveries in *London Orbital* is that one way
to address the motorway is to focus on matters of space and not
time, yielding to continuous movement while travelling around
the motorway's endless circuit. Yet a distinct aspect of freeway
temporality is revealed even in this ostensible rejection of time:
apparent endlessness, where time is seemingly without beginning,
duration or closure, and instead appears as an eternal present,
devoid of historical past or immediate future. American artist Allan
D'Arcangelo described his interstate-based paintings of the 1960s
as evoking experiences in which 'with the passage of time, nothing
has happened'.[62] Of course, time as duration or limited period does
occur on freeway journeys, and films reveal this whenever their
characters refer to distances in terms of time ('it's only three hours
to Houston') or when they speak, as does Withnail on the M1 in
Withnail and I, of 'making time' when speeding down the highway.
Similarly, just as Virilio contends that 'like a magic mirror, the
windshield permits the future to be seen',[63] so the constant onward
rush of the freeway surface ahead signifies a constant movement
away from the past and into forthcoming events. And yet this is,
of course, only ever a metaphor, for no automobile can accelerate
historical time, and instead freeway driving only allows glimpses
of a future that is highly imminent and measurable in seconds and
minutes rather than hours or days. Instead, the effect of hurtling
down a single-point perspective is that the distant horizon never
arrives, the driver being like Kowalski in *Vanishing Point*, tearing
down the converging lines of the view ahead towards a destination
never attained. More usually, therefore, it is the sense of endless

time which dominates freeway driving, a world where the past has departed, where the future is visible yet never reached, and where the present morphs into a never-ending, non-stop world.

This, then, is a peculiar condition of freeway driving, whereby apparent endlessness does not necessarily produce the dulled, destination-focused and thought-free mental state which many contend is endemic to this kind of driving. For example, much work is done while people journey along freeways, either meeting at service stations and motels, making calls or even reading.[64] Even more significantly, freeway driving is a space and time for contemplation – where the very neutral and supposedly boring experience of driving is re-invigorated by thoughts, memories, ideas and inspirations of all kinds. As David Brodsly comments in *L.A. Freeway*, 'driving provides a scheduled opportunity to do nothing. The freeway commute is Los Angeles' distinctively urban form of meditation.'[65] This is, for example, why Vija Celmins's photorealistic painting *Freeway* (1966) suggests that the car interior and windscreen operate as a kind of calming filter against the lively traffic and vibrant sky up ahead. Yet this is not contemplation as pure absence, as a space-time of nothingness. In *America* Baudrillard speaks of driving as 'a spectacular form of amnesia' where not only is 'everything to be obliterated' but also, and tellingly, where 'everything is to be discovered'.[66] This is why Maria Wyeth in Joan Didion's novel *Play It As It Lays* (1970; film version, Frank Perry, 1972) turns to driving compulsively along the Californian freeways in order to deal with her mental breakdown and sense of social disconnection. Nor are such actions confined to those most scarred by the complexities of urban life, and indeed contemplation while driving along a

freeway is often enjoyed during the most normal of journeys. As one British driver affirms, 'commuting to work on the M1 is a real pleasure. I have time to reflect on my day ahead, go through my classes, sing at the top of my voice.'[67] Indeed, it is the highly distinct nature of freeway driving, being at once focused on immediate traffic and at the same time half-dreaming and removed from the specificity of driving – what art theorist Jonathan Crary refers to as the driver's 'diffuse attentiveness and quasi-automatism'[68] – which allows this to happen. In short, the very uniformity of freeway driving experience – relatively constant views, road conditions and speeds combined with extended periods at the wheel – allows the driver to enter a more contemplative state than would be possible when, for example, driving through the heaving mêlée of a busy city or along the switch-back path of a country road. Furthermore, freeway driving, like other kinds of driving, is not devoid of senses other than sight but is in fact full of subtle sensations of touch, vibration, smell, sound and other stimuli, all of which can at once propel the mind into more distant thoughts and, at the same time, pull the driver back to the immediacy of driving.[69]

Given the power of this equation, where the immediate present is connected to distant thoughts through driving along a distinct landscape, many films unsurprisingly depict the road as a space of contemplation and release where thoughts are gathered and actions planned. In *Wild Strawberries*, the rushing tarmac signifies passages of introspection wherein aged doctor Eberhard Isak Borg (Victor Sjöström) is prompted to accept who he has become and to consider his approaching death. A similar concern with one's place within the world occurs in *The Wrong Move*, in which Wilhelm (Rüdiger

The road surface rushes by as Eberhard Isak Borg reflects on life and approaching death. *Wild Strawberries* (Ingmar Bergman, 1957).

Vogler) conducts a largely futile search for inspiration to write and a sense of identity. Wilhelm's extended and disjointed musings are here strung out alongside lingering shots of industrial West Germany: for example, when Wilhelm travels along a blank night-time autobahn towards Frankfurt this is followed by his descriptions of a graffitied tower block and his passionless urge to have sex with a fellow traveller. As we have seen, the many freeway and highway scenes in Wenders's later *Paris, Texas* further develop this structuring of roads, travel and thought, providing Travis with the extended space and time in which to piece together memory, relationships and identity, as well as ultimately to decide on how to cope with his love for his wife Jane and son Hunter. In other drives that are equally instilled with periods of deliberation and reflection, Anna

philosophically proclaims that 'inside me there is only a void, a tremendous void' as she drifts down a blank Milan autostrada with lover Renzo in *Yesterday, Today and Tomorrow*, while in Chip Lord's art video *Motorist* (1989) the driver (Richard Marcus) creates a mobile narrative and confession as he drives from the u.s. southwest to Los Angeles in a 1962 Ford Thunderbird, variously exploring childhood memories, the everyday American landscape, the Ford motor company and the automobile in general.

Marion contemplates her crime as the road moves relentlessly forward. *Psycho* (Alfred Hitchcock, 1960).

The sense of freeway driving as a suspended reality or escape from the world is particularly intense when the past has collapsed under the weight of a recent dramatic event. For example, in *Psycho* the impetus for thought is particularly urgent when Marion Crane (Janet Leigh) imagines how others may react to her theft as she drives her Ford Fairlane 500 along the freeway-like uniformity of dual carriageways, with nothing ahead except constantly moving traffic, the occasional sign and telegraph pole, and the single-point perspective arrowing forward. There are no turns or intersections to distract Marion from her thoughts, only the constantly moving road

surface as a recurrent reminder that she is fleeing the scene of a crime. At the end of the journey even the road itself disappears, obscured by a heavy downpour and an arcing windscreen wiper, creating an even more intense mood of doubt and anxiety as she is constantly dazzled by oncoming headlights; and then, seeing the illuminated sign of the Bates Motel emerge out of the dark, Marion makes the fatal decision to stop at her final destination. Another film which portrays the freeway as a place of alternative reality comes forty years later, this time with the shockingly empty motorway

The eternal present of the motorway, with past and future burning up ahead. *28 Days Later* (Danny Boyle, 2002).

portrayed in *28 Days Later* (Danny Boyle, 2002). Here, however, the circumstances are somewhat different: in providing Frank, Hannah, Selena and Jim with respite from the bloody fallout of the 'Rage' virus, the M1 is menacingly without time, suddenly cut adrift from both centuries of history and the security of an expected

future, and so is thrust into an eternal present where everything
has changed and nothing can be assumed. As the survivors savour
a period of temporary relaxation in an LTI Fairway taxi, they reflect
on all that has happened and, most importantly, steel themselves for
the desperate future ahead, ominously signalled by the vast expanse
of vacant motorway and its now useless signs, bridges, lamp-posts
and wind turbines. Time here is endless – in their history, which
has been destroyed by cataclysmic events, in their journey, which
is truly without any certain destination, and in their future, which
is equally unpredictable and unknown.

The refugees in *28 Days Later* have only emergency broadcasts
to listen to, the otherwise silent radio adding to the sense of apocalypse
as they drive along the barren motorway. The poignancy of this effect
derives, of course, from the fact that, under normal conditions, music
and the radio frequently provide a positive companion in the auto-
mobile, acting as a catalyst for personal thought and mental alertness
and so keeping the driver simultaneously disconnected from, yet aware
of, the road ahead. Films as diverse as *They Live by Night, Orphée*
(Jean Cocteau, 1949), *The Hitch-Hiker* (Ida Lupino, 1953), *American
Graffiti, Wild at Heart* (David Lynch, 1990) and *Red Lights* (*Feux
rouges*, Cédric Kahn, 2004) all show music and other audio inputs –
from the radios fitted to American cars in the late 1930s to cassette
decks, 8-tracks, CD players and now mp3 and iPod connectivity –
which are now a constant presence for many drivers, providing a
ubiquitous component of their everyday driving experience.

As a result of the capricious quality of the radio, the driver
can be transported to an unexpected mental destination. In such
a manner, 'the car radio envelops you in its own space', writes the

film director and video artist Julia Loktev, so that 'the sound of the radio fills the car'. Alternatively the driver can, through the deliberate selection of music via CD or mp3 player, be contained within a world entirely of their own making and self-determined boundaries, so that the music played 'depends entirely on the mental fantasy you play out whenever you're behind the wheel'.[70] Here the relatively random nature of the radio playlist is replaced by a more personal ordering of music, but the overall effect remains the same: 'an infinite soundtrack for the external landscape that scrapes the windshield'.[71]

Radio On is especially telling in this respect, and the mesmerizing qualities of Kraftwerk's minimalist 'Radioactivity' emanating from Robert's cassette player add much to the air of deliberate contemplation as he drives down the M4. Music, driving and the motorway here all form a tentative correlation between the immediate present (the repetitive uniformity of driving on the motorway), the uncertain past (his brother's death) and the equally ambiguous nature of the impending future (what Robert will discover on arriving in Bristol). Just as Kraftwerk robotically intone that 'radioactivity is in the air for you and me', so something equally invisible pervades Robert's world, something still unknown and whose effects are similarly as yet unquantified. Consequently, whereas surface streets and country roads provide Robert with a landscape of crime, drugs, suicide, politics, war, prostitution, pornography and alienation, the motorway allows Robert to escape into himself and consider his life and trajectory. Driving on this road protects, calms and reassures, while also allowing for new deliberations to occur and decisions to be made; the motorway at

once distances, filters and buffers, and also reconnects, re-establishes and rethinks. Indeed, for the director, Petit, the wider meaning of driving transcends the portrayal of Robert's particular journey in *Radio On* for, as he has commented, motorway driving in particular is 'the most unreal thing', a 'good thing' which 'stimulates the imagination' while everything else is only 'a snare and a delusion'.[72] Motorway driving here thus goes beyond simply providing a temporary respite from the modern world, and instead is seen as providing its own and possibly even *the* true reality, a peculiar kind of intersection of time, space and movement where our private imaginary creates the only certainty on which we can justly rely.

Don't Switch the Camera Off

Although this book is not directly concerned with film-making techniques such as framing, editing, sequencing, site location and so forth, we have already seen how many directors approach the task of capturing, representing and exploiting the potential of driving. It is worth briefly recalling some of these approaches here and, in particular, drawing out some of the challenges and difficulties of representing driving on film.

In *Man with a Movie Camera*, in order to self-critically depict modern urban life Dziga Vertov explicitly deploys such techniques as Dutch angles, reflections, montage, split screens, superimpositions, slow motion, tracking shots, negative reversals, extreme close-ups, double exposures and freeze frames. The film's final sequence is a crescendo of fast-moving cars, trains, crowds, faces and moving

machinery, culminating in a shot of an eye as a camera, thus making it absolutely explicit that *Man with a Movie Camera* is not so much a representation as an investigation into how we view the modern world. In a later avant-garde context Stan Brakhage also focuses on film as a way of making people see differently. Rather than through narrative or manifest subject-matter, meaning in films like *Dog Star Man* (1961–4), *Mothlight* (1963) and *Kindering* (1987) is conveyed through composition, camera movements, rhythms in images, editing or paint on the film itself. Although cars and driving figure rarely in Brakhage's work, his films nonetheless mimic the condition of viewing by freeway driving, it can be argued, by being best seen as instances of 'light moving in time' and by individuals (rather than

In the car along with Bart and Laurie. *Gun Crazy* (Joseph H. Lewis, 1949).

mass audiences), who watch in a state of attentiveness and openness, and subsequently create the film in their own imagination.[73] In this way Brakhage's films equate with the way in which freeway drivers often drive alone, watching the road and landscape ahead with the kind of relatively contextless seeing 'in the first person' described in the previous chapter, and producing their own readings and meanings based on a personal reaction to the unfolding scene ahead as well as on their own more distanced thoughts.

Returning to a more overtly automobile-based setting, Joseph H. Lewis filmed much of his B-movie *Gun Crazy* on location, frequently relying on in-car footage and sound to make the audience feel they are placed alongside the bank robbers. In a renowned sequence lasting an unedited 3 minutes 13 seconds, we are placed in the rear seat of a stolen Cadillac Series 61 with Bart and Annie. Without interruption, we see the car (and ourselves) move through the small town of Hampton, park, Bart get out, Annie talk to a passing cop while Bart robs the Hampton Building & Loan Association, then both of them getting back into the car before driving out of town while checking that no one is following (with Annie looking back past the camera/audience). This inventively tense sequence is highly cinematic, making the viewer become the camera when turning and panning to look at events, yet is also highly realistic, being shot in real time and at close quarters, without extreme lens views or other manipulations. This cinematographic technique has been extraordinarily influential on innumerable chase sequences ever since, such as the opening action of *Drive*, where the director deploys digital cameras mounted both inside and outside of the fleeing Chevrolet Impala. The effect is to fix the audience alongside the

thieves throughout a studiedly psychological game of cat-and-mouse through the back streets of Los Angeles.

Another way of suggesting that the audience is in the car is provided by low-quality film stock, such as the Super 8 home movies within *Paris, Texas* which impact a sense of personal memories, real people and authentic lives. Hand-held cameras have also been deployed by many other directors, such as Godard in *Breathless,* where an Eclair Cameflex lets the audience become a passenger within Michel's various car journeys, both being spoken to and listening to his internal ramblings. Andrew Kötting's experimental documentary road movie *Gallivant* (1997) combines Super 8 and other film stock with time-lapse photography, alternating colouration, undercranking and stuttering panning shots in order to engender, like Wenders's *Paris, Texas* 'home movies', a seemingly amateur yet decidedly knowing depiction of a genuine and resonant journey.

More commonly, innumerable directors have created an overt cinema-within-a-cinema whenever the windscreen either frames the driver head-on or looks down the approaching road. To give but a few examples of this ubiquitous technique, both kinds of view are evident in *Psycho* when Marion drives towards the Bates Motel, the sustained concentration on her face being alternated with similarly focused views of the road ahead. Hitchcock uses this technique to emphasize Marion's increasingly anxious mental state, as well as her movement towards an uncertain and gruesome future. In the crime thriller *Payroll* director Sidney Hayers makes equally effective if less sustained use of the near-black and squared-off window surround of the wage robbers' Land Rover to create an acutely cinematic view of Tyneside. Similarly the windscreen of a 1959 Ford Custom 300 in

The windscreen as framing and timing device. *The Killers* (Don Siegel, 1966).

The Killers (Don Siegel, 1964) acts as a dramatically stylized framing device when a robbery is prepared by gangsters Sheila Farr and Jack Browning. Siegel also provides other, equally successful vistas when, a few minutes later, a high-speed view following the Ford as it energetically bumps along a rough back road is mixed with static, overhead and back-projection shots, all of this creating a complex cinematic study of driving in motion.

As many of these techniques make clear, cinematic depictions of driving are always an artifice. Indeed, many artists and film-makers have doubted the degree to which driving, and particularly the subtle complexity of freeways, can be understood or represented visually. 'There is no way you can frame it', asserts artist Tony Smith of freeway driving, 'you just have to experience it'.[74] Or as Phil in *Alice in the Cities* notes of the Polaroids he takes while driving his 1973 Plymouth Satellite through America, 'they never really show what it was you saw'. Instead filmic portrayals of driving always filter reality; indeed, they conjecture as to what driving might be or could be

'The M25 only begins to make sense if you don't switch the camera off.' *London Orbital.*

like, a state in between true actuality and pure imagination which at once reflects, interprets, mediates, creates and postulates a condition of driving at speed, in a certain car, along a particular road, with a distinct mental attitude and body action, and within a specific cultural and historical frame.

We see this kind of self-reflection most explicitly, especially in relation to freeways, in *London Orbital*. Here, as Petit admits after weeks of attempted cutting, 'the M25 firmly resists editing, resists linear interpretation'. Indeed, the M25 even 'resists filming', for the use of digital tape seems to Petit to produce images too lacking in emulsive shadows for a truly filmic depiction of motorway driving. 'Tape is ubiquitous, too flexible and too accommodating, it can shoot anything', complains Petit, 'tape is flat, tape is over-bright and electronic.' But herein also lies the answer for, as Petit recognizes, 'tape is logging, a hand-held diary' and, in the last analysis, 'there was no

reason to cut'. Petit here understands that the most authentic record
of the M25 is provided by the tape-fuelled surveillance cameras
which line it. 'Edited time made no sense in relation to the subject',
he realizes, and in the end concludes that 'the M25 only begins
to make sense if you don't switch the camera off.' The notion
that specific qualities of freeway driving lead to a unique modern
experience, and in particular to contemplative reflection, thus reaches
its ultimate cinematic expression, where the blank repetition of
the road causes the film-makers' art to collapse into a new form. The
Motopia of the M25 is a kind of tape-tarmac/tarmac-tape where driv-
ing and its representation are equally endless and uniform, offering
a distinct combination of recurrent anti-image aesthetics, constant
forward motion and a dreamlike existence which never ends.

4 ALTERED STATES

Speed is optimism because velocity gathers together and
synthesizes life. Velocity kills memory, folding back upon
oneself, remorse. Velocity attacks, it does not suffer; it is
almost always the master of life and its forces.[1]
Filippo Tommaso Marinetti, *c.* 1921

Since the eighteenth century and new kinds of horse-drawn carriages,
wheel-based transportation can be divided into two camps: one
based on function, where the driver focuses on getting somewhere
as efficiently as possible, and the other based on exhilaration,
where the driver revels in new mobile emotions and experiences.[2]
In particular, high speed driving can transport the driver into a
kind of parallel world of mental and physical alertness, a world cut
free from the constraints common to other forms of driving, and
where the driver's own absorption within the experience of driving
is most important. In this environment, while the driver remains
attentive to where they are going, it is the inner nature of the experi-
ence which comes to the fore, creating an attenuated and dominant
sense of speed and exhilaration, acceleration and adrenaline, danger
and calmness. It is this kind of speed this chapter explores through
four interlinked areas: transcendence, transgression, car chases
and crashes.

Transcendence

Motoring journalist David Vivian distinguishes between a car's rate of acceleration and the manner in which it delivers that acceleration as an experiential thrust (such as the Ariel Atom's acceleration, 'hair-trigger, instant as a detonating bomb and tipped with a kind of chainsaw savagery'), while cultural sociologist John Tomlinson similarly distinguishes between 'machine speed', where nature is dominated by mechanisms, and 'unruly speed', which escapes discipline and regulation, thus entering into a world of risk, violence and sensory pleasures.[3] In pursuing this unruly speed drivers can follow Marinetti and the Futurist project in rejecting Enlightenment reason and concomitant efficiency, scheduling and safety, and instead pursue a world that is unstandardized, unreliable and uncontrolled, where events unfold in an uncertain, instinctive and irrational manner. Speed is here associated with the transcendental, with moving not just from one place to another but from one state of being to another, a transformation involving fear, flight, intoxication, rapture, horror and hallucination.[4]

 Although some have argued that the 'ecstatic dimension' to speed and acceleration can only be felt firsthand,[5] it is this aspect of high-speed driving that is nonetheless dynamically expressed in many films. Indeed, such a transformative journey is an integral part of the very first narrative movie to incorporate an automobile journey, *The Runaway Match, or Marriage by Motor* (1903), where a young couple elope in a car and are chased to the church where they marry. Here the automobile both transports people from one place to another and, more importantly, transmits them into a new life of passion and sentiment.[6] As early motorist and u.s. president William

Howard Taft described it, such an experience is like 'atmospheric champagne'.[7] It can also, in extreme circumstances, invoke a new way of knowing the world, being focused less on logic and certainty and more on direct experience, intuition and immediacy. The consequent experience can even approach a modern-day sublime, where the driver has an encounter with danger and terror of such magnitude and character that it cannot be readily quantified.

We see this in many posters and other early motoring representations,[8] most notably in Jacques-Henri Lartigue's famous photograph of a racing car in *Grand Prix de l'Automobile Club de France, automobile Delage* (1912), where tilted spectators, angled poles, a hunched driver, striated ground, distorted rear wheels and the partly blurred form of a semi-cropped Delage together suggest a rush of almost indefinable energy, urgency and terror.[9] A few years later, *Les Mystères du château du dé* reconfigures this sublime condition as an attenuation of strangeness within the everyday, where a vibrating and erratic high speed journey moves from rationality and certainty into Dada-Surrealist chance, dreams and psycho-sexuality. *Mosaik in Vertrauen* (1955) by experimental film-maker Peter Kubelka presents an equally avant-gardist portrayal, montaging real-life footage of racing and crashes from Le Mans with scenes of industry, transport and everyday life. The result is a discontinuous and disconcerting series of images and parallel sounds, all of which the viewer has to recombine associatively rather than logically.

In the more mainstream *The Third Man* (Carol Reed, 1949) a different kind of psychological strangeness occurs when writer Holly Martins (Joseph Cotton) is whisked away on a wildly careening ride, thinking he is being taken to his death. Low-down shots, Expressionist

angles and cutaways to watching faces all render this fast-paced car
journey an urgent and delirious event, and the episode is particularly
unsettling given that it occurs midway through what is otherwise a
largely foot-borne movie, with alleys, staircases, doorways and rooms
rather than, as here, a hurtling and disorientating passage through the
dark and cold-hearted streets of a desolate post-war Vienna. More
exuberantly, the gothic-camp *Faster Pussycat Kill! Kill!* shows three
violent go-go dancers who take their sports cars – Billie in a 1959 MGA
MkI, Rosie in a 1958 Triumph TR3A and Varla in a 1965 Porsche 356C
– on a high-speed excursion through the Mojave desert, including
a three-way chicken run in which Varla calmly drives through the
middle of panicking Billie and Rosie.

 A rare automobile scene in the dystopian *A Clockwork Orange*
(Stanley Kubrick, 1971) shows another immersal in high-speed
violence when psychopathic Alex (Malcolm McDowell) and his
three droogs steal a low-slung 'Durango 95' (a mid-engined Probe
16) for a night-time countryside jaunt, driving underneath a lorry
and terrorizing pedestrians and other drivers. In terms recalling the
Futurist manifesto,[10] Alex describes how 'the Durango 95 purred
away real horrorshow – a nice, warm vibraty feeling all through
your guttiwuts. We fillied around for a while with other travellers
of the night, playing hogs of the road.' In a cartoon-like shot of the
four delinquents perched atop the hurtling Durango, backed by a
weirdly green-glowing landscape, speed feeds the gang's manic state
and increases their predilection for 'ultra-violence'. This kind of
high-speed journey as an intensification of an individual's state
of mind is particularly apparent in many of David Lynch's films,
including *Lost Highway* (1997), where the oncoming rush of the

Dorothy, Jeffrey
and Frank take a
high-speed journey
into psycho-sexual
and violent hell.
Blue Velvet (David
Lynch, 1986).

road surface signifies a change of psychic state into confusion,
mystery and insanity. A similar condition occurs in an often over-
looked scene of Lynch's psycho-surrealist *Blue Velvet* (1986), when
sado-masochistic sociopath Frank (Dennis Hopper) takes innocent
Jeffrey (Kyle MacLachlan), singer Dorothy (Isabella Rossellini) and
four others on a 100-mph-plus joyride in his 1968 Dodge Charger.
Part of Jeffrey's descent into the psycho-sexual hell constructed by
Frank, speed here injects a dynamic trajectory into a film otherwise
composed largely of static interiors and, in particular, allows Jeffrey
to realize both his horror at Frank's violent sexual proclivities and
attraction for them as a means to gain Dorothy for himself. As
invoked by a quickening road surface, staring headlights, flashing
lights and the sound of a roaring v8, and set against the claustropho-
bically dark interior of the Dodge's crowded cabin, speed here signifies
being inescapably out of control while moving deeper into a hidden
America of dark secrets, bizarre appetites and brutal violence.[11]

 As these films suggest, individuals existing in an alternative
world are often further intensified through speed. Perhaps most

extreme in this respect is *Mad Max* (George Miller, 1979), which uses velocity as an integral part of its construction. In a post-apocalyptic Australia fatalities are frequent and lawlessness, murder and rape equally common, and speed, like a cowboy's gun, is a means of both protection and attack. For Max (Mel Gibson), after his family is slain by an outlaw gang, life in the Main Force Patrol (MFP) highway police fuels his transformation into a vengeful and merciless killer; he becomes 'Mad Max', part-human, part-car and part-gun. As his black 'Pursuit Special' Ford Falcon XB GT hurtles down bleak highways, the massive supercharger atop a towering V8 emits an animalistic shriek, heightening Max's near psychopathic state of mind. The road similarly bucks and dives as Max relentlessly pursues those he aims to kill. Speed at once propels, intensifies, completes and symbolises Max's dispassionate determination; it entirely frames his world, and finally, after eliminating the last of the gang, Max can do nothing except propel himself at the single-point perspective of

Max enters a state of determined and merciless revenge. *Mad Max* (George Miller, 1979).

the straight road ahead. This Australian gothic film thus diverts from the course of the u.s. road movie, which frequently dwells upon existential being and death, to focus instead on a more direct engagement with actual, physical death and conditions of danger, terror and menace.[12]

Transformative car journeys can also involve other realities that are highly aestheticized in appearance. Glimpses of this process include the fast-paced collage of Virgil Widrich's experimental animation *Fast Film* (2003), the supernatural visions and parallel worlds of *Wild at Heart*, and the glowing blue lights, hallucinogenic patterns and supernatural appearances of psychological thriller *The Mothman Prophecies* (Mark Pellington, 2002). Also notable is the 'Beat the Devil' (Tony Scott, 2002) episode of bmw's *The Hire* series, where the driver (Clive Owen) races the Devil (Gary Oldman) down the Las Vegas Strip and into the surrounding desert in order to grant James Brown another 50 years of youthful life. Saturated colouration, dark contrasts and fast edits all combine to evoke a sense of intense enclosure, crazed competition and, above all, otherworldly velocity.

Of particular note here is the overtly unreal world of Oliver Stone's *Natural Born Killers*, developed from a Quentin Tarantino screenplay, where serial killers Mickey (Woody Harrelson) and Mallory (Juliette Lewis) embark on an lurid and gory journey partly of their own imagination and partly of televisual construction. 'I see the future', says Mallory while gyrating atop a 1970 Dodge Challenger and bathed in heavenly light, 'there's no death, because you and I are angels.' After killing Mallory's parents, the couple undertake a hallucinatory drive lit by flames and fireworks, and through

such journeys the speeding automobile delivers everything from psychedelic exhilaration and extreme thrills to wild irresponsibility and unadulterated self-absorption, a fantasy world in which – despite allegorical allusions to social themes of the family, criminality, media and mental health – no one seems to matter except Mickey and Mallory themselves. Their extraordinary separation from normality is reinforced by a distinct absence of character insight, giving little explanation as to how they have arrived at their outrageous form of behaviour. Instead, watching *Natural Born Killers* projects us straight into a fully formed vision of Mickey and Mallory's dream-like existence, only to find that we also, as consumers and demanders of violence in film, are implicated as an integral component of their lives. We too, therefore, journey in the car with Mickey and Mallory, not physically as in a latter-day *Gun Crazy*, but in a postmodern combination of the intellectual and the virtual, sucked in by a bewitching combination of childlike reasoning, frenziedly oscillating pace and a complex, hyperactive visual intensity.

If high-speed transcendental experiences range from horror and terror to disorientation, eroticism and frenzy, then they can also involve a very different kind of self-absorption: calmness and tranquility. 'Once you "turn a ton" you're in another world', describes driver and philosopher Lou Marinoff. 'The scenery flashes by a lot faster, but everything else decelerates. It becomes strangely still and you feel a floating sensation.'[13] This kind of effect occurs because, at speeds of 100 mph plus, the human brain can no longer cope with the onrush of visual information and so creates a tunnel vision where the visual field closes in and the mind focuses purely on what lies ahead.[14] The result is a distinct change in the driver's perception of

Mickey and Mallory drive into exhilaration, irresponsibility and self-absorption. *Natural Born Killers* (Oliver Stone, 1994).

space, time and mental stimulation, neatly summarized by motoring journalist Alistair Weaver's account of a 130-mph autobahn run as an experience where 'all is calm, civilized', and by philosopher Jean Baudrillard's contention that 'at more than a hundred miles an hour, there's a presumption of eternity.'[15] Films depicting this quality of serenity in the midst of otherwise fear-inducing situations include *To Catch a Thief* when Francie calmly propels her Sunbeam Alpine along cliff-top roads, *A Man and a Woman* (*Un homme et une femme*, Claude Lelouch, 1966) when racing driver Jean-Louis lifts his hands from the steering wheel of a Ford GT40 while negotiating the high-speed banking of the Montlhéry racetrack, *Vanishing Point* when Kowalski gently smiles to himself while plunging suicidally into a road block, and *Two-Lane Blacktop* when The Driver and The Mechanic disinterestedly dispatch their rivals in various accelerative street races. *The World's Fastest Indian* (Roger Donaldson, 2005) similarly suggests a harmony of man, machine and landscape when Burt Munro judderingly traverses Bonneville, with only the micro texture of the white salt, flat line horizon and distant mountains as points of reference.

Two other films are worthy of special note here: Franken-
heimer's *Grand Prix* (1966) and Lee H. Katzin's *Le Mans* (1971).
The latter film is, as its title suggests, based on the famous 24-hour
sports car race held annually in France, incorporating footage
from the real 1970 event. Michael Delaney (Steve McQueen) races
a Porsche 917K in the distinctive sky-blue and orange livery of
sponsors Gulf. With very little by way of plot, and even less by
way of dialogue (Delaney says his first words in the 35th minute),
Le Mans focuses instead on the rivalry between Delaney and Ferrari
driver Erich Stahler (Siegfried Rauch), but above all it is a voyage
into endurance car racing's intense trackside atmosphere, muscular
machinery and complex on-track experiences. The intricate depiction
of crashes in *Le Mans* is considered below, but of interest here is
its treatment of time. First, this occurs as intense expectation and
anticipation before the race commences, particularly during the few
seconds prior to the actual start, in which an extended period of
stillness and silence is disrupted only by a thumping heartbeat before
a last moment of pure silence and arrested bodies. As the race finally
begins, a riotous explosion of engines, dials, noise, smoke and accel-
eration ensues. Yet instead of, as we might expect, a frantic contest
with charging drivers and barging cars, *Le Mans* subsequently simply
depicts, in many ways, a continuation of the still time that preceded
the race. This is of course appropriate for a race which stretches
through an entire day and night, in which a gradual evolution of
events is punctuated only by occasional pitstops, breakages, over-
taking and, as we shall see later, accidents. But the sense of calm
time in *Le Mans* is also appropriate for the immediate experience
of endurance racing itself, where high speed is not encountered as

short-lived injection or hyperactive rush, but as a way of being, relatively constant state and developing condition. *Le Mans* visualizes this temporality through a highly formalist treatment of headlights as ovals of blue and white dancing across a black screen, as well as a more conventional view of lights criss-crossing a darkened track. Most telling of all are the depictions of the Mulsanne Straight, the 3.7-mile road that provided drivers in 1970, even when moving at over 200 mph, with around 1 minute of uninterrupted maximum speed. As Delaney's Porsche closes in on the race leaders in the very last lap, he overtakes slower cars down the arrow-straight Mulsanne, guided by a single dashed line and the twin borders of Armco and trees towards a distant corner that seems to never arrive. Throughout, the mood is not of frenzy or adrenaline but of determination and composure, a kind of calm alertness while awaiting sight of the rivals ahead. High velocity here is stillness, expectancy and considered patience.

Frankenheimer's *Grand Prix* similarly combines inventive cinematography with authentic race footage, and so provides a clear insight into both the actuality and spirit of 1960s motor racings. Alongside many other features of Grand Prix racing – from technical engineering to danger, rivalry, ruthlessness and the glamorous high life – many of the onboard sequences show how drivers exist in a space and time quite discrete from the surrounding cameras, competition and crowds, where the tumultuous pace of the track is the only world which matters, and so provides a protective zone of concentrated man, machine and speed where all else is erased. Much of this is due to the aesthetic appearance of the track. For example, in contrast to the frenzied visual cauldron of the twisting

street circuit at Monaco, where *Grand Prix* starts, the later races at Spa and Monza offer long straights and gentle high-speed curves, down which the driver moves in a near horizontal position, arms outstretched and lying feet-first just inches off the ground. Nosecone-mounted cameras reveal how the driver consequently sees little more than a continuous ribbon of grey tarmac, bounded by the simple green strip of the roadside, as straight after straight and curve after curve pass by. Even the high-speed banking at Monza – whose tilted road, extreme vibration and noise undoubtedly provide an exhilarating sense of dangerous velocity – simultaneously yields a sense of constancy and the relative immobility of the cars as they stick close to each other along its endless curvature. The resulting visual world is defined by little more than the road surface, an inner yellow line, upper banking barriers, serried trees and an expansive blue sky.

A sense of the sublime on the Monza banking. *Grand Prix* (John Frankenheimer, 1966).

If a feeling of calmness is engendered by this reductive field, it is also due to the driver's mental state. Most notable of all is the driver's ability to erase all consideration of danger, and to instead enter what F1 driver Ayrton Senna famously described as 'driving by instinct' while 'in a different dimension' and becoming 'detached from everything else'.[16] This is exactly the mental state suggested by *Grand Prix*. 'It has always seemed to me', explains Ferrari driver Jean-Pierre Sarti (Yves Montand), 'to do something very dangerous requires a certain absence of imagination.' Despite many drivers in *Grand Prix* seeing their fellow competitors badly injured or killed, they choose to ignore the perilous nature of their trade, perhaps contemplating serious risk when away from the track but never when driving. During the race scenes of *Grand Prix*, therefore, the drivers focus on nothing except that which they are doing, thinking only of their interrelation with car and the track. For example, while negotiating the Monza banking, Scott Stoddard (Brian Bedford) describes on a voiceover what is occurring, such as the 180 mph speed, the road's roughness, the way the car flicks around and is pushed into the banking by centrifugal forces, the way it bottoms out, shakes and bangs, and the consequent need for the driver's fast reactions. Yet all of this adds not to the impression of extreme exhilaration or danger but, by contrast, by being heard in combination with the view of the banking forever unfolding, to the sense of mental and physical control, the driver evidently dealing with all that Stoddard identifies while maintaining constant forward momentum. The overall effect is compelling and hypnotic, a bounded world of reductive aesthetic qualities and hugely focused mental capacity, a world which – for all its evident velocity and potential for disaster

– is serene, self-enclosed and without disruption. It is sublime, confronting a situation of terror and danger in such a way that these things are not calculated or quantified but are pushed aside in favour of a transcendent passage into a world of pure speed, vision and concentration.

Transgression

In contrast to the highly individualistic experiences that invoke the transcendental or sublime, another dimension to high-speed driving is that of transgression, where the driver knowingly crosses social boundaries, breaks rules, violates conventional mores and challenges the established balance between right and wrong, and between social responsibility and personal freedom. This, of course, has been a common feature in film from the beginning, as made clear in *The ? Motorist* where two speeding Edwardian motorists outwit courtroom officials and the police.

Even more compelling than sensationalized drama and action films are depictions of real-life transgression, and recent years have seen the appearance of innumerable specialist DVDs and video games. Especially popular are the Japanese *Megalopolis Expressway Trial* DVD series (Nikkatsu, 1988–96) portraying illegal racing on the Shuto Expressway and other Tokyo roads, and now known globally through street racing video games like *Midnight Club* (Rockstar, 2000–8). Other games incorporating transgressive street racing include *Grand Theft Auto* (DMA/Rockstar, 1997–) and *Need for Speed* (Electronic Arts, 1994–). Within real-life street racing, DVD

offerings include the Swedish *Getaway in Stockholm* (Duke, 2000–) and *Ghost Rider* series (Team Ghost Rider/Müller, 2002–).[17] YouTube and other websites also offer thousands of examples of illegal driving and racing, from high-velocity freeway drives to dangerous turns, spins and other antisocial manoeuvres on public roads. Within mainstream movies, films inspired by the street racing scene include Hong Kong director Andrew Lau Wai-Keung's *The Legend of Speed* (1999) and *Initial D* (2005); Malaysian Syamsul Yusof's *Evolusi* KL *Drift* (2008) and *Evolusi* KL *Drift 2* (2010); as well as the American *The Fast and the Furious* series; *Biker Boyz* (Reggie Rock Bythewood, 2003); *Redline* (Andy Cheng, 2007); *Street Racer* (Teo Konuralp, 2008) and *Fast Track: No Limits* (Axel Sand, 2008).

The most notorious depiction of transgressive speed, however, does not involve quite such outrageous velocities, manoeuvres or denials of authority. Claude Lelouch's short vérité *C'était un rendez-vous* (1976) consists of little more than a solitary high-speed journey through Paris streets, undertaken in the early hours, using a single take via a camera mounted on the front of an unseen car. The journey begins with an emergence from the dark tunnel of the Paris Périphérique at Porte Dauphine, then darting forward to the grand 1.4-mile Avenue Foch, rounding the Arc de Triomphe, hurtling down the 2-mile straight Champs-Élysées, dodging right across the Place de la Concorde onto the Quai des Tuileries along the Seine, before cornering hard left and accelerating through the imposing arches of the Louvre and across rue de Rivoli. Onwards, the trajectory moves north along the arrow-straight Avenue de l'Opéra and alongside the massive Paris Opéra before continuing north along rue de la Chaussée-d'Antin towards the Sainte Trinité church, then

veering right along rue Jean-Baptiste Pigalle. By now, open boulevards and wide squares have closed up, and buildings lean in alongside narrow streets; at one point the car slowly straddles the pavement to pass a refuse truck. Lurching round Place Pigalle, the car turns left along the cobbled Boulevard de Clichy, again slowing around another refuse truck, before passing the Moulin Rouge and turning abruptly right into rue Caulaincourt. After a long gently curving street, and now two-thirds through the journey, the car slows for the much tighter streets of Montmartre and impatiently weaves southeast up to an eventual resting point next to the Basilique de Sacré Coeur and a spectacular view over Paris. The driver appears as he runs in front of the camera to embrace his waiting girlfriend, thus finally explaining both the reason for the journey and title of the film.

Produced, as an intertitle explains, without film cranking or other trickery, being reliant purely on the car's determined trajectory, the 7 minutes 54 seconds of automobile movement in *C'était un rendezvous* is an unedited depiction of illegal driving, providing an authentic sense of high-velocity passage through a distinctive city. We do not ride with the driver, but instead, through the bumper-level camera, gain an even more heightened experience that is at once fascinating, compelling and hypnotic, the carless and driverless view combining with the twilight streets to layer an air of fantasy upon what is otherwise evidently a highly realistic journey. Significantly, although at one point in its hyperactive slicing through Paris the car may hit 125 mph, the average speeds are actually not that high, probably being at most 76 mph even along Avenue Foch.[18] Instead, it is not absolute speed but the impression of speed which matters

Approaching Sainte Trinité. *C'était un rendezvous* (Claude Lelouch, 1976).

most, for *C'était un rendezvous* provides this sensation in abundance. Tarmac, cobbles, grand buildings, local shops, arches, lights, signs, other cars and pedestrians all fly by in an unendingly tumultuous fashion. A revving engine, furious gear changes, squealing tyres and echoes off Paris architecture add a similarly frenzied soundtrack, while the flashing headlights of oncoming cars provides yet another layer of drama. 'I'd never seen anything like it', described documentary film-maker Richard Symons of his first viewing of the film, 'nine minutes of adrenaline that simply leaves your jaw on the floor'.[19]

Yet beyond the dreamlike immersion in a world of startling authenticity, there is another very different quality to *C'était un rendezvous*, for a sense of reprehensibility and immorality quickly surfaces once we realize that the car is neither slowing nor stopping for intersections, that all red traffic lights are being ignored and that, whenever necessary, the driver moves to the wrong side of the road or takes to the pavement to maintain maximum momentum. In

addition, there are several near misses, including a woman who walks in front of the car as it veers into rue Caulaincourt and, a few seconds later, a white Mini that slowly crosses the same street. Refuse lorries are avoided at the last moment, slower vehicles are overtaken with alarming alacrity, and the car barely grips the road when tyres shriek under hard cornering. Pigeons are sent into the air, caught dramatically in the arc of the headlights while accelerating through Montmartre. As a result, *C'était un rendezvous* is not just exhilarating but also decidedly disconcerting, for the unavoidable sense of threatening danger means we can wholly condone neither the driver's actions nor our own vicarious enjoyment of what we see. The very authenticity of the footage underscores this dilemma – if *C'était un rendezvous* were a fictional movie, we could then relax in the secure knowledge that no one was being endangered, but the combination of cinema-quality imagery with an attenuated everyday realism makes viewing such scenes at once addictive and disturbing. Even Lelouch seems to feel this way, and in a recent interview he appears ashamed of his actions, regarding the film as a selfish and immoral act.[20]

In this context it in unsurprising that, apart from viewing the film itself, much of the interest around *C'était un rendezvous* concerns how it was made and received. Several rumours have persisted, including Lelouch being arrested following the initial screening in 1976, that the filming used a Ferrari 275GTB with a camera mounted gyroscopically on its front grille, and that a Formula 1 racer performed the actual driving. In fact, the car was a Mercedes 450SEL, the camera – loaded with film stock left over from Lelouch's *Si c'était à Refaire* (1976) – was a wide-angled Eclair Cameflex on a conventional

mount, the driver was Lelouch was himself, and a Ferrari (Lelouch's own 275GTB) was indeed deployed – but only for the soundtrack added during post-production. Many of these clarifications are now well known, diffusing the considerable aura around a film that for many years was viewed only through private screenings and illicit video copies. Nonetheless, the interlocked three-way reaction which many have to the film – admiration for the authentic speed and reality, fascination through hypnotic immersal and reprehension at the risk-taking and danger to others – remains as strong as ever, and this is no doubt why *C'était un rendezvous* continues to maintain its reputation as one of the most compelling of all driving films.

Moreover, many have recreated *C'était un rendezvous* in their own terms. For example, in the short *The Fast and the Famous* (Jeremy Hart, 2009), American chat show host and car enthusiast Jay Leno is inspired by Lelouch's film to take a Mercedes SLS AMG on an early morning search for the 'hidden racetrack' within Los Angeles. Other projects inspired by Lelouch's film include the *Getaway in Stockholm* series and *The Run* (John Bruno, 2003), a promotional DVD wherein a Nissan 350Z undertakes a six-minute dash through cobbled Prague to rendezvous with a woman, as well as numerous television pro-grammes, such as the UK's *Fifth Gear*, which in 2007 retraced the Paris run using a small Citroën and front-mounted camera. Earlier that year, rock band Snow Patrol used extensive footage from *C'était un rendezvous* for their video to 'Open Your Eyes', where the otherworldly quality of Lelouch's trajectory comes to the fore. Such depictions help to increase awareness of films like *C'était un rendezvous* – car enthusiast Internet forums, for example, frequently refer to it – but in these later versions the outright transgression seen

in the original is pushed back, and indeed many copyists explicitly announce that, unlike Lelouch's film, all possible risks have been removed, professional drivers employed and authorities informed. Instead, therefore, it is still the original *C'était un rendezvous* and other vérité films like the *Megalopolis Expressway Trial* series which best capture the complex character of transgressive driving, providing an experience which is at once exhilarating, compelling and disturbing.

Chase

Of all filmic depictions of driving, the car chase is undoubtedly the most distinctive means of conveying drama and thrills. Indeed, the reputations of *The French Connection* and *Bullitt* are today dominated by their chase sequences, while other films, *Ronin* and *Gone in 60 Seconds* for example, are constructed almost entirely of chases (the latter includes a single car chase lasting 34 minutes, the longest in movie history). And although some might see such car chases as offering little more than surface drama, these scenes are often deeper explorations of many different themes, subjects and meanings.

Humour and Immersal

One prevalent genre of car chase is based on humour, as is particularly evident in innumerable pre-war Keystone Kop movies and other Mack Sennett productions, such as *Lizzies of the Field* (Del Lord, 1924), as

well as in light-hearted post-war movies as diverse as *Doctor in the House*, *Smokey and the Bandit* (Hal Needham, 1977), *Convoy* (Sam Peckinpah, 1978) and *Dukes of Hazzard* (Jay Chandrasekhar, 2005). Although the chase's unique action is exploited here primarily to generate laughter, it also generates implicit social critique – upper-class pomposity, working-class self-protectionism, middle-class priggishness, police bureaucracy, criminal immorality, environ-mentalist self-righteousness and politicians' double-standards are all frequently addressed. Hence in *Convoy*, *Smokey and the Bandit* and the *Dukes of Hazzard* we see the police force's asinine stupidity counterposed against the 'good' outlaw driver, who uses a speeding vehicle, CB radio and wit to invoke the wild rebel spirit of the American South, refusing to yield to the dominance of the Union, while simultaneously raising a bellyful of laughs.[21]

Of particular interest here are films that immerse the viewer in the chase action. Movies as diverse as the live-action *Dirty Mary Crazy Larry*, *Death Proof* and *The Fast and the Furious* series, as well as animation-dependent films like *Tron* and *Speed Racer*, all do this by creating a different world within which the viewer rides along. Other movies go further, providing a heightened sense of the viewer somehow participating in the high-speed events. This occurs, for example in the high-speed action of *Drive* and in one of this film's most inspirational sources, the car chase in *Bullitt* (see below) where Arriflex cameras allow the viewer to sit up front inside the speeding cars. Similarly, the original *Gone in 60 Seconds* of 1974 provides an equally visceral sense of vibrating, real-world authenticity. Such thrills are not confined to more recent movies. For example, one interwar film, *The Crowd Roars* (Howard Hawks, 1932), combines

onboard and external views, jostling drivers, sliding cars, dirt-filled air, heavy vibration and blurred vision to convey the dynamic and reckless nature of early motor-racing. Two decades later, *Checkpoint* (Ralph Thomas, 1955) also depicted high-speed action in a similarly successful manner. Incorporating footage from the 1956 Mille Miglia sports, run along Italian roads between Brescia and Rome, the racing scenes here are also a kind of car chase, as industrial spy and murderer O'Donovan (Stanley Baxter) escapes in an Aston Martin Lagonda. The charging and jostling field of red and green racers is shown as a vibrant composition of saturated colours, dynamic blurs and constant vibrations, and the juxtaposition of onboard and tracking shots evokes an authentic sense of what it was like to propel a sports car through 1950s Italy.

Character and Expertise

A notable feature of nearly all chase sequences is the way they emphasize qualities of fortitude, self-reliance and resourceful invention, as is evident from early films such as *A Beast at Bay* (D. W. Griffith, 1912), *The Fast and the Furious* and *The Great Escape* (John Sturges, 1963), and from *White Lightning* to *The Bourne Identity* (Doug Liman, 2002).

A particularly recurrent theme in this equation between driving style and character within car chases is the way police expertise is portrayed. An early version occurs within the social realism of *The Blue Lamp*, where the police are society's moral guardians, upholding decency against haphazard instances of crime committed by a few desperate youngsters. At the beginning of *The Blue Lamp* (Basil

Dearden, 1950), after an announcement that the film is dedicated to the whole 'Police Service of Britain', the imperious tones of a high court judge resonate out. 'I have no doubt', the judge intones, 'that one of the best preventives of crime is the regular uniformed police officer on the beat.' Other early scenes show local bobbies dealing considerately with cheeky traders, cheery drunks, lost children and stray dogs. Given this explicit ideological setting, it is unsurprising that, in one of the first major car chases in British cinema, the police always have the upper hand. While murderer Tom Riley (Dirk Bogarde) and accomplice Spud (Patric Doonan) become increasingly demonic as they steer their Buick coupe through west London, the authorities are calm and collected. Using clear observations and studied radio communication – handwritten notes are even taken while in pursuit – the police are the epitome of responsible and systematic law enforcement. When a group of uniformed schoolgirls foolishly walk out in front of a chasing police car, despite having just recoiled from the speeding Buick, the teacher screams theatrically while, in sharp contrast, the police driver simply brakes hard to an undramatic halt. Variously aided in their search by ragamuffin children and other members of the public, and given words of support from the same street traders whose life they occasionally make difficult, the police are even joined in the final hunt for Riley by figures from the criminal underworld. As a result, and unlike many other car chases, this episode in *The Blue Lamp* is less an immersion in thrills, adrenaline or fear as a comforting reminder that the audience can always rely on – and should always give support to – the systematic and considerate police. This is the car chase as a social reminder, psychological reassurance and ideological instruction.

The driving competence of *The Blue Lamp* is picked up by many subsequent depictions of professional drivers, notably in the near wordless 'The Driver' (Ryan O'Neal) in *The Driver*, the precision of street racer Takashi (Brian Tee) in *The Fast and the Furious: Tokyo Drift*, and the expert manoeuvres of Jason Bourne (Matt Damon) in *The Bourne Identity* (Doug Liman, 2002), Josselin Beaumont (Jean-Paul Belmondo) in *Le Professionel* (Georges Lautner, 1981) and the anonymous driver (Ryan Gosling) in *Drive*.

A manic Popeye Doyle. *The French Connection* (William Friedkin, 1971).

From the early 1970s onwards, however, the police have not always been portrayed as adept and reliable professionals. In particular *The French Connection* (William Friedkin, 1971) provides one of film history's wildest chases when narcotics detective Jimmy 'Popeye' Doyle (Gene Hackman) hurtles underneath a New York train track after a drugs gunman. Driving a commandeered 1971 Pontiac LeMans, Doyle speeds through intersections, swerves through oncoming traffic, hits a car and a truck and barely avoids a terrified mother and baby. Thrilling and absorbing in its graphic reality, the sequence dynamically demonstrates Doyle's determined

yet irresponsible approach to his job. Nearly killing a woman, child and numerous others evidently matters less to Doyle than getting his man, and his maniacal state is further heightened by the way he constantly blares the Pontiac's horn, by his linear trajectory underneath the straight-line train track, and by the flickering high-contrast lighting penetrating down onto his face and windscreen. At once likeable and bigoted, dedicated and overzealous, dependable and alcoholic, Doyle's behaviour in this chase sequence underlines the qualities of a complex anti-hero, someone whose manic drive creates all manner of chaos in his and other people's lives.

Perhaps the most sophisticated use of an extended car chase as a demonstration of complex character behaviour came three years before *The French Connection*, in the combination of a dark 'Highland Green' 1968 Ford Mustang GT 390 CID Fastback, detective Frank Bullitt (Steve McQueen) and the streets of San Francisco in *Bullitt*. The setting is introduced right after the title sequence, when a Sunshine Cab skims over the city's uniquely undulating topography, while Bullitt's adept driving talents are subtly introduced when he parallel parks the Mustang with deft ease. Midway through the film, the 11-minute car chase builds slowly, beginning when Bullitt notices two hitmen parked up in a sinister black Dodge Charger R/T Magnum. As the hitmen warily track the detective, the mood is tense but calm, while a battle of wits gradually intensifies. The chase imagery, as with Yates's earlier *Robbery*, is overtly matter of fact, showing real streets replete with everyday vehicles, pedestrians, crossings and inclines. Suddenly, however, in one of cinema's great moments, Bullitt's Mustang appears in the rearview mirror of the hitmen's Charger,

and the roles are now reversed. Lightweight Arriflex cameras allow for a great variety of unusual shots – including details of the drivers' faces and the clipping-in of a seatbelt – all of which announce that the real action is to begin. As the hitmen suddenly turn left, the distinctive bass and saxophones of Lalo Schifrin's jazzy score abruptly stop, and we are left with only the distinctive roar of the Ford and Dodge as the chase takes off. As the cars surge around the brows, descents, dips and corners of San Francisco, all of what we now think of as the standard elements of the car chase make an appearance: dramatic jumps, fast turns, fierce acceleration, near misses, false turns, jolting bumps, squealing tyres and roaring engines. The effect, as with all good car chases, is compelling and thrilling, as we are sucked into a captivating dynamic.

Fast-moving automobile action as sound and vision is supplied in abundance, but why have so many cited *Bullitt*'s as the greatest of all movie car chases?[22] The distinctive soundtrack, rumbling cars and Billy Fraker's inventive cinematography (including retina-detaching vibrations and other visceral feeds from numerous car-mounted cameras) are worth noting, but three other factors are particularly important. First, the city itself provides much of the drama, with San Francisco's hills creating not only a menacing terrain around which Bullitt and the hitmen slowly stalk, and then a pulsating roller coaster as they accelerate fiercely, but also dramatically vertiginous views; at times, the Mustang and Charger seem to be launched into the cityscape and bay below. The city too, then, is an active participant in the chase. Second, for all the undoubted thrills and skills on display, this is a chase of psychology as much as of action, where tension and determination as well as gasoline and v8s propel the

Frank Bullitt's Ford Mustang appears in the rearview mirror. *Bullitt* (Peter Yates 1968).

vehicles onward. The dark professionalism of the mysteriously wordless hitmen, flipping from deadly intent to resolute escape when Bullitt emerges from behind, adds to the sense of this being a battle of minds and tactics as well as of cars and power. Third, and most importantly, Bullitt's deadpan cool – combining dispassionate resolve with a no-bullshit attitude and expert skills – underpins the entire chase. Unruffled when he first spies his assailants, composed when he turns the tables to slowly track them, and equally imperturbable when chasing the Charger out of San Francisco, Bullitt epitomizes masculine determination, resolute focus and almost nonchalant control. In contrast to the Popeye Doyle's lunatic pursuit in *The French Connection*, Frank Bullitt is equally relentless but never steps beyond the limits of his own driving ability or mental

capacity. When a motorbike is sent sliding by the hitmen's Charger, Bullitt not only spears off-road to avoid further danger but checks the biker is okay before rejoining the chase. Even violence – standard fare in most chases – is not a first option, and only after Bullitt chases the mobsters onto the open roads is a gun used for the first time, and even then it is not by Bullitt himself. Nonetheless, the detective is still prepared to take extreme measures when necessary, and the chase ends when he barges the hitmen at high speed, launching their Charger into a gas station where it explodes. As the two hitmen are strewn unconscious and burning inside the upturned wreckage, there is no display of emotion or drama from Bullitt, who simply observes the gruesome double death in a plain and perfunctory manner.

Bullitt's character is, however, even more complex than this might suggest. One danger of the car chase is that it may operate as standalone drama, isolated from the narrative. With *Bullitt*, however, the car chase, despite being a dramatic addition to Robert L. Pike's original novel *Mute Witness*, is undoubtedly an integral part of the movie. Unlike the relatively simplistic Popeye Doyle in *The French Connection*, Frank Bullitt is ambiguous and difficult to understand, and the chase sequence is hence an essential part of how his complex character is revealed and developed. An informally dressed working man who spends his time investigating the dirty world of crime, someone who buys TV dinners and speaks infrequently, Bullitt is nonetheless at ease in sophisticated social settings and with his exotic girlfriend Cathy (Jacqueline Bisset). Unlike his nemesis, the besuited politician Walter Chalmers (Robert Vaughn), who wishes to incarcerate members of the mob primarily to enhance his own career,

Bullitt is concerned less with courtroom victories than with individual people, fellow colleagues and, above all, discovering the truth behind a murder. The silent, skilful and measured air with which Bullitt propels his glamorous Mustang around San Francisco is then, ultimately, a demonstration of his difference to Chalmers in style and attitude, being not slick, strategic or political but cool, active and self-confident. The sequence allows the audience to side with Bullitt and not Chalmers, the chase's kinetic intensity giving visceral and dynamic form to his ethical stance. Here, we find ourselves participating in a critique of politics and policing – siding with Bullitt's world-view, involving action rather than words, intervention rather than manipulation, personal style rather than formulaic codes, and searching for immediate truth rather than distant victory.[23]

It is also worth noting one further aspect of the *Bullitt* car chase, and that is its immediate and enduring reputation. While the whole film was well received in 1968, the car chase particularly caught the public's attention, and so was used extensively in posters and other promotional material. The widely publicized fact that McQueen did nearly all his own driving during the chase (although it later emerged that stuntmen Loren Janes and Bud Edkins largely stood in for McQueen,[24] while the Dodge was driven by stuntman Bill Hickman, who also played one of the hitmen) added to the immediate impact, as did McQueen's reputation as a committed motorcycle and car enthusiast. 'I'm not sure', considered McQueen, 'whether I'm an actor who races or a racer who acts.'[25] Yet more publicity for the chase came when Frank P. Keller's editing won an Oscar. Constantly held up as the very best chase sequence, and minutely studied for all manner of details and inconsistencies

(a Charger hubcap is repeatedly knocked off and then magically reappears, while the same green VW Beetle is viewed on at least four separate occasions), the sequence is particularly admired by car enthusiasts, and today specialist websites such as The Bullitt and the International Mustang Bullitt Owners Club provide inordinate amounts of information concerning *Bullitt* rallies and other events, how the sequence was made, its cars and how to create a replica.[26] *Bullitt* memorabilia as innumerable models, slot cars, toys, clothing and so forth is also widely available. In 1997, some seventeen years after McQueen's death, Ford, working with advertising agency Young & Rubicam and director Paul Street, made a highly sophisticated commercial for its new Puma sports coupe in which new filming combines with cleverly manipulated footage from the original *Bullitt* to show McQueen/Bullitt apparently driving the Puma around San Francisco, while accompanied by the film's distinctive original music. In 2008 Ford also launched a new 'Bullitt' version of its fifth generation Mustang, complete with Highland Green paintwork, Bullitt-logo fuel cap and other references to the 1968 car. As with the Mini chase sequences in the two versions of *The Italian Job*, the car chase in *Bullitt* has now passed firmly over into mass public consciousness, where it is still being re-promoted and re-experienced in innumerable ways.

Cities and Streets

An intriguing facet of the movie car chase is how it suggests a different mapping of cities and their streets. Particularly interesting here is *White Heat* (Raoul Walsh, 1948), in which a police chase

Norson heads through an alien New York. *Side Street* (Anthony Mann, 1950).

explicitly disorientates the viewer among the topography of Los Angeles.[27] Even more sophisticated is another film noir, *Side Street* (Anthony Mann, 1950), where the police pursue guilt-ridden opportunist thief Joe Norson and his murderous assailant George Garsell around New York's Wall Street district. Overhead shots disclose a labyrinth of empty streets and side-alleys, while ground-level views convey claustrophobia and impending capture. The overall effect renders New York for Norson and Garsell a place of alien brutality, a city truly knowable only by the police and their systematic technologies of coordinated radio and automobile response. While Garsell is shot dead, the repentant Norson – 'weak like some of us, but foolish like most of us' – is recuperated by this system, and, as he is wheeled away in an ambulance, a final voiceover announces that

'he's going to be all right'. Three years earlier, *The Naked City* (Jules Dassein, 1947), the first crime film to use extensive location shooting, mapped New York through telephones and police networks,[28] and here *Side Street*, one of the very first films to include a modern set-piece car chase, extends the same logic to automotive technology and mobility. Consequently, through its car chase *Side Street* represents the dangerous and unruly life that the modern city delivers to its residents, while, by contrast, the police's control of that same chase underlines their ability to maintain conditions of safety, morality and behaviour. If the city for its everyday citizens is unmappable and untamed, then for the authorities it is a place to be understood and secured. We as audience thus come to know the city through the same logic, as irrational and wild when encountered through immediate experience, but as coherent and protective when comprehended through the eyes of the police, film and other modern technologies.

By contrast, a very different city is presented in many other car chases. In the exhilarating final chase within *Ronin* (John Frankenheimer, 1998) Paris loses the mesmeric otherworldliness evoked by *C'était un rendezvous*, becoming a forbidding and inescapable labyrinth of narrow streets, dark tunnels and dense traffic, fabricated from hard tarmac, concrete and metal, and wherein collisions and explosions suddenly occur. At one stage Deidre, Seamus and Gregor in their 1991 BMW 535i are chased by Sam and Vincent in a 1996 Peugeot 406 through the dimly lit Champerret Tunnel (eerily similar to the Pont de l'Alma underpass where Princess Diana died one year earlier), drilling through oncoming traffic, and violently battering and shooting their way into the daylight.

Returning to New York, the 12-minute car chase in *The Seven-Ups* (Philip D'Antoni, 1973) is a cinema classic, and shows renegade policeman Buddy Manucci (Roy Scheider) in a 1973 Pontiac Ventura Spring chasing two police-killers in a 1973 Pontiac Grand Ville around Upper Manhattan and across the George Washington Bridge. The cars surge over pavements, through red lights and across intersections, weaving through traffic and hitting parked cars in a highly realistic New York replete with crowded pavements, pressing buildings, blaring horns, pot-holes and playing kids. The use of extensive low-down, windscreen and tracking shots, as well as glassy reflections of city architecture, at once increases frenzied motion and brings the grainy urban fabric right into the action. *The Seven-Ups* thus depicts a very different New York to *Side Street*, one that is no longer systematically controlled by the police at a distance, and now a place of hands-on entanglements, fast-moving events and gritty exploits. Above all, it is a place where things go wrong as often as they go right. Indeed, at the end of the chase, Manucci submarines his Pontiac under the rear of a stationary truck. Improbably avoiding serious injury, his deeply silent and shocked manner, blowing hard while walking away from the roof-less wreckage, nevertheless shows that Manucci has taken on all New York has to offer, and has very nearly paid the ultimate price. The city here is multifarious and unforgiving, and not to be messed with lightly.

Crash

Manucci's near-fatal crash in *The Seven-Ups* is a reminder that car chases, races and many other forms of cinematic driving often end

in a serious accident. These terminal events are not confined to the movie screen, for car crashes are unfortunately a common occurrence in modern life. Sometimes it is high-profile celebrities who are killed. Over the last century, dancer Isadora Duncan, film stars James Dean and Jayne Mansfield, military general George Patton, musicians Carl Perkins, Eddie Cochran and Marc Bolan, royalty Diana, Princess of Wales and Princess Grace of Monaco, writer Nathaniel West, painter Jackson Pollock, photographer Helmut Newton and philosopher Albert Camus all met their deaths while travelling in automobiles. Such famous events are, of course, only the tip of the iceberg, and everyday accidents occur in enormous numbers. In 1906–7, over 90 per cent of the 2,000 cars in Berlin were involved in an accident,[29] and in early 1920s America one motorist in seven was involved *every year* in an accident resulting in injury or death.[30] Today, more than 1.2 million people die on the world's roads annually, along with 20–50 million non-fatal injuries.[31] Public interest in such incidents is also immense, from media-fuelled fascination with celebrity deaths to low-key local press reporting of neighbourhood accidents, community concerns with driving conditions and consumer interest in car safety.

This widespread fascination is further deepened by filmic depictions of automobile crashes. And although the car crash can often be a somewhat prosaic filmic device – simply creating narrative change, providing humour or signifying curious goings-on – it may also have a complexity of role, depth of meaning and magnitude of impact that far exceed any other portrayal of driving.

Internal Worlds

Given the fatalistic attraction many people have towards car crashes, some very early films unsurprisingly delve into the internal world and aftermath of the crash's dynamic and sudden forces. While *The Automobile Accident* (Louis and Auguste Lumière, *c.* 1903–5) humorously shows the fragmentation of a pedestrian's body, and the *Explosion of a Motor Car* similarly portrays a policeman trying to reassemble the body parts of four automobilists after being been blown skyward, another Cecil Hepworth film from 1900 is ultimately less comical in nature. The 42 seconds of *How It Feels to Be Run Over* shows the perspective of a pedestrian/camera looking down a country road. As a veering car approaches, the driver and passengers gesticulate at the viewer/audience to move aside. The car then heads straight into the camera, and the screen turns black. Simple and direct, *How It Feels to Be Run Over* portrays both seeing a car approach and the shock of a sudden impact. The actual space and time of the crash, wherein the pedestrian is run over, is signified by only the black screen and some handwritten symbols – '?!!!?! Oh! Mother will be pleased' – thus comforting the audience that it is the on-screen victim, and not themselves, who has been struck. However, the same audience's very recent filmic participation in a crash is still present through immediate memory, and is further preserved by the very abruptness of the minimal black screen. The same audience therefore – in their nervous laughter – realizes that they too will have to gamble on avoiding an accident when encountering such new technology themselves. So although the crash here is not tragic – being devoid of trauma or suffering – there is a serious message: people must take risks if they are to take advantage of the world's newly experiences and pleasures.[32]

Later films portray participation in car crashes in very different ways, notably *Death Proof*, whose fascination with the space and time during a crash is detailed and horrific. When 'Stuntman' Mike heads his muscular Chevrolet Nova into the small Honda Civic of Arlene and three other women, the resulting carnage is a grotesque maelstrom of glass, clothes, limbs and car parts. At once extraordinarily explicit and gorily vivid – with high-contrast lighting picking out splintering glass, bright blood and dark shiny metal against a night-time background – the effect is of being inside a tornado from hell, where all materials and objects, whether living or automobile, are dismembered with indiscriminate ferocity. An equally shocking if not gory crash comes in *Dirty Mary Crazy Larry*, when the entire movie – essentially one long car chase – is abruptly concluded as the bright green Dodge Charger Hemi 440 of Mary, Larry and Deke ploughs into the side of a train. Less than four seconds in duration, from initial panicked reaction to explosive impact, five simple shots show in turn terrified expressions, the Dodge aiming at the train, the impact and then two differing views of the car exploding beside the railtrack. Without the extended horror or visceral complexity of *Death Proof*, the crash is shown as it must arise for many victims: wholly unexpected and almost instantaneous. As Mary, Larry and

Arlene's face is torn off by a wheel. *Death Proof* (Quentin Tarantino, 2007).

Deke lie burning in the wreckage, the film credits roll. And so, in dwelling over the burning and not the crash, the conclusion of *Dirty Mary Crazy Larry* emphasizes the finality of what has occurred. Ultimately, the car crash here is at once a positive and a negative, an underscoring of the vivacious life that has been lived with spirit and joy, and is now gone.

As the abrupt ending of *Dirty Mary Crazy Larry* suggests, if speed is to continue producing those thrilling and transcendental experiences, then its effects must never become routinized. The crash offers a way out of this immersal in speed, ending our ever-increasing addiction with its hallucinatory properties.[33] On the other hand, the crash itself also offers addictive properties, and many films thus emphasize the theatrical nature of the car crash in a variety of unexpected ways. Most notable here is the original

The crash as glorious repetition. *Gone in 60 Seconds* (H. B. Halicki, 1974).

Gone in 60 Seconds, where the concluding 34-minute sequence involving Maindrian Pace (H. B. 'Toby' Halicki) fleeing the police in his famous yellow 'Eleanor', a 1973 Ford Mustang Mach 1, is a veritable festival of car crashes. Vehicles are subjected to innumerable sideswipes, bumps, rear-ends and spins, serving up a visual assault of high-speed trajectories and accidents – all of which justifies a reputation as the most relentless of car crash movies, one which stays almost entirely within the internal world of the car crash itself, and where little else matters.[34]

 If *Gone in 60 Seconds* resides comfortably within the car crash – indeed, revelling in its glorious repetition – then other films are more circumspect about depictions of blood and death. How is it that we can be so fascinated by such accidents, when the result, evident from mutilated corpses strewn in the wreckage, is clearly the awful actuality of life now ended? One answer comes from motor racing films, where the crash is typically depicted as a thrill gained vicariously by spectators. As driver Joe Greer (James Cagney) describes racing fans in *The Crowd Roars* (Howard Hawks, 1932),

'Is this what you want?' *Grand Prix* (John Frankenheimer, 1966).

'they're watching for wrecks and roaring for blood', just as the movie accepts this quality in its own audience when showing, for example, the fiery death of Greer's colleague in a powerful combination of dramatic views and documentary-style footage. A similar conflation of deadpan recording, theatricality and critical comment occurs in *Grand Prix* when complex depictions of accidents are complemented by considerations of physiological and emotional aftermath. Hence we ride with Scott Stoddard and Pete Aron (James Garner) as they plunge headlong into the walls and harbour at Monaco, but are also shown sober reportage of Stoddard being cut from the wreckage, as well as reflective scenes of Aron observing the damaged car and of Stoddard later struggling to return to racing. More theatrically, after Sarti is killed at Monza, his lover Louise, with the Ferrari driver's red blood on her palms, screams hysterically 'Is this what you want?' The camera takes Louise's eye view, and we look through her smeared hands at crowding photographers, as if we are demanding this question not only of spectators and media but also of the film-makers and our-selves as audience. We are no longer allowed to stand detached from the car crash but are brought within it, and are asked to consider our own role in its production, representation and dissemination.

Similar comments on the immediate spectacle and mediated voyeurism of the car crash are made in films such as *Vanishing Point*, when Kowalski's explosive demise is watched by CBS media and an expectant crowd of locals, while the immediate aftermath is wandered over by both spectators and camera. But the most complex consideration of crash voyeurism in film is provided by the controversial *Crash* (David Cronenberg, 1996), an adaptation of J. G. Ballard's novel of 1973.

Crash centres on Toronto film producer James Ballard (James Spader) and his wife Catherine (Deborah Kara Unger), who, after James is involved in a serious crash, reinvigorate their dysfunctional relationship through symphorophiliac arousal by car wrecks, scars, injuries, videos, photographs, reenactments or even by being in crashes themselves. Voyeuristically, *Crash* is infused with depictions of people watching others while crashing, as when James attends a recreation of the death of James Dean staged by crash obsessive Vaughan (Elias Koteas). After a melodramatic introduction before applauding spectators, Vaughan and two assistants reenact Dean's fatality in precise detail, complete with accurate replicas of the film star's 'Little Bastard' Porsche 550 Spyder and the oncoming 1950 Ford Tutor. The crash itself is sudden, followed by the camera lingering over the bodies of the participants, with Vaughan carefully explaining the injuries sustained by the original victims. In a later scene, while randomly sideswiping barriers with a Lincoln Continental convertible similar to the one in which J. F. Kennedy died, Vaughan announces his desire to drive a 'crash car with a history' such as Albert Camus' Facel Vega, Nathaniel West's station wagon or Grace Kelly's Rover 3500. Shortly afterwards, Vaughan, James and Catherine arrive upon a highway accident, which they realize is a re-staging of Jayne Mansfield's fatal crash, complete with her famously scalped head and dead dog, and which has been created by one of Vaughan's earlier accomplices, Colin Seagrave (Peter MacNeill). Unconcerned with Seagrave's death, other than that he had undertaken the reenactment alone ('you couldn't wait for me?!'), Vaughan and the others wander around this 'work of art' in a hyper-fascinated reverie. They are particularly drawn to the presence of the

Reenactment of
the death of
Jayne Mansfield.
Crash (David
Cronenberg, 1996).

victims, mimicking their postures, photographing everything and
even recording Catherine among the wreckage.

Through such psychological immersion and fixated analysis,
Crash has none of the smash extravaganza of *Death Proof* and
Gone in 60 Seconds, still less the emotional concerns of *Grand Prix*.
Where Godard's *Alphaville, Pierrot le fou, Week End* (1967) and
Contempt (*Le Mépris*, 1963) are detached from violence through
cinematic stylization, *Crash* uses its characters' reactions to main-
tain a curiously flat atmosphere. The result is an absence of deep
trauma or pain, whether physical or emotional.[35] Instead, just as
James and Catherine are removed from their actions, as if none
of them are of their own making, so we as audience are kept away
from any emotional engagement. In this sense the effect is similar
to watching amateur Abraham Zapruder's sequences of Kennedy's
assassination, where the fascination with seeing a real death is flat-
tened by the silent film stock's evident artificiality (that is, we are
not in fact directly witnessing Kennedy's death, but instead viewing
a jerky and speckled recording of that event) and by its repeated
reshowings on television, in other movies and on the Internet. As
for the Zapruder sequence, with *Crash*, we as audience are voyeurs,

seeing events unfold in graphic detail but always kept apart, so that we observe a film about accidents that are themselves observed and mediated. This is not the crash as direct experience or immersal, but as a complex condition of being, where the crash is apparently presented as a vicarious thrill but is actually a condition of watching, recording and rewatching. Indeed, in *Crash* even death itself has to be mediated – as with Seagrave's recreation of Mansfield's collision – or practiced, as with the James and Catherine's own accident restagings with which the film concludes. As Catherine lies next to her upturned Mazda MX5 and declares herself unhurt, James intones urgently, 'Maybe the next one, darling, maybe the next one.' If there is any direct thrill to be had here, then it can only emerge through this kind of planned, staged and voyeuristic event.

External Worlds

If *Crash* particularly explores personal voyeurism, then other films emphasize a greater social dimension to the crash, connecting to the external world beyond the car itself. Very often, this involves different versions of masculinity, such as male brotherhood (*They Drive by Night*), rivalry (*They Live by Night*), resilience (*Thunder Road, Winning, Collateral, The World's Fastest Indian*), revenge (*The California Kid*), or a general propensity for violence (*Point Blank, The Ipcress File, Get Carter*). Alternatively, social themes in the crash range from morality (*La Glace à trois faces, Mad Max*) to the end of a personal era (*Driving Miss Daisy, Ferris Bueller's Day Off*), tense relationships (*Wild Strawberries*), rejection (*Open Your Eyes*), social difference (*Changing Lanes*), intolerance (*Bonnie and*

Clyde, Easy Rider), indifference (*Two-Lane Blacktop*) or the threat of advanced technology (*I, Robot*).

One notable connotation of the car crash is that it signifies a general social or even global condition. Bruce Conner's avant-garde *A MOVIE* (1958) thus posits high-speed crashes as being part of a larger modern construct of technology, war, disaster, sex and death, while *Jízda* (Jan Sverák, 1994) uses Ana's fatal car crash after an extended lazy summer journey to symbolize the end of carefree post-revolutionary Czechoslovakia. The bizarre *The Cars that Ate Paris* (Peter Weir, 1974) shows automobile crashes as lying at the very centre of a community, including its economy, social rationale and endemic violence, where drivers become absorbed into their cars' murderous and demonic behaviour, while a different automobile-centred society is provided in another Australian film, *Mad Max 2: Road Warrior* (George Miller, 1981). Even more theatrically, in the dystopian fascist America of *Death Race 2000* (Paul Bartel, 1975), demand for bloody entertainment is met by the televized spectacle of the Annual Transcontinental Road Race, where drivers win according to their speed and number of innocent pedestrians they strike. This gruesome contest is 'the symbol of everything we hold dear' and 'our American way of life', gushes Junior Bruce, a slick TV presenter. 'Sure it's violent. But that's the way we love it. Violent, violent, violent!' *Crash*, too, has an eye on societal context, observing that the car crash is a rare instance of death penetrating through capitalism's veneer of glossy consumerism, and thus develops sub-themes concerning twentieth-century dependence on the automobile, product obsolescence and social indifference.[36] As with many of Ballard's stories, this is a premonition of an upcoming world: James

and fellow accident victim Helen Remington (Holly Hunter) agree that Toronto traffic seems to be gathering for some kind of special yet incomprehensible reason, while James and Catherine later watch the streaming highway from their apartment balcony, searching for signs of a near future about to arrive.

Political connotations to the car crash are particularly evident in Godard's *Pierrot le fou* and *Week End*, which both depict wreckages as highly stylized tableaux, where mannequin-like bodies, grotesquely posed and covered in over-bright blood, are studiously ignored by uncaring passers-by. In *Pierrot le fou* Ferdinand (Jean-Paul Belmondo) and Marianne (Anna Karina) come across a surreal accident where a car has apparently flown off an isolated stretch of elevated autoroute. A man lies slumped amidst the wreckage and a woman stares through the improbable frame of a car window, yet Ferdinand and Marianne dance around unconcerned and see only an opportunity to fake their own deaths. In *Week End*, this behaviour is even more extreme, with middle-class Roland (Jean Yanne) and Corinne (Mireille Darc) planning, hoping for, causing, witnessing and overreacting to innumerable accidents. Minor bumps in Paris escalate into fights and gunfire, while once out of the capital in their 1960 Facel Vega Facellia they come across horrific crashes to which their reaction is of pure indifference. 'If only it were Papa and Mama', says Corinne of a collision between a fashionable young couple's Triumph sports car and a local farmer's tractor. Godard here inserts an intertitle declaring this to be 'The Class Struggle'; dressed in brash red shoes, yellow trousers and green sweater, while comically saturated in blood, the girlfriend screams at the 'peasant oik' tractor driver that her now deceased boyfriend 'had the right of way' for 'he was young, handsome, rich' and so 'had the

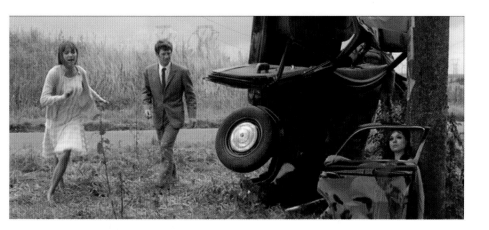

Marianne and Ferdinand see an opportunity to fake their own deaths. *Pierrot le Fou* (Jean-Luc Godard, 1965).

right over fat ones, poor ones, old ones'. Similar scenes abound, as when Corinne and Roland cause a pile-up and she can only shriek for her lost Hermès handbag. As voiceovers, flashbacks, intertitles and other overtly artificial devices make clear, the crash is being used to construct explicitly critical commentary on colonial violence and the contradictions of a 'civilized society'. In both *Pierrot le fou* and *Week End*, the crash is therefore variously symbolic of capitalism's global violence and imperialism, Westerners' indifference to others, desensitization to pain and horror, inability to care, and a contrary propensity to overreact to inconsequential events. The crash can even be read as the wreckage of imperialist capitalism as it approaches collapse, as indicated in *Week End* by Corinne and Roland's journey and their final capture by a hippie community of cannibals.

Moving from Godard's bored adults into a younger life-stage, teenage angst and coming-of-age is yet another recurrent theme among car crashes. For Mic in *Les Tricheurs*, the deliberate collision

of her expensive Jaguar XK140 with a petrol tanker signifies a lack of love and satisfaction in an adolescent post-war France filled with cynical sex and instant gratification – and fulfils her wish to die like James Dean, 'young and at high speed'. This is a particular concern of the 1950s, and pre-eminently of *Rebel Without a Cause* whose exploration of troubled youth crackles with themes of male homo-social friendship, latent homosexual adoration, parent–child alien-ation, developing masculinity, casual violence and weary ennui.

As Jim (James Dean) and Buzz (Corey Allen) share a cigarette just before their famous race and, for Buzz, fatal dash to the cliff edge, Jim asks, 'Why do we do this?' 'Well', Buzz replies, 'you gotta do something.' This scene is based partly on director Ray having read of teenagers playing a head-on game of chicken run on Los Angeles' Mulholland Drive.[37] In *Rebel Without a Cause* this becomes a more theatrical event, with the two men accelerating either side of an exhilarated Judy (Natalie Wood) and down an avenue of headlights formed by the assembled teenagers' cars. The stagelike choreography quickly turns to private and psychological intensity, as Buzz realizes his sleeve is caught on the door-handle, preventing him from bailing out, and then plummeting over the precipice to an explosive death. Unlike the somewhat nostalgic depiction of a drag race crash between John and Falfa in *American Graffiti*, the crash in *Rebel Without a*

Teenage America in trouble, as Buzz tries to bail out. *Rebel Without a Cause* (Nicholas Ray, 1955).

Cause does not signify a relatively painless transition from youth to adulthood, but is far more serious, not just as a tragic event but as an indication of the hopeless depth of teenage angst, dysfunctional relationships and aimlessness. The crash is not a wake-up call, or a moment of passing along to a better world, but an integral part of, and a further descent within, a world bereft of clear meaning or valued emotion. It is also, of course, infamously if not entirely logically connected with James Dean's own automobile death, which took place just 27 days before the u.s. release of *Rebel Without a Cause.*

Suburban American youth and their close relationship to the automobile is explored somewhat differently in John Carpenter's *Christine* (1983). Here the car itself – a candy-red 1958 Plymouth Fury – is a recurrent source of violence, using supernaturally regenerative capabilities and remorseless malevolence to take over its owners and kill others through ingenious and tortuous means.

Christine, the malevolent 1958 Plymouth Fury, tries to choke Leigh to death. *Christine* (John Carpenter, 1983).

Whereas Elliott Silverstein's *Car* (1977) depicts its customized 1971
Lincoln Continental as a demonic threat arriving from outside of
a terrified Utah community, in *Christine* the Plymouth represents
the threat from our inner psyche. Themes of sex, parent–child
antagonism, the Oedipal complex, masculinity, loyalty, revenge,
death and rebirth are all discernible, as the car invokes psychological
invasion as well as physical violence against its new owner, Arnie
(Keith Gordon), his girlfriend, Leigh (Alexandra Paul) and anyone
else who gets in its way.

Material Beauty

The startling impact of the crash scenes in Godard's *Pierrot le fou,
Week End* and *Contempt* is generated from their composition as
balanced painting tableaux, devoid of pain and trauma, where
dislocated objects are possessed of a strange beauty. This fascination
with the crash as being somehow a site of art is, of course, not
confined to Godard, and poets and artists such as Carlos Almaraz,
the Ant Farm Collective, Theo Baart, Jim Dine, Allen Ginsburg,
Edward Kienholz, Robert Longo, Tony Messenger, James Rosenquist,
Dustin Shuler, Wolf Vostell, Andy Warhol and Grant Wood have
all incorporated the crash into their work, with the large-scale
photographs of Dean Rogers's *Death Drive* series (2009) providing
particularly haunting explorations of the actual crash sites of nine
celebrity fatalities.[38]

A sense of mortality, fatality and the mutability of bodies
– whether automobile or human – frequently pervades more
aesthetically oriented filmic depictions of crashes, as with the scene

Material beauty as a Lincoln Continental is slowly crushed. *Goldfinger* (Guy Hamilton, 1964).

in *Death Proof* noted earlier, which revels in gothic splendour as well as material repulsion. Intently menacing rather than gory is a scene from *Goldfinger*, where the gangster Solo is placed in the boot of a Lincoln Continental, and then disposed of at a wrecking yard when the Lincoln is placed into an enormous crushing machine and compacted into a cube. Close-ups show the car's physical body being forcefully rearranged, its crumpled dark metal, splintering chrome and cracking glass allowing us to imagine – but not see – what is also happening to Solo inside. The camera dwells on the fractured angular shapes being produced, while the unyielding might of the hydraulic compressing jacks is emphasized by their robotic movement and boisterous hissing – all of which creates a scene of compelling material beauty but also terrible human truth. In a supernatural reversal of this process, 'Christine', the possessed Plymouth Fury in *Christine*, re-arranges herself after having been

attacked, her battered bodywork, smashed glass and ripped leather eerily bending and healing themselves back into shape. Here, the beauty is a magical transformation, creating from raw materials a living entity where previously there was none.

As to be expected, *Crash* also dwells on the beauty and material matter of the car crash. Initially, the physical minutiae of the car wreckage itself dominates, with Catherine caressing James as he lies in hospital while reading out lurid details of buckled panels, cracked dials, speckled blood, damp carpeting and the smell of blood and oil. This arousal rapidly transforms into more explicit intersections, with James having intercourse with Remington after visiting their mutual crash scene, and then with Gabrielle (Rosanna Arquette), whose legs are sheathed in an elaborate exo-skeleton of steel braces and who offers a vulva-shaped scar for him to penetrate. Catherine, too, is fascinated by the physical impact of crashes upon the body, becoming herself bruised during robust sex with Vaughan, whose scars she kisses, while passing through the crashlike enclosure of an automated car wash. In all of this, the appearance, site, aura and after-effects of accidents work together to invoke a visual and psychological beauty. The participants' sex, if not their love, is intensified through their heady immersal in visual triggers, material stimulation and psychological presence. For Vaughan at least, this is a fundamental 'psychopathology' where he tries to live out the car crash as a 'fertilizing rather than a destructive event' that liberates sexual energy 'with an intensity that's impossible in any other form'. Here, art meets life – and death – in a constructed and considered form: the intersection of materials (car and body) through actions (sex and the crash), in an extremely passionate and highly aesthetic combination.

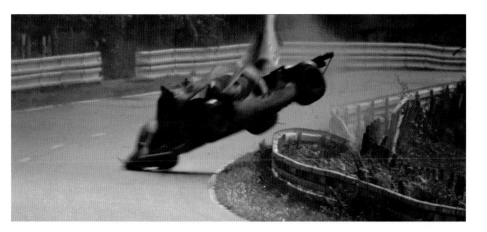

The unfolding intensity of a high speed crash. *Le Mans* (Lee H. Katzin, 1971).

The most explicit exploration of the aesthetics of a crash in motion occurs not with a conventional road accident, but in one of the racing scenes of *Le Mans*. When Delaney swerves to avoid a slower competitor, his Gulf Porsche sideswipes the Armco, losing its left front arch. Veering rightwards, it strikes the Armco again, smashing its windscreen. Having pinballed again across the track, the Porsche strikes the barriers at a less oblique angle, causing it to nearly overturn and its bodywork disintegrate, then hitting the barrier twice more before finally coming to a rest. It is not, however, the first full-speed showing of the ferocious accident that is most significant, but Delaney's immediate re-imagining as he sits immobile – unhurt but shocked – in the driver's seat. In this mesmeric replay we hear the impact's sounds in a highly focused manner, isolated against a near silent background, while slow-motion views similarly disclose the precise angles at which the Porsche strikes the barriers, the patterns of splintering windscreen, the snakelike

contortions of the barriers and, above all, how the bodywork breaks, creases and flies off as if made of cardboard. At one point the entire rear section lifts up like a butterfly's wings and folds into the windscreen before finally detaching and rolling over the Armco. Eventually the Porsche – now missing most of its skin, its engine still running and tyres spinning in smoky fury – comes to a rest head-on into the barriers. This mesmeric sequence closely correlates with real racing drivers' descriptions of their crashes, in which time often seems to stand still and every moment is remembered in graphic detail. As Australian driver Mark Webber recalls his own Le Mans crash in 1999, 'everything was slowed down absolutely; I remember everything that happened in the clearest detail.'[39]

Delaney's accident is a deep immersion within the inner materiality of a car crash, providing a convincing portrayal of a car being methodically dismembered and flayed. It also has under-currents of real trauma: during the filming of *Le Mans*, racing driver David Piper had the rear tyre deflate on his Porsche, causing it to crash and break in half, while he himself later had a lower leg amputated – for which 'sacrifice' Piper was given a special appre-ciation in the credits.[40] Ultimately, however, the Delaney crash sequence is notable primarily for its studious portrayal of a crash as a material collision. Both car and driver are at the mercy of immense and unruly forces, and in the resulting time-space crash the car in particular becomes matter out of sync, where each object and material reacts differently, producing fissures in surfaces, splits within bodies, ruptures across junctions and an uncoordinated chaos of rapidly departing elements. This is not a purely analytic depiction, for there is real beauty in the way the glass cracks and

splinters, the bodywork crumples and twists, the chassis jumps and tilts, the Armco contorts and distorts, and the tyres smoke and spin. Because we know Delaney is unhurt, we focus on the psychological force within his mental state, re-experiencing the crash through the driver as well as through the camera, adding a layer of direct involvement to what is already a complex rearrangement of space, time and materials. The overall effect is the extraordinary sight of a machine being transformed in front of one's eyes, a scene of material beauty as well as of great and unfolding intensity.

Alternative Time

As Delaney's momentary re-imagination of his accident suggests, a distinctive feature of the crash is how it can shift time away from conventional modes of narrative and linearity. For example, complex temporal depictions come in two quite different films, both of which treat time as a central component of their structure. The first is Claude Sautet's *Les Choses de la vie* (1970), later remade by Mark Rydell as *Intersection* (1994). In Sautet's original, Paris architect Pierre Bérard (Michel Piccoli) is fatally injured when spinning his 1959 Alfa Romeo Giuletta Sprint against a pig transporter and another truck at a countryside junction, before overturning and hitting two trees. Thrown clear, Pierre lies twitching but near to death, during which time his past life appears in a series of memories and flashbacks. The opening sequence of *Les Choses de la vie* is particularly intriguing as it starts with the immediate aftermath of the wreck before showing in turn the damaged Alfa, the accident itself and finally the journey to the crash site. Furthermore, the

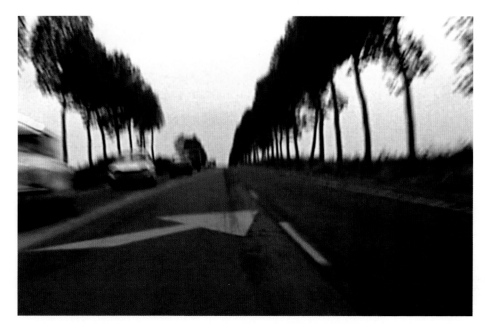

accident and journey are shown in reverse, so that we travel backwards
in space and in time. Subsequent scenes show Pierre's earlier life –
his joyous yet unresolved life with new girlfriend Hélène (Romy
Schneider), as well as his strained relationship with estranged wife
Catherine (Léa Massari) and son Bertrand (Gérard Lartigau) – and
are intercut with occasional flashes backwards/forwards to the crash,
thus adding to a complex layering of time and memory.

 Midway through *Les Choses de la vie* the crash site is revisited,
along with further analysis by other witnesses. At this stage, six differ-
ent kinds of times are all at work: a longer history of remembered time
(episodes from Pierre's life with Hélène and Catherine); immediate

Travelling back-
wards in time and
space at the start
of *Les Choses de la
vie* (Claude Sautet,
1970).

history (events just before the crash); the present (the actual time and space of the crash, portrayed in slow motion as a poetic event); the immediate present-future (aftermath with reactions and analysis, portrayed in a more factual and explanatory manner); the present inserted into the past as future (flashes backwards/forwards to the crash, intercut into scenes of Pierre's earlier life); and an imaginary past/future (Pierre, while being rushed to hospital, dreams of an idyllic rural wedding with Hélène, whose guests disturbingly include not only Catherine but the other drivers involved in his accident). All of this creates an innovative assemblage of times and memories, constructing a powerful sense of social layering, psychological complexity and the aleatory nature of life. Furthermore, the concluding scenes provide one more twist in the plot and temporality as Sautet snaps the movie into an immediate and closing present. After Pierre has died on the operating table, Catherine opens a letter from among Pierre's personal effects and learns of his relationship with Hélène, just as Hélène herself speeds up to the hospital in her white Mini, only to be informed of Pierre's death. As Catherine tears up the letter and throws it away, Pierre dies for her in love as well as in body, and as Hélène quickly leaves the hospital shocked and alone, she fails to fulfil her love for Pierre. Finally, the complex structuring of *Les Choses de la vie* reaches a conclusion in emotion and time, and the film ends.

The other movie to represent time around a crash in a particularly complex manner is *Final Destination 2* (David R. Ellis, 2003). In White Plains, New York, Kimberly Corman (A. J. Cook) has a premonition of a massive accident just before joining Route 23 and refuses to move her 1996 Chevrolet Tahoe suv. While being

questioned by officer Thomas Burke (Michael Landes), a version of her premonition comes true, thus sparing the lives of herself and those still waiting to join the highway. For the remainder of the film, Death stalks those who should have died, dispatching them in a series of grisly accidents, some also involving automobiles. Although apparently straightforward, within this narrative there is a more complex version of time than might at first seem to appear.

First, there is the sophisticated depiction of the multiple vehicle crash itself. This begins with various indications to Kimberley that an accident is imminent, as when 'Highway to Hell' plays on the radio along with news of anniversary of the Flight 180 air crash (from the first *Final Destination* film), a school bus contains boys shouting 'pile up', her Dad calls to say the Chevrolet is leaking transmission

Kimberley has a premonition of a car crash. *Final Destination 2* (David R. Ellis, 2003).

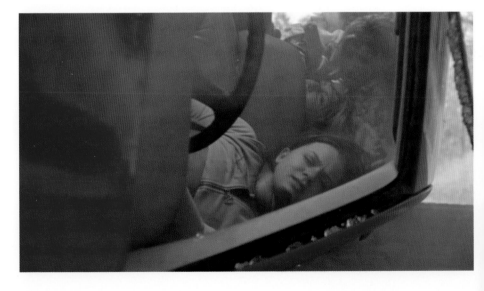

fluid, she nearly sideswipes a lumber truck, a flicked spliff causes a momentary fire on the windscreen of a passing SUV, a small boy strikes toy cars against each other, a policeman spills his coffee and so forth. When the accident actually occurs, it is even more complex than these minor signals suggest. Initially, the lumber truck spills its load and decapitates the policeman and a motorcyclist is crushed against a log, while the SUV whose windscreen had been set on fire somersaults, two other cars explode and the lumber truck continues to weave and shed more of its timber. Kimberley's Chevrolet hits a log and overturns several times, while a teenager is trapped screaming in a fiery 1987 Pontiac Firebird. The vivid violence befits a horror movie, but is also sophisticatedly drawn out in space and time, showing the unfolding duration and variation of the pile-up as well as moments of real pain and terror. The result is an attenuation of different kinds of time – fast and slow, accelerating and deceler-ating, occurring and suspended, immediate and oncoming – along with additional layers of spatial convolution, complex material properties and the fragility of cars and bodies, as well as the sudden-ness, interrelatedness, unavoidability and individuation of events.

Second, despite its overt drama, this massive incident does not actually happen, but is only Kimberley's premonition of a crash in which she and her three companions are going to be involved. Instead, a substitute present is revealed when, as Kimberley stands beside the highway explaining her actions to the disbelieving officer, the offending lumber truck indeed passes by, shedding its load and causing a massive accident. A few moments later, a truck crashes into her Chevrolet, killing her three friends, but leaving unscathed those who are still in their vehicles behind and whose supposedly

imminent deaths Kimberley had foreseen. The complex spectacle of the previous traffic incident is now finally disclosed as indeed a premonition, leaving the audience at once enthralled by the horror of what they have seen – now understood to be a detailed vision rather than an actuality per se, and supplemented by an alternative present and, of course, a consequently different future yet to unfold. Already, therefore, the movie presents a multiple layering of different versions of the immediate past, current present and possible future.

Third, the rest of *Final Destination 2* portrays Death endeavouring to heal this temporal disruption, killing off the erroneous survivors and so restoring the fatalities seen in Kimberley's 'premonition'. Moreover, the ever-diminishing group of survivors are equally determined in their attempts to thwart such a possibility, maintaining their continued existence in the alternative world that Kimberley's premonition and subsequent actions have allowed. The result is a battle between competing versions of past, present and future, where the crash operates as a central hub around which all other events and actions revolve. The spatial, material and temporal complexity within the multiple highway accident is now supplemented by the temporal variations which ensue, as different narratives are alternatively sustained, cut short or brought into collision.

Ultimately, the crash is revealed as a provisional pivot within not only a particular driving experience but within life itself; time, space and social being are all thrown into disarray, doubt and disorder, the car journey and crash within it thus having created not a final destination at all, but only uncertain options, difficult challenges and unknown futures. And so driving in general here, too, emerges not as a route but as an ongoing journey, not as a function but as an

experience, not as a singular quality but as a complex intersection of times, places, speeds, materials, emotions and lives. Through such films, we understand that driving is neither pure physical reality nor virtual representation, but is instead a mediated and provisional possibility, a dynamic act whose exact nature can never be entirely controlled, prescribed or predicted.

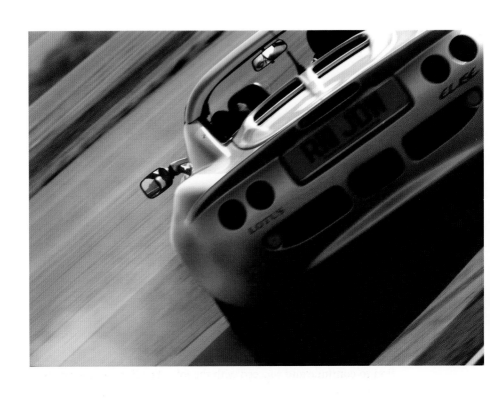

CONCLUSION

To conclude this exploration of filmic driving experiences, it is worth noting one of the most enduring characteristics of the car crash, namely the way it can lead to a rebirth of those involved.[1] Of course, many people in both movies and real life do die in traffic accidents, and the terminal and tragic nature of such occasions should never be underestimated. But is also the case that for many of the cinematic crashes noted in the previous chapter, as with most real-life accidents, many if not all of the participants do survive, and indeed, in film at least, often do so in a manner where they are in some way reborn, re-energized or reconfigured. To cite but a few disparate examples, for Delaney in *Le Mans* and Manucci in *The Seven-Ups*, their horrific crashes lead to a renewed determination to continue and succeed with the jobs. For Robert in *Kings of the Road* (*Im Lauf der Zeit*, Wim Wenders, 1976), the deliberate driving of his vw into a river at the start of the film marks both the end of his old life and the start of a new journey with Bruno. For Maindrian Pace in the 1964 *Gone in 60 Seconds*, every single crash seems to add further to his sense of independence and being alive, and for Vaughan, James, Catherine and the other participants of *Crash* it is sexual arousal as well as some kind of deeper philosophical positioning that are reinvigorated with every wreckage they encounter. Alternatively, for Pelham in *The Man Who Haunted*

A track day driver in a Lotus Elise.

227

Himself, César in *Open Your Eyes* and Kimberley in *Final Destination 2*, the car crash brings with it a curious combination of both death and rebirth where, on the one hand, a certain kind of life is ended but, on the other, a different life is cast anew in a strange yet vital manner.

Delaney immediately after his tumultuous crash. *Le Mans.*

When in *Grand Prix* the F1 driver Pete Aron is asked why he races, he suggests that this is 'maybe to do something that brings you so close to the possibility of death and survive it is to feel life and living so much more intensely'. This highlights an important quality to both high speed and general driving practices: that such experiences can also carry with them the opposite of speed and exhilaration; that is to say, they are inevitably accompanied by, as we have seen, crashes, accidents, damage, injury and even death. Filson Young, for example, spoke of the 'startling, intoxicating, appalling' experience of speed, and how it amounted to a 'shock-ing death-challenging appearance'.[2] Yet it is exactly this kind of challenging and potentially dangerous driving which many find

so compelling both in films and even in real life. A case in point here is the burgeoning market today in 'track day' driving at race circuits around the world, where, under controlled circumstances, drivers take their own cars onto the racetrack in order to drive fast and unfettered by normal road conditions and regulations. The Nurburgring Nordschleife facility in Germany, for example – originally constructed in the 1920s for vehicle testing and club racing – has now gained iconic status as being 'like no other track on earth', where drivers encounter 13 unforgiving miles of undulating straights and 73 mountainous and tree-lined corners, a place which creates 'a feeling you'll never forget and an experience you will want to repeat' and which F1 champion Jackie Stewart once described as 'the ultimate driver challenge'.[3] This seeming motoring nirvana is, however, not exactly child's play; Stewart calls the Nordschleife 'The Green Hell', and between three and twelve fatalities occur there every year. This fact is frequently underlined to drivers; for example, at a recent track day at the Nordschleife, the preliminary track-walk and briefing session included a detailed introduction to some of the track's most unforgiving corners and switchbacks, including the daunting Schwedenkreuz-Aremberg section as a place 'where you really can die'.[4] This was not, of course, an instruction for those present to go off and crash fatally, but conversely that they should, while driving at relatively high speed, try very hard not to damage themselves or their vehicles. What such a statement also implies, therefore, is that the ability to control and avoid such accidents is part of the demanding pleasure of driving. This is one of the reasons why driving is often seen as more satisfying than train journeys, for it brings the driver to the edge of herself or himself.

Like skiing, skateboarding, surfing or other kinds of highly mobile sporting activity, in driving danger is neither denied nor celebrated, but instead is acknowledged and confronted. 'There's always the chance it will all go wrong', explains *Circuit Driver* magazine, and 'deep down that's probably a big part of the reason why we all do track days – driving at the limit only means something if that limit is tangible, if it can bite'.[5]

This does not mean, however, that such dangers are welcomed in themselves. Rather, as Filson Young explains, high-speed driving is the ability 'to meet all these risks smiling, and to turn them into safety', thus concurring with the psychoanalyst Michael Balint's contention that any real 'thrill' is always a combination of fear, pleasure and confident hope.[6] The early racing driver Charles Jarrott, winner of the Circuit des Ardennes race in 1902, acknowledged that the 'spice of danger' certainly added to the fascination of motorsport, but even he had reservations. 'There is a certain amount of sport in it', admitted Jarrott, 'but when in getting up in a race one has to take the precaution beforehand of leaving everything in order for the assistance of one's executors, the sporting spirit is rather dampened'. As a result of such concerns, and no doubt also remembering his own experiences of a much publicized incident causing the death of many spectators at the start of the 1903 Paris–Madrid road-race, Jarrott understandably preferred racing speeds to be kept to less life-threatening levels, which in his view meant being below an average of 60 mph.[7] Or, as *Circuit Driver* noted over a century later, 'happily, moments on trackdays are rarely converted into accidents'.[8]

More generally, therefore, it is not the actuality of a terminal ending of a fatal crash or serious accident, but instead the experience

and the cyclical nature of speed and its attendant possibility of
a crash that prevail most strongly within driving culture. Early
motorists and poets were keenly aware of the close relationship
between dynamism and life on the one hand and potential death
and destruction on the other. G. Stewart Bowles's 'The Song of the
Wheel' (1903), for example, begins with these three lines: 'Fire in
the heart of me, moving and chattering / Youth in each part of me,
slender and strong / Death at the foot of me, rending and shattering'.[9]
It is also worth recalling that, in the Futurist manifesto, the seminal
moment at which this most modern of avant-garde movements
began was a car crash experienced by Marinetti a year earlier. And
so after Marinetti's car is recovered from a ditch – 'they thought it
was dead, my beautiful shark, but a caress from me was enough to
revive it; and there it was, alive again, running on its powerful fins!'
– the Italian artist proclaims one of the central tenets of Futurism,
namely that 'we intend to sing the love of danger, the habit of energy
and fearlessness'.[10] The birth of Futurism thus begins both with a
car crash and with a positive life-enhancing rebirth, and this is what
the pleasure of driving is perhaps ultimately all about: the challenge
to the driver, and their renewal and reinvigoration, every time they
drive. Even early motoring in some of its supposedly most genteel
of guises could offer this kind of experience; Emily Post, for example,
writing about 'making up lost time easily' in Nebraska, explains
how 'you forget that ordinarily you dislike whizzing along the
surface of the earth, and for just this once – even though you think
of it more in terror than in joy – you are approaching the raceway
of America, and you, too, are going to race'.[11] A century later, and
the philosopher Marinoff describes such high-speed driving in even

more effusive terms. 'The mind is calm, unruffled, yet utterly ecstatic. You experience a thrill, a joy, a rush of delight of being alive . . . This is nirvana my friends. Some attain it by sitting; others by chanting; folks such as me (and maybe you) by taking the road more swiftly travelled'.[12] It is exactly through this kind of vital experience – through the driving of an automobile – that the human subject emerges as someone who has encountered one of the most distinctive and ubiquitous conditions of the modern world, who indeed has not only survived but thrived within it, and who has become, as a result, a different kind of person.

Returning now to some of the comments made in the introduction to *Drive* regarding contemporary concerns around private, public and mass transportation, then if we are indeed to deal with the problems of congestion, pollution, energy consumption, health and safety that car use undoubtedly contributes towards, then we must, in doing so, also seriously consider that the undoubted pleasures of driving play no small part in why people will not simply abandon their cars even if fully affordable, efficient, ubiquitous and useful forms of public transport were suddenly to become readily and universally available. In short, without addressing the cultural reasons as to why people like to drive, a purely quantitative, economic, managerialist or scientific approach to transportation will always fall short of its desired aims. Indeed, the oft-stated functionalist approach to reducing the amount of private car driving – namely that journeys by car should only be made when absolutely essential – could be simply reversed. That is, car driving should never be essential, never be necessary; rather, driving should only be undertaken as a form of pleasure – and hence the kinds of cultural

Edwardian
motorists flee
their pursuers in
The ? Motorist
(Walter Booth for
R. W. Paul, 1906).

and mobile experiences explored in this book could be even more enjoyably pursued.

Alternatively, one of the essential challenges of addressing any overuse of automobiles is therefore that of creating, as Melvin M. Webber has argued, more auto-like transportations: other forms of mobility which replicate the advantages – both perceived and actual – of driving cars.[13] In his own analysis Webber focuses largely on issues of functional mobility in terms of access, parking, geography, population distribution and so forth, but to these we might now add the multitudinous, rich and diverse pleasures of the act of driving, which this book has sought to explicate – from the experiences of the fantastically speeding Edwardians of *The ? Motorist* in the 1900s right through to those of the irrepressibly upbeat Poppy of *Happy-Go-Lucky* in the 2000s – and which the millions of drivers around the world will today not wish to readily forego.

Nor is this a matter of superficial or indulgent experiences. As philosopher Loren E. Lomasky has argued, automobility complements

233

our sense of autonomy, and so both corresponds with and encourages the kind of positive, self-directing impulse that is so valued in our contemporary society. Furthermore, as Lomasky also argues, driving additionally complements other core cultural values, including those of 'freedom of association, pursuit of knowledge, economic advancement, privacy, and even the expression of religious commitments and affectional preference.'[14] In this way, as shown so clearly and diversely in the many films and other cultural manifestations referred to in this book, car driving – and particularly the cultural, political, social and experiential benefits we gain from directly engaging in it – is an integral part of our modern society, and therefore is something to be preserved, celebrated and even encouraged.

Poppy learns to drive in *Happy-Go-Lucky* (Mike Leigh, 2008).

REFERENCES

INTRODUCTION

1 Roland Barthes, 'Mythologie de l'automobile: La Voiture, projection de l'ego', *Oeuvres complètes* [1963] (Paris, 2002), pp. 234–42, and quoted in Jean Baudrillard, *The System of Objects* (London, 2005), pp. 25–6 n7.

2 John Urry, 'The System of Automobility' (2002), at www.its. leeds.ac.uk; and Ruth Brandon, *Auto Mobile: How the Car Changed Life* (London, 2002), p. 385.

3 Mimi Sheller and John Urry, 'The City and the Car', *International Journal of Urban and Regional Research*, XXIV/4 (2000), pp. 737–57; Mike Featherstone, Nigel Thrift and John Urry, eds, *Automobilities* (London, 2005); and Steffen Böhm, Campbell Jones, Chris Land and Mat Paterson, 'Introduction: Impossibilities of Automobility', *Sociological Review*, LIV/1 (2006), pp. 1–16.

4 A. B. Filson Young, *The Complete Motorist: Being an Account of the Evolution and Construction of the Modern Motor-car, Etc.* (London, revd 5th edn, 1905), p. 274.

5 Steffen Böhm, Campbell Jones, Chris Land and Mat Paterson, eds, *Against Automobility* (Oxford, 2006); Jim Conley and Arlene Tigar McLaren, eds, *Car Troubles: Critical Studies of Automobility* (Abingdon, 2009); Kingsley Dennis and John Urry, *After the Car* (Oxford, 2009); and Brian Ladd, *Autophobia: Love and Hate in the Automotive Era* (Chicago, IL, 2008).

6 Brandon, *Auto Mobile*, p. 386.

7 Young, *Complete Motorist*, p. xxiv.

8 See, for example, Warren James Belasco, *Americans on the Road: from Autocamp to Motel, 1910–1945* (Cambridge, 1979); Shane Birney, *A Nation on Wheels: Australia and the Motor Car* (Sydney, 1986); James J. Flink, *America Adopts the Automobile, 1895–1910* (Cambridge, 1970); James J. Flink, *The Automobile Age* (Cambridge, 1988); David Gartman, *Auto Opium: A Social History of American Automobile Design* (London, 1994); David Jeremiah, *Representations of British Motoring* (Manchester, 2007); Jane Holtz Kay, *Asphalt Nation: How the Automobile Took over America, and How We Can Take It Back* (New

York, 1997); Peter J. Ling, *America and the Automobile: Technology, Reform and Social Change* (Manchester, 1989); John McCrystal, *100 Years of Motoring in New Zealand* (Auckland, 2003); Sean O'Connell, *The Car and British Society: Class, Gender and Motoring, 1896–1939* (Manchester, 1998); Sean O'Connell, *The Social and Cultural Impact of the Car in Interwar Britain* (Warwick, 1995); William Plowden, *The Motor Car and Politics, 1896–1970* (London, 1971); and Peter Thorold, *The Motoring Age: The Automobile and Britain, 1896–1939* (London, 2003).

9 See, for example, Richard Benson et al., *The Secret Life of Cars, and What They Reveal About Us* (London, 2007); Cynthia Golomb Dettelbach, *In the Driver's Seat: The Automobile in American Literature and Popular Culture* (Westport, CT, 1976); David D. Lewis and Laurence Goldstein, eds, *Automobile and American Culture* (Ann Arbor, MI, 1983); Peter Marsh and Peter Collett, *Driving Passion: The Psychology of the Car* (London, 1986); Daniel Miller, ed., *Car Cultures* (Oxford, 2001); and Gerald Silk, ed., *Automobile and Culture* (Los Angeles, CA, 1984).

10 See, for example, Reyner Banham, *Los Angeles: The Architecture of Four Ecologies* (Harmondsworth, 1973); David Brodsly, *L.A. Freeway: An Appreciative Essay* (Berkeley, CA, 1981); Tim English, *Overlanding:*

The Ultimate Road Trip (London, 2004); Phil Llewellin, *The Road to Muckle Flugga: Great Drives in Five Continents* (Sparkford, 2004); Peter Schindler, *On the Road: Driving Adventures, Pleasures and Discoveries* (Hong Kong, 2005); and Alistair Weaver, *A Drive on the Wild Side: Twenty Extreme Driving Adventures from Around the World* (Dorchester, 2007).

11 See, for example, Donald Appleyard, Kevin Lynch and John R. Myer, *The View from the Road* (Cambridge, 1964); Marc Augé, *Non-places: Introduction to an Anthropology of Supermodernity* (London, 1995); Jean Baudrillard, *America* [1968] (London, 1988); Jonathan Crary, *Suspensions of Perception: Attention, Spectacle and Modern Culture* (Cambridge, 2000); Sara Danius, *The Senses of Modernism: Technology, Perception, and Aesthetics* (Ithaca, NY, 2002); Enda Duffy, *The Speed Handbook: Velocity, Pleasure, Modernism* (Durham, NC, 2009); Jeffrey T. Schnapp, 'Crash (Speed as Engine of Individuation)', *Modernism/Modernity*, VI/1 (1999), pp. 1–49; Jeffrey T. Schnapp, 'Three Pieces of Asphalt', *Grey Room*, I/11 (2003), pp. 5–21; Alison Smithson, *AS in DS: An Eye on the Road* (Delft, 1983); Robert Venturi, Denise Scott Brown and Steven Izenour, *Learning from Las Vegas* (Cambridge, 1972); and Paul Virilio, *Negative Horizon: An*

Essay in Dromoscopy (London, 2005).

12 Nigel Thrift, 'Non-representational Theory', *The Dictionary of Human Geography*, ed. R. J. Johnston, Derek Gregory, Geraldine Pratt and Michael Watts (Oxford, 2000).

13 Roland Barthes, 'The New Citroën', *Mythologies* [1957] (London, 1973), pp. 95–7.

14 Mimi Sheller, 'Automotive Emotions: Feeling the Car', *Theory, Culture and Society*, XXI/4–5 (2004), pp. 221–42.

15 Baudrillard, *America*, p. 54.

16 See, for example, Iain Borden, *Skateboarding, Space and the City: Architecture and the Body* (Oxford, 2001); Iain Borden, Jane Rendell and Joe Kerr with Alicia Pivaro, eds, *The Unknown City: Contesting Architecture and Social Space* (Cambridge, 2001); and Iain Borden, 'Machines of Possibility' (2004), at www.issuu.com.

17 Quoted in Kenneth Hey, 'Cars and Films in American Culture, 1929–1959', in *Automobile and American Culture*, ed. David D. Lewis and Laurence Goldstein (Ann Arbor, MI, 1983), p. 193.

18 Juhani Pallasmaa, *The Architecture of Image: Existential Space in Cinema* (Helsinki, 2007), p. 7.

19 Baudrillard, *America*, p. 56.

20 See, for example, Steven Cohan and Ina Rae Hark, eds, *The Road Movie Book* (London, 1997); Tom Conley, *Cartographic Cinema* (Minneapolis, 2007); Giampiero Frasca, *Road Movie: Immaginario, Genesi, Struttura E Forma Del Cinema Americano on the Road* (Turin, 2001); David Laderman, *Driving Visions: Exploring the Road Movie* (Austin, 2002); Ewa Mazierska and Laura Rascaroli, *Crossing New Europe: Postmodern Travel and the European Road Movie* (London, 2006); Devin Orgeron, *Road Movies: From Muybridge and Méliès to Lynch and Kiarostami* (London, 2008); Jack Sargeant and Stephanie Watson, eds, *Lost Highways: An Illustrated History of Road Movies* (London, 1999); and Jason Wood, *100 Road Movies* (London, 2007).

1 CITIES

1 Pedro Juan Larrañaga, *Successful Asphalt Paving: A Description of Up-to-date Methods, Recipes and Theories, with Examples and Practical Hints, for Road Authorities, Contractors, and Advanced Students* (London, 1926). Quoted in Jeffrey T. Schnapp, 'Three Pieces of Asphalt', *Grey Room*, V/11 (2003), p. 12.

2 Quoted in Ruth Brandon, *Auto Mobile: How the Car Changed Life* (London, 2002), p. 304.

3 Julian Smith, 'A Runaway Match: The Automobile in the American Film, 1900–1920', *Automobile and American Culture*, ed. David D. Lewis and Laurence Goldstein (Ann Arbor, MI, 1983), pp. 184–7; and David

Gartman, *Auto Opium: A Social History of American Automobile Design* (London, 1994), pp. 36 and 54.

4 Devin Orgeron, *Road Movies: From Muybridge and Méliès to Lynch and Kiarostami* (London, 2008), pp 39–43.

5 Gerald Silk, 'Reality and Beyond the Real', *Automobile and Culture*, ed. Gerald Silk (Los Angeles, CA, and New York, 1984), pp. 110–13.

6 Blaine A. Brownell, 'A Symbol of Modernity: Attitudes toward the Automobile in Southern Cities in the 1920s', *American Quarterly*, XXIV/1 (1972), pp. 34–6; and Eliza Russi Lowen McGraw, 'Driving Miss Daisy: Southern Jewishness on the Big Screen', *Southern Cultures*, VII/2 (2001), pp. 41–59.

7 James J. Flink, *The Automobile Age* (Cambridge, 1988), pp. 159 and 359.

8 Michael L. Berger, 'The Car's Impact on the American Family', *The Car and the City: The Automobile, the Built Environment and Daily Life*, ed. Martin Wachs and Margaret Crawford (Ann Arbor, MI, 1992), p. 66.

9 Gregory Votolato, *Transport Design: A Travel History* (London, 2007), p. 97; and Orgeron, *Road Movies*, pp. 42–3.

10 Clay McShane, *The Automobile: A Chronology of its Antecedents, Development and Impact* (London, 1997), p. 127.

11 'The Ballad of Thunder Road', co-written by Robert Mitchum and Joao Gilberto.

12 Virginia Scharff, *Taking the Wheel: Women and the Coming of the Motor Age* (Toronto, 1991), pp. 111–33; Gartman, *Auto Opium*, p. 98; Flink, *The Automobile Age*, pp. 162–4; and Roger Miller, 'Selling Mrs Consumer: Advertising and the Creation of Suburban Social Relations, 1910–1930', *Antipode*, XXIII/3 (1991), pp. 282–4.

13 Cited in Cotten Seiler, *Republic of Drivers: A Cultural History of Automobility in America* (Chicago, IL, 2008), p. 42.

14 'Red Lorry, Yellow Lorry', episode 5 of *From A to B – Tales of Modern Motoring* (BBC, 1994).

15 Charles L. Sanford, '"Woman's Place" in American Car Culture', in *Automobile and American Culture*, ed. Lewis and Goldstein, p. 139; and Berger, 'The Car's Impact on the American Family', pp. 68–72.

16 Quentin Tarantino, interviewed in the documentary 'Stunts on Wheels: The Legendary Drivers of Death Proof', contained in the 2-disc DVD special edition of *Death Proof* (2007).

17 For example, Steffen Böhm, Campbell Jones, Chris Land and Matthew Paterson, eds, *Against Automobility* (Oxford, 2006); Jason Henderson, 'Secessionist Automobility: Racism, Anti-urbanism, and the Politics of Automobility in Atlanta, Georgia', *International Journal of Urban and Regional Research*, XXX/2 (2006), pp. 293–307; and Brian Ladd,

Autophobia: Love and Hate in the Automotive Era (Chicago, IL, 2008).

18 Kenneth Hey, 'Cars and Films in American Culture, 1929–1959', *Automobile and American Culture*, ed. Lewis and Goldstein, pp. 195–7.

19 Kristin Ross, *Fast Cars, Clean Bodies: Decolonization and the Reordering of French Culture* (Cambridge, 1995), pp. 50–54.

20 Documentary 'Taxi Driver Stories', contained in the 2-disc DVD special edition of *Taxi Driver* (2007); and Iva Pekárková, *Gimme the Money: The Big Apple as Seen by a Czech Driver* (London, 2000).

21 Paul Schrader, *Taxi Driver* (London, 2000), p. xxiii.

22 Raymond Williams, 'Alienation', *Keywords* (London, 1988), p. 36.

23 Nigel Coates, *Guide to Ecstacity* (London, 2003), pp. 129–30.

24 Georg Simmel, 'The Metropolis and Mental Life' [1903], in *Cities and Society: The Revised Reader in Urban Sociology*, ed. P. K. Hatt and A. J. Reiss (New York, 1951), pp. 635–46.

25 For the Mini and *The Italian Job* (1969) see Christy Campbell, *Mini: An Intimate Biography* (London, 2009); Matthew Field, *The Making of the Italian Job* (London, 2001); Peter Filby, *Amazing Mini* (Yeovil, 1981); Simon Garfield, *Mini: The True and Secret History of the Making of a Motor Car* (London, 2009); Rob Golding, *Mini: Thirty-five Years On* (London, revd edn, 1994); Brian

Laban, *The Mini: Forty Years of Fun* (London, 1999); Jon Pressnell, *Mini: The Definitive History* (Sparkford, 2009); Graham Robson, *Mini: A Celebration of Britain's Best-loved Small Car* (Sparkford, 2006); L.J.K. Setright, *Mini: The Design of an Icon* (London, 1999); www.miniworld. co.uk, www.paulsmithmini.co.uk; www.roblightbody.com; and www.theitalianjob.com. See also the documentary 'Get A Bloomin' Move On' contained in the 2003 DVD release of the 1969 version of *The Italian Job*.

26 Henri Bergson, *Matter and Memory* [1896] (New York, 1988); and Enda Duffy, *The Speed Handbook: Velocity, Pleasure, Modernism* (Durham, NC, 2009), pp. 168–9.

27 Jim Conley, 'Automobile Advertisements: The Magical and the Mundane', in *Car Troubles: Critical Studies of Automobility*, ed. Jim Conley and Arlene Tigar McLaren (Abingdon, 2009), pp. 37–57.

28 Garfield, *Mini*, pp. 205–25.

29 Ibid., pp. 245–7.

30 Coates, *Guide to Ecstacity*, p. 215.

31 Robert Venturi, Denise Scott Brown and Steven Izenour, *Learning from Las Vegas* (Cambridge, 1972).

32 Nigel Thrift, 'Driving in the City', *Theory, Culture and Society*, XXI/4–5 (2004), p. 45.

33 Steven Jacobs, 'From Flâneur to Chauffeur: Driving through Cinematic Cities', in *Imagining the*

City, vol. I: *The Art of Urban Living*, ed. Christian Emden, Catherine Keen and David Midgley (Oxford, 2006), pp. 224–5.

34 Henri Lefebvre, *Introduction to Modernity: Twelve Preludes, September 1959–May 1961* (London, 1995), p. 95.

35 Seiler, *Republic of Drivers*, pp. 60–66.

36 Lefebvre, *Introduction to Modernity*, p. 119

37 Tim Edensor, 'Automobility and National Identity: Representation, Geography and Driving Practice', *Theory, Culture and Society*, XXI/4–5 (2004), pp. 108–10.

38 Rudyard Kipling, letter to Filson Young, in A. B. Filson Young, *The Complete Motorist: Being an Account of the Evolution and Construction of the Modern Motor-car, Etc.* (London, revd 5th edn, 1905), p. 250.

39 Jesse Crosse, *The Greatest Movie Car Chases of All Time* (St Paul, 2006), p. 16.

40 Jacobs, 'Flâneur to Chauffeur', p. 219.

41 Jean-Luc Godard, *Jean-Luc Godard par Jean-Luc Godard* (Paris, 1968), p. 383, quoted in Ross, *Fast Cars, Clean Bodies*, p. 40.

42 Young, *Complete Motorist*, pp. 171–2.

43 Kurt Möser, 'The Dark Side of "Automobilism", 1900–30: Violence, War and the Motor Car', *The Journal of Transport History*, XXIV/2 (2003), pp. 244–6; David Sharpley, 'Driver Behaviour and the Wider Social Context', *Driver Behaviour and Training*, ed. Lisa Dorn (Aldershot, 2003), pp. 381–7; and Tom Vanderbilt, *Traffic: Why We Drive the Way We Do (and What It Says About Us)* (London, 2008).

44 Nigel Taylor, 'The Aesthetic Experience of Traffic in the Modern City', *Urban Studies*, XL/8 (2003), p. 1622.

45 Warren James Belasco, *Americans on the Road: from Autocamp to Motel, 1910–1945* (Cambridge, 1979), pp. 19–39.

46 Vanderbilt, *Traffic*, pp. 108–10.

47 Edward W. Soja, *Postmodern Geographies: The Reassertion of Space in Critical Social Theory* (London, 1989), pp. 222 and 244–6.

48 For an extended discussion of driving in *Chinatown*, see Iain Borden, 'Chinatown, Automobile Driving and the Unknowable City', in *Urban Constellations*, ed. Matthew Gandy (Berlin, 2011), pp. 186–9.

2 JOURNEYS

1 A. B. Filson Young, *The Complete Motorist: Being an Account of the Evolution and Construction of the Modern Motor-car, Etc.* (London, revd 5th edn, 1905), pp. 142–3.

2 Ruth Brandon, *Auto Mobile: How the Car Changed Life* (London, 2002), pp. 79–80.

3 Brandon, *Auto Mobile*, pp. 223–8.

4 Cesare Santoro, *Hitler Germany as Seen by a Foreigner* (Berlin, 1938)

and R. J. Overy, 'Cars, Roads, and Economic Recovery in Germany, 1932–8', *The Economic History Review*, XXVIII/3 (August 1975), pp. 475–6, cited in Brandon, *Auto Mobile*, p. 203.

5 Young, *Complete Motorist*, p. 276.

6 Dallas Lore Sharp, *The Better Country* (Boston, 1928), p. 130, quoted in Belasco, *Americans on the Road*, p. 24.

7 Belasco, *Americans on the Road*, pp. 19–39; and Gabrielle Barnett, 'Drive-by Viewing: Visual Consciousness and Forest Preservation in the Automobile Age', *Technology and Culture*, XLV/1 (2004), p. 42.

8 Belasco, *Americans on the Road*, esp. p. 86.

9 Quoted in Belasco, *Americans on the Road*, p. 87.

10 Henry Vollam Morton, *In Search of England* [1927] (Harmondsworth, 1960); and E. B. White, *Farewell to Model T* [1936] (New York, 2003).

11 'Female driver, 36, Penzance', quoted in Richard Benson et al., *The Secret Life of Cars, and What They Reveal About Us* (London, 2007), p. 6.

12 Steve Cropley, 'A Week in Cars', *Autocar*, CCLXVIII/2 (13 April 2011), p. 17.

13 Sara Danius, 'The Aesthetics of the Windshield: Proust and the Modernist Rhetoric of Speed', *Modernism/Modernity*, VIII/1 (2001), pp. 99–126; and Sara Danius, *The Senses of Modernism: Technology, Perception, and Aesthetics* (Ithaca, NY, and London, 2002).

14 Ilya Ehrenburg, *The Life of the Automobile* [1929] (London, 1999), pp. 4–5.

15 Young, *Complete Motorist*, p. 291.

16 *Ibid.*, p. 281.

17 Mark Nawrot, 'Depth from Motion Parallax Scales With Eye Movement Gain', *Journal of Vision*, III/11 (December 2003), pp. 841–51; and Tom Vanderbilt, *Traffic: Why We Drive the Way We Do (and What It Says About Us)* (London, 2008), pp. 91–2.

18 Quoted in Danius, 'Aesthetics of the Windshield', p. 109.

19 Paul Virilio, 'Dromoscopy, or the Ecstasy of Enormities', *Wide Angle*, XX/3 (1998), pp. 11–12, pp. 65–72; and Paul Virilio, *Negative Horizon: An Essay in Dromoscopy* (London, 2005).

20 Steven Spielberg interviewed in the documentary 'A Conversation with Steven Spielberg on the Making of *Duel*' contained in the DVD special edition of *Duel* (2005).

21 Marcel Proust, *Remembrance of Things Past*, vol. I: *Swann's Way* (www.gutenberg.org, 2009). Originally published as *Du côté de chez Swann* (1913). These lines of *Swann's Way* are based on a section from Marcel Proust, 'Impressions de Route en Automobile', *Le Figaro* (19 November 1907). See Alessia

Ricciardi, 'Cinema Regained: Godard between Proust and Benjamin', *Modernism/Modernity*, VIII/4 (2001), pp. 645–51; and Danius, 'Aesthetics of the Windshield', pp. 99–126

22 Anne Friedberg, 'Urban Mobility and Cinematic Visuality: The Screens of Los Angeles – Endless Cinema or Private Telematics', *Journal of Visual Culture*, 1/2 (2002), p. 184.

23 Gerald Silk, 'Proliferation and Assimilation', in *Automobile and Culture*, ed. Gerald Silk (Los Angeles, CA, and New York, 1984), p. 75; Gregory Votolato, *Transport Design: A Travel History* (London, 2007), pp. 78–9; and interviews with David Hockney from the *Evening Standard* (8 July 1983) and *The Face* (September 1983), reproduced at http://shapersofthe80s.com.

24 Max Forsythe, *Drive by Shooting* (London, 2004); Lee Friedlander, *America by Car* (San Francisco, CA, 2010); Edward Ruscha, *Every Building on the Sunset Strip* (Los Angeles, CA, 1966); and Robbert Flick, M. J. Dear, David L. Ulin and Tim B. Wride, *Trajectories* (Los Angeles, CA, 2004).

25 Virilio, 'Dromoscopy', p. 13.

26 Wolfgang Schivelbusch, *The Railway Journey: The Industrialization and Perception of Time and Space in the 19th Century* (Leamington Spa, new edn, 1986), p. 57; Georg Simmel, 'The Metropolis and Mental Life' [1903], in *Cities and Society: The Revised Reader in Urban Sociology*, ed. P. K.

Hatt and A. J. Reiss (New York, 1951), pp. 635–46.

27 For example, Henry Catchpole, 'Is this the Greatest Road in the World?', *Evo*, 144 (June 2010), pp. 96–105; Andy Markowitz, 'Ceaucescu's Folly', *The Guardian*, 'Travel' section (23 April 2005); Peter Schindler, *On the Road: Driving Adventures, Pleasures and Discoveries* (Hong Kong, 2005); Alistair Weaver, 'The World's Best Road', *Autocar* (24 January, 2006), pp. 64–9; Alistair Weaver, *A Drive on the Wild Side: Twenty Extreme Driving Adventures from around the World* (Dorchester, 2007); Greg Fountain, ed., *Epic Drives* (Peterborough, 2009); and www.theworldsbestdrivingroads.com.

28 Lady Mary Jeune, letter to Filson Young (20 June 1904), in Young, *Complete Motorist*, p. 236.

29 Quoted in Chris Mosey, *Car Wars: Battles on the Road to Nowhere* (London, 2000), p. 186.

30 'Son cerveau est une piste sans fin où pensées, images, sensations ronflent et roulent, à raison de cent kilomètres à l'heure. Cent kilomètres, c'est l'étalon de son activité. Il passe en trombe, pense en trombe, sent en trombe, aime en trombe, vit en trombe. La vie de partout se précipite, se bouscule, animée d'un mouvement fou, d'un mouvement de charge de cavalerie, et disparaît cinématographiquement.' Octave Mirbeau, *La 628-E8* (Paris, 1907), p. 55. See also Danius,

'Aesthetics of the Windshield',
pp. 110–11.

31 Young, *Complete Motorist*, p. 275.

32 Michael Atkinson, 'Crossing the
Frontiers', *Sight and Sound*, IV/1
(1994), pp. 14–17; Steven Cohan and
Ina Rae Hark, 'Introduction', in *The
Road Movie Book*, ed. Steven Cohan
and Ina Rae Hark (London, 1997),
p. 1; David Laderman, 'The Road
Movie Rediscovers Mexico: Alex
Cox's *Highway Patrolman*', *Cinema
Journal*, XXXIX/2 (2000), pp. 78–9;
Cotten Seiler, *Republic of Drivers:
A Cultural History of Automobility in
America* (Chicago, IL, 2008), pp. 42–3.

33 For example, Cohan and Hark, eds,
The Road Movie Book; Tom Conley,
Cartographic Cinema (Minneapolis,
2007); Ron Eyerman and Orvar
Lofgren, 'Romancing the Road: Road
Movies and Images of Mobility',
Theory, Culture and Society, XXII/1
(1995), pp. 53–79; Giampiero Frasca,
*Road Movie: Immaginario, Genesi,
Struttura e Forma del Cinema
Americano on the Road* (Turin, 2001);
David Laderman, *Driving Visions:
Exploring the Road Movie* (Austin,
2002); Ewa Mazierska and Laura
Rascaroli, *Crossing New Europe:
Postmodern Travel and the European
Road Movie* (London, 2006); Devin
Orgeron, *Road Movies: From
Muybridge and Méliès to Lynch and
Kiarostami* (London, 2008); Jack
Sargeant and Stephanie Watson, eds,
*Lost Highways: An Illustrated History

of Road Movies* (London, 1999);
and Jason Wood, *100 Road Movies*
(London, 2007).

34 For example, Fleda Brown, *Driving
with Dvorak: Essays on Memory and
Identity* (Lincoln, 2009); Tim English,
Overlanding: The Ultimate Road Trip
(London, 2004); Tony Hiss, *In Motion:
The Experience of Travel* (London,
2011); Phil Llewellin, *The Road to
Muckle Flugga: Great Drives in Five
Continents* (Sparkford, 2004); Ewan
McGregor and Charlie Boorman, *Long
Way Round: Chasing Shadows across
the World* (London, 2004); W. Scott
Olsen, *At Speed: Travelling the Long
Road between Two Points* (Lincoln,
NE, 2006); and Schindler, *On the Road*.

35 For the original short story, see
Richard Matheson, *Duel: Terror
Stories by Richard Matheson* (New
York, 2003).

36 Spielberg in 'A Conversation with
Steven Spielberg'.

37 Timothy Corrigan, *A Cinema
Without Walls: Movies and Culture
after Vietnam* (London, 1991), p. 145,
cited in Cohan and Hark,
'Introduction', p. 2.

38 Matheson, *Duel*, p. 37.

39 Laderman, *Driving Visions*,
pp. 128–31.

40 Corrigan, *A Cinema Without Walls*,
p. 143, cited in Cohan and Hark,
'Introduction', pp. 2–3.

41 Laderman, *Driving Visions*, pp. 133–4.

42 Ibid., pp. 142–4.

43 Corrigan, *A Cinema Without Walls*,

pp. 143–5, cited in Cohan and Hark, 'Introduction', p. 2.

44 Tim Cresswell, 'Mobility as Resistance: A Geographical Reading of Kerouac's *On the Road*', *Transactions of the Institute of British Geographers*, xviii/2 (1993), pp. 249–62.

45 Carlo Di Carlo and Giorgio Tinazzi, eds, *The Architecture of Vision: Writings and Interviews on Cinema* (New York, 1996); and Juhani Pallasmaa, *The Architecture of Image: Existential Space in Cinema* (Helsinki, 2007), p. 120.

46 Ian Leong, Mike Sell and Kelly Thomas, 'Mad Love, Mobile Homes, and Dysfunctional Dicks: On the Road with Bonnie and Clyde', *The Road Movie Book*, ed. Cohan and Hark, pp. 70–89; and Corey Creekmur, 'On the Run and On the Road', ibid., p. 92.

47 Jack Sargeant, 'Killer Couples: From Nebraska to Route 666', *Lost Highways*, ed. Sargeant and Watson, p. 159.

48 Callie Khouri, quoted in Maria Sturken, *Thelma & Louise* (London, 2000), p. 73.

49 Adam Webb, 'No Beginning. No End. No Speed Limit: *Two-lane Blacktop*', *Lost Highways*, ed. Sargeant and Watson, p. 82–8.

50 Young, *Complete Motorist*, p. 40.

51 Corrigan, *A Cinema Without Walls*, pp. 145–6, cited in Cohan and Hark, 'Introduction', p. 2.

52 Jack Sargeant, '*Vanishing Point*: Speed Kills', in *Lost Highways*, ed. Sargeant and Watson, pp. 93–7; and John Beck, 'Resistance Becomes Ballistic: Vanishing Point and the End of the Road', *Cultural Politics*, iii/1 (2007), pp. 35–50.

53 Sargeant, *Vanishing Point*, p. 96.

54 Richard C. Sarafian, audio commentary to the us dvd edition of *Vanishing Point* (2004).

3 MOTOPIA

1 Geoffrey Jellicoe, *Motopia: A Study in the Evolution of Urban Landscape* (London, 1961).

2 For example, Antonio Amado, *Voiture Minimum: Le Corbusier and the Automobile* (Cambridge, 2011); Jonathan Bell, ed., *Architecture: When the Car and the City Collide* (Basel, 2001); Robert Fishman, *Urban Utopias in the Twentieth Century: Ebenezer Howard, Frank Lloyd Wright, and Le Corbusier* (Cambridge, 1982); Murray Fraser, 'The City, the Car and the Dwelling', in *Architecture and the Special Relationship: The American Influence on Post-war British Architecture* (Abingdon, 2007); Moshe Safdie and Wendy Kohn, *The City after the Automobile: An Architect's Vision* (London, 1997); and Elizabeth A. T. Smith, 'The Drive-in Culture' and 'Traffic Systems and the Visions of City Planners', in *Automobile and Culture*, ed. Gerald

Silk (Los Angeles, CA, and New York, 1984), pp. 200–3 and 294–9.

3 Norman Bel Geddes, *Magic Motorways* (New York, 1940); Helen J. Burgess, 'Futurama, Autogeddon: Imagining the Superhighway from Bel Geddes to Ballard', *Rhizomes*, 8 (Spring 2004), at www.rhizomes.net; Expositions Publications, *Official Guide Book* (New York, 1939); David Gelernter, *The Lost World of the Fair* (New York, 1995); General Motors, *Highways and Horizons: The General Motors Exhibit Building* (Detroit, MI, 1939); Edward Dimendberg, 'The Will to Motorization: Cinema, Highways, and Modernity', *October*, 73 (Summer 1995), pp. 90–137; and Cliff Ellis, 'Lewis Mumford and Norman Bel Geddes: The Highway, the City and the Future', *Planning Perspectives*, XX/1 (2005), pp. 51–68.

4 Ruth Brandon, *Auto Mobile: How the Car Changed Life* (London, 2002), pp. 289–90.

5 Roland Barthes, 'The New Citroën', *Mythologies* [1957] (London, 1973), pp. 95–7.

6 Dimendberg, 'The Will to Motorization', p. 126; and Paul Mason Fotsch, 'The Building of a Superhighway Future at the New York World's Fair', *Cultural Critique*, XLVIII (2001), pp. 65–97.

7 Brandon, *Auto Mobile*, pp. 201–2.

8 Grant Geyer, '"The" Freeway in Southern California', *American Speech*, LXXVI/2 (2001), p. 222; and

Brandon, *Auto Mobile*, pp. 342–3.

9 Wilbur Smith, *Future Highways and Urban Growth* (New Haven, CT, 1961), p. 3; U.S. Department of Transportation, Federal Highway Administration, 'Interstate FAQ', at www.fhwa.dot.gov; James J. Flink, *The Automobile Age* (Cambridge, 1988), pp. 368–73; James Howard Kunstler, *The Geography of Nowhere: The Rise and Decline of America's Man-made Landscape* (New York, 1993), p. 107; Cotten Seiler, *Republic of Drivers: A Cultural History of Automobility in America* (Chicago, IL, 2008), pp. 69–104; and Cliff Ellis, 'Interstate Highways, Regional Planning and the Reshaping of Metropolitan America', *Planning Practice and Research*, XVI/3–4 (2001), pp. 247–69.

10 Seiler, *Republic of Drivers*, p. 91.

11 Peter Merriman, *Driving Spaces: A Cultural-historical Geography of England's M1 Motorway* (Oxford, 2007), pp. 103–40; and CBRD (Chris's British Road Directory), at www.cbrd.co.uk.

12 Taiwan Area National Expressway Engineering Bureau, at www.taneeb.gov.tw.

13 Thomas J. Campanella, '"The Civilising Road": American Influence on the Development of Highways and Motoring in China, 1900–1949', *Journal of Transport History*, XXVI/1 (2005), p. 79.

14 Dimendberg, 'Will to Motorization',

pp. 90–93; and Thomas Zeller, *Driving Germany: The Landscape of the German Autobahn, 1930–1970* (Oxford, 2007).

15 Brian Ladd, *Autophobia: Love and Hate in the Automotive Era* (Chicago, IL, 2008), pp. 153–9.

16 Dimendberg, 'Will to Motorization', p. 90.

17 Henri Lefebvre, *The Production of Space* (Oxford, 1991), p. 313; Marc Augé, *Non-places: Introduction to an Anthropology of Supermodernity* (London, 1995); Jean Baudrillard, *America* [1968] (London, 1988); and Edward C. Relph, *Place and Placelessness* (London, 1976), p. 90.

18 Guy Debord, 'Theses on Traffic', *Situationist International Anthology*, ed. Ken Knabb (Berkeley, CA, 1981), p. 56.

19 Tim Edensor, 'Defamiliarizing the Mundane Roadscape', *Space and Culture*, VI/2 (2003), pp. 151–68; David Inglis, 'Auto Couture: Thinking the Car in Post-war France', *Theory, Culture and Society*, XXI/4–5 (2004), pp. 204–19; and Peter Merriman, 'Driving Places: Marc Augé, Non-places, and the Geographies of England's M1 Motorway', *Theory, Culture and Society*, XXI/4–5 (2004), pp. 145–67; Richard Sennett, *The Fall of Public Man: On the Social Psychology of Capitalism* (New York, 1974), p. 14; and Richard Sennett, *Flesh and Stone: The Body and the City in Western Civilization* (London,

1994), p. 18.

20 Dimendberg, 'Will to Motorization', pp. 127–37.

21 Martin Pawley, 'Where the Big Sheds Are', in *The Strange Death of Architectural Criticism: Martin Pawley, Collected Writings*, ed. David Jenkins (London, 2007), p. 226, quoted in Joe Moran, *On Roads: A Hidden History* (London, 2009), p. 149.

22 Iain Borden, 'Playtime: "Tativille" and Paris', in *The Hieroglyphics of Space: Reading and Experiencing the Modern Metropolis*, ed. Neil Leach (London, 2002), pp. 217–33.

23 David Matless, *Landscape and Englishness* (London, 1998), p. 64; and Moran, *On Roads*, p. 130.

24 Iain Sinclair, *London Orbital: A Walk around the M25* (London, 2002).

25 Anon, 'A Car Talk With Julian Opie', *Carl's Cars*, 12 (Summer 2005), pp. 98–101.

26 R. J. Gibbens and Y. Saacti, *Road Traffic Analysis Using MIDAS Data: Journey Time Prediction* (Cambridge, University of Cambridge Computer Laboratory Technical Report 676, December 2006), p. 17.

27 Seiler, *Republic of Drivers*, p. 126.

28 Brandon, *Auto Mobile*, p. 353.

29 Moran, *On Roads*, p. 22.

30 Ibid., p. 101; and 'The Secret Life of the Motorway: Falling In Love, The Honeymoon Period and The End of the Affair', three-part BBC television documentary (produced and directed

by Emma Hindley, first screened BBC4 21, 22 and 23 August 2007).

31 Suzanne Greaves, 'Motorway Nights with the Stars', *The Times* (14 August 1985), p. 8, quoted in Merriman, *Driving Spaces*, p. 181; and 'The Secret Life of the Motorway: The Honeymoon Period'.

32 Tony Brooks, 'The Hazards of M1', *The Observer* (8 November 1959), p. 5, quoted in Merriman, *Driving Spaces*, pp. 171–2.

33 Patrick Mennem, 'I Drive on Britain's Space-age Highway', *Daily Mirror* (30 October 1959), quoted in Moran, *On Roads*, p. 27.

34 Gordon Wilkins, 'London's Three-ring Motorway', *Illustrated London News* (1972), p. 31, cited in Sue Robertson, 'Visions of Urban Mobility: The Westway, London, England', *Cultural Geographies*, 14 (2007), pp. 79–80.

35 Françoise Sagan, *With Fondest Regards* (New York, 1985), p. 65, quoted in Kristin Ross, *Fast Cars, Clean Bodies: Decolonization and the Reordering of French Culture* (Cambridge, 1995), p. 21.

36 Par Blomkvist, 'Transferring Tech nology-shaping Ideology: American Traffic Engineering and Commercial Interests in the Establishment of a Swedish Car Society, 1945–1965', *Comparative Technology Transfer and Society*, II/3 (2004), pp. 273–302.

37 For example, John Foster, 'John Buchan's "Hesperides": Landscape Rhetoric and the Aesthetics of Bodily Experience on the South African Highveld, 1901–1903', *Ecumene*, v/3 (1998), pp. 323–47; and Wolfgang Schivelbusch, *The Railway Journey: The Industrialization and Perception of Time and Space in the 19th Century* (Leamington Spa, new edition, 1986).

38 Dimendberg, 'Will to Motorization', pp. 107–10 and 115–16. See also William H. Rollins, 'Whose Landscape? Technology, Fascism and Environmentalism on the National Socialist Autobahn', *Annals of the Association of American Geographers*, LXXXV/3 (1995), pp. 494–520.

39 Merriman, *Driving Spaces*, pp. 60–102; and Peter Merriman, '"Mirror, Signal, Manoeuvre": Assembling and Governing the Motorway Driver in Late 1950s Britain', *Sociological Review*, LIV/1 (2006), pp. 75–92.

40 Donald Appleyard, Kevin Lynch and John R. Myer, *The View from the Road* (Cambridge, 1964), esp. pp. 37 and 39; and Eduardo Alcântara De Vasconcellos, 'The Use of Streets: A Reassessment and Tribute to Donald Appleyard', *Journal of Urban Design*, IX/1 (2004), pp. 3–22.

41 For example, Louis Ward Kemp, 'Aesthetes and Engineers: The Occupational Ideology of Highway Design', *Technology and Culture*, XVII/4 (1986), pp. 759–97.

42 Robert Venturi, Denise Scott Brown and Steven Izenour, *Learning from Las Vegas* (Cambridge, 1972).

43 Reyner Banham, *Los Angeles: The Architecture of Four Ecologies* (Harmondsworth, 1973), pp. 35 and 88–90.

44 Lawrence Halprin, *Freeways* (New York, 1966), p. 5, quoted in David Brodsly, *L.A. Freeway: An Appreciative Essay* (Berkeley, CA, 1981), p. 50.

45 Rowan Moore, 'Let's Celebrate the Westway', *Evening Standard* (Tuesday, 11 July 2000), p. 28.

46 Halprin, *Freeways*, p. 16, quoted in Brodsly, *L.A. Freeway*, p. 50; Vivien Arnold, 'The Image of the Freeway', *Journal of Architectural Education*, XXX/1 (1976), pp. 28–30.

47 Banham, *Los Angeles*, pp. 23 and 213–4.

48 Tony Smith, 'Talking with Tony Smith: Conversations with Samuel Wagstaff, Jr', in *Theories and Documents of Contemporary Art: A Sourcebook of Artists' Writings*, ed. Kristine Stiles and Peter Selz (Berkeley and Los Angeles, CA, 1996), pp. 127–8, cited in Merriman, *Driving Spaces*, p. 15.

49 Alison Smithson, *AS in DS: An Eye on the Road* (Delft, 1983), pp. 91–4 and 140–45; and Merriman *Driving Spaces*, pp. 15–16.

50 Merriman, *Driving Spaces*, pp. 14–15; Schivelbusch, *Railway Journey*, p. 55; Mitchell Schwarzer, *Zoomscape: Architecture in Motion and Media* (New York, 2004), p. 99; Paul Virilio, 'Dromoscopy, or the Ecstasy of Enormities', *Wide Angle*, XX/3 (1998), pp. 11–22; and Paul Virilio, *Negative Horizon: An Essay in Dromoscopy* (London, 2005).

51 Virilio, 'Dromoscopy', pp. 12–13.

52 Home Office, *Roadcraft: The Police Drivers' Manual* (London, 1960), p. 75.

53 Quoted in Jason Wood, 'Radio On and the British Cinematic Landscape', essay in the accompanying booklet to the BFI DVD version of *Radio On* (2008), p. 1. See also 'Radio On', at www.lightsinthedusk.blogspot.com.

54 Edensor, 'Defamiliarizing the Mundane Roadscape', pp. 151–68; Greg Noble and Rebecca Baldwin, 'Sly Chicks and Troublemakers: Car Stickers, Nonsense and the Allure of Strangeness', *Social Semiotics*, XI/1 (2001), pp. 75–89; and Hagar Salamon, 'Political Bumper Stickers in Contemporary Israel: Folklore as an Emotional Battleground', *Journal of American Folklore*, CXIV/453 (2001), pp. 277–308.

55 Jellicoe, *Motopia*, p. 18; and Moran, *On Roads*, pp. 142–4.

56 Suzanne Greaves, interviewed in 'The Secret Life of the Motorway: The Honeymoon Period'.

57 Quoted ibid.

58 Quoted in Christophe Studeny, *L'Invention de la vitesse. France, XVII-Ie-XXe Siècle* (Paris, 1995), p. 192, and cited in Jeffrey T. Schnapp, 'Crash (Speed as Engine of Individuation)', *Modernism/Modernity*, VI/1 (1999), pp. 19–21.

59 A. B. Filson Young, *The Complete Motorist: Being an Account of the Evolution and Construction of the Modern Motor-car, Etc.* (London, revd 5th edn, 1905), pp. 273–8.

60 Mike Jackson, *The M4 Sights Guide: Find Out About Everything You Can See from Your Vehicle on the Motorway* (Worcester, 2005), pp. 58 and 74.

61 Roy Phippen, *M25 Travelling Clockwise* (London, 2004); Roger Green, *Destination Nowhere: A South Mimms Motorway Service Station Diary* (Twickenham, 2004); and Margaret Baker, *Discovering M1* (Tring, 1968).

62 Quoted in Gerald Silk, 'Cultural Reconstruction, Explosion, and Reflection', in *Automobile and Culture*, ed. Silk, p. 139.

63 Virilio, 'Dromoscopy', p. 17.

64 Eric Laurier, 'Doing Office Work on the Motorway', *Theory, Culture and Society*, XXI/4–5 (2004), pp. 261–77; and Richard Benson et al., 'Work, Rest and Play', *The Secret Life of Cars, and What They Reveal About Us* (London, 2007), pp. 42–56.

65 Brodsly, *L.A. Freeway*, p. 41.

66 Baudrillard, *America*, p. 9.

67 'Male driver, 35, South London' and 'Female Driver, 34, Hull', quoted in Benson et al., *The Secret Life of Cars*, pp. 6 and 22.

68 Jonathan Crary, *Suspensions of Perception: Attention, Spectacle and Modern Culture* (Cambridge, 2000), p. 78.

69 Susan Robertson, 'Visions of Mobility: The Sensational Spaces of Westway', MA Cultural Geography dissertation, Royal Holloway (2003), p. 34; and Edensor, 'Defamiliarizing the Mundane Roadscape', pp. 160–61.

70 Sam Delaney, 'Garage Anthems', *The Guardian*, 'The Guide' supplement (13 August 2005), pp. 4–5.

71 Julia Loktev, 'Static Motion, or the Confessions of a Compulsive Radio Driver', *Semiotexte*, VI/1 (1993), quoted in Michael Bull, 'Soundscapes of the Car: A Critical Study of Automobile Habitation', *Car Cultures*, ed. Daniel Miller (Oxford, 2001), p. 185; Michael Bull, 'Automobility and the Power of Sound', *Theory, Culture and Society*, XXI/4–5 (2004), pp. 243–59; and Greil Marcus, 'Back Seat', *2wice*, V/2 (2001), pp. 35–7.

72 Chris Petit, 'Dancing Alone on the Céline', essay in the accompanying booklet to the BFI DVD version of *Radio On* (2008), pp. 4–5.

73 Fred Camper, untitled introductory essay accompanying the Criterion DVD *By Brakhage: An Anthology* (2003), n.p.

74 Smith, 'Talking with Tony Smith', p. 128, cited in Merriman, *Driving Spaces*, p. 15.

4 ALTERED STATES

1 Filippo Tommaso Marinetti, quoted in Lawrence S. Rainey, 'Selections from the Unpublished Diaries of F. T.

Marinetti', *Modernism/Modernity*, I/3 (1994), p. 21.

2 Jeffrey T. Schnapp, 'Crash (Speed as Engine of Individuation)', *Modernism/Modernity*, VI/1 (1999), p. 8; and Alexander H. (Sandy) McCreery, 'Turnpike Roads and the Spatial Culture of London: 1756–1830', PhD thesis, UCL Bartlett School of Architecture (2004).

3 David Vivian, 'No Limits', *Evo* (November 2009), p. 31; and John Tomlinson, *The Culture of Speed: The Coming of Immediacy* (London, 2009), pp. 9 and 44–71.

4 Schnapp, 'Crash', pp. 9 and 34.

5 John Beck and Paul Crosthwaite, 'Velocities of Power: An Introduction', *Cultural Politics*, III/1 (2007), p. 25.

6 Julian Smith, 'A Runaway Match: The Automobile in the American Film, 1900–1920', in *Automobile and American Culture*, ed. David D. Lewis and Laurence Goldstein (Ann Arbor, MI, 1983), pp. 181–2.

7 Quoted in Cotten Seiler, *Republic of Drivers: A Cultural History of Automobility in America* (Chicago, IL, 2008), p. 44.

8 Ruth E. Iskin, 'Father Time, Speed and the Temporality of Posters around 1900', *KronoScope*, III/1 (2003), pp. 33 and 38–42.

9 Enda Duffy, *The Speed Handbook: Velocity, Pleasure, Modernism* (Durham, NC, 2009), pp. 177–80; and Gerald Silk, 'Invention and Celebration', in *Automobile and*

Culture, ed. Gerald Silk (Los Angeles, CA, and New York, 1984), pp. 51–2.

10 Gerald Silk, 'Cultural Reconstruction, Explosion, and Reflection', *Automobile and Culture*, ed. Silk, p. 129.

11 Michael Atkinson, *Blue Velvet* (London, 1997).

12 Susan Luckman, 'Road Movies, National Myths and the Threat of the Road: The Shifting Transformative Space of the Road in Australian Film', *The International Journal of the Humanities*, VIII/1 (2010), pp. 113–25.

13 Lou Marinoff, 'Persistence Pays', *Times Higher Education Supplement*, 1941 (1 April 2010), p. 47.

14 Peter Marsh and Peter Collett, *Driving Passion: The Psychology of the Car* (London, 1986), p. 183.

15 Alistair Weaver, '200mph in Germany', *A Drive on the Wild Side: Twenty Extreme Driving Adventures from Around the World*, 2007), p. 113; and Jean Baudrillard, *Le Système des objects* (Paris, 1968), p. 68, quoted in Kristin Ross, *Fast Cars, Clean Bodies: Decolonization and the Reordering of French Culture* (Cambridge, 1995), p. 21.

16 Ayrton Senna, interviewed in Gerald Donaldson, *Grand Prix People: Revelations from Inside the Formula 1 Circus* (1990), quoted in Clyde Brolin, *Overdrive: Formula 1 in the Zone* (London, 2010), pp. 2–3.

17 At www.getawayinstockholm.com and www.ghostridermovie.net.

18 Glenn Elert et al., 'Speed of a Car:
 C'était un Rendezvous', at www.
 hypertextbook.com; and analysis
 by Sumner Brown, cited in Jesse
 Crosse, *The Greatest Movie Car
 Chases of All Time* (St Paul, 2006),
 pp. 46–7.
19 At www.rendezvousdvd.com.
20 At www.claude-lelouch.ifrance.com;
 'La Vérité sur le court métrage, enfin
 dévoilée', at www.axe-net.be; 'Making
 of Rendezvous', documentary with
 Claude Lelouch, at www.youtube.com;
 Elert et al., 'Speed of a Car'; and
 Crosse, *Greatest Movie Car Chases*,
 pp. 46–7.
21 Jack Sargeant and Stephanie Watson,
 'Looking for Maps: Notes on the
 Road Movie as Genre', in *Lost
 Highways: An Illustrated History of
 Road Movies*, ed. Jack Sargeant and
 Stephanie Watson (London, 1999),
 p. 8.
22 For example, Crosse, *The Greatest
 Movie Car Chases*, esp. pp. 172–4.
23 For example, Todd Berliner, 'The
 Genre Film as Booby Trap', *Cinema
 Journal*, XL/3 (Spring 2001), pp.
 25–46; Thomas Leitch, *Crime Films*
 (Cambridge, 2004), pp. 231–40; and
 Nick Roddick, 'Bullitt Proof', *Sight
 and Sound*, XX/11 (2010), p. 17.
24 Marc Myers, 'Chasing the Ghosts of
 Bullitt', *Wall Street Journal* (26 January
 2011), p. D7.
25 Quoted on the back cover of William
 F. Nolan, *Steve McQueen: Star on
 Wheels* (New York, 1972) and

www.stevemcqueen.com.
26 At www.ponysite.de; and
 www.imboc.com.
27 Steven Jacobs, 'From Flâneur to
 Chauffeur: Driving through
 Cinematic Cities', in *Imagining the
 City*, vol. I: *The Art of Urban Living*,
 ed. Christian Emden, Catherine Keen
 and David Midgley (Oxford: Peter
 Lang, 2006), p. 218.
28 M. Christine Boyer, 'Twice-told
 Stories: The Double Erasure of
 Times Square', *The Unknown City:
 Contesting Architecture and Social
 Space*, ed. Iain Borden, Jane Rendell
 and Joe Kerr with Alicia Pivaro
 (Cambridge, 2001), pp. 30–53.
29 Brian Ladd, *Autophobia: Love and
 Hate in the Automotive Era* (Chicago,
 IL, 2008), p. 73.
30 George R. Chatburn, *Highways and
 Highway Transportation* (New York,
 1923), p. 204, cited in T. C. Barker,
 'The International History of Motor
 Transport', *Journal of Contemporary
 History*, XXIX/1 (1985), p. 15.
31 World Health Organization (WHO),
 Global Status Report on Road Safety
 (Geneva, 2009), pp. vii–ix and 1–3;
 and Mark Dery, 'Always Crashing in
 the Same Car: A Head-on Collision
 with the Technosphere', *Against
 Automobility*, ed. Steffen Böhm,
 Campbell Jones, Chris Land and
 Matthew Paterson (Oxford, 2006),
 p. 228.
32 Duffy, *Speed Handbook*, pp. 224–5.
33 Schnapp, 'Crash', pp. 34–5.

34 Denise Halicki, introduction to the remastered DVD edition of *Gone in 60 Seconds* (2005).

35 Parveen Adams, 'Death Drive', in *The Modern Fantastic: The Films of David Cronenberg*, ed. Michael Grant (Westport, 2000), pp. 111–12.

36 Dery, 'Always Crashing in the Same Car', pp. 223–39; and Iain Sinclair, *Crash* (London, 2008); and Terry Harpold, 'Dry Leatherette: Cronenberg's *Crash*', *Postmodern Culture*, VII/3 (1997), np.

37 '*Rebel Without a Cause*: Defiant Innocents', documentary contained in the 2-disc DVD special edition of *Rebel Without a Cause* (2005).

38 Jeremy Millar and Michiel Schwarz, eds, *Speed: Visions of an Accelerated Age* (London, 1998); Steven Jay Schnieder, 'Death as Art/The Car Crash as Statement: The Myth of Jackson Pollock', in *Car Crash Culture*, ed. Mikita Brottman (London, 2002), pp. 278–81; Gregory Votolato, *Transport Design: A Travel History* (London, 2007), p. 82; Peter Wollen, 'Automobiles and Art', in *Autopia: Cars and Culture*, ed. Peter Wollen and Joe Kerr (London, 2002), pp. 33–5; Gerald Silk, 'The Image of the Automobile in American Art', in *Automobile and American Culture,* ed. Lewis and Goldstein, pp. 206–21; and Silk, *Automobile and Culture*; and Ken Russell, 'Death Drive by Dean Rogers', *The Times* (2 October 2009) and at www.timesonline.co.uk.

39 Quoted in Brolin, *Overdrive*, p. 126.

40 Andre40, 'Ford F3L and David Piper', at www.gt40s.com, 'The Auto Collection' forum.

CONCLUSION

1 Jeffrey T. Schnapp, 'Crash (Speed as Engine of Individuation)', *Modernism/Modernity*, VI/1 (1999), pp. 19–21.

2 A. B. Filson Young, *The Complete Motorist: Being an Account of the Evolution and Construction of the Modern Motor-car, Etc.* (London, revd 5th edn, 1905), p. 282.

3 Richard Meaden, *Classic Motorsport Routes* (Basingstoke, 2007), pp. 142–9; Chris Nixon, *Kings of the Nurburgring. Der Nurburg: A History, 1925–1983* (Isleworth, 2005); and 'Ultimate Nurburgring Guide', *Evo*, 82 (August 2005), pp. 107–24.

4 Ron Simons, briefing session at RSR Nurburg track day, Nurburgring Nordschleife (Wednesday, 29 November 2010).

5 Mike Breslin, 'Cover Story', *Circuit Driver*, 94 (May 2007), p. 30.

6 Young, *Complete Motorist*, p. 284; and Michael Balint, *Thrills and Regression* (New York, 1959), cited in Peter Wollen, 'The Crowd Roars: Suspense and Cinema', ed. Jeremy Millar and Michiel Schwarz, *Speed: Visions of an Accelerated Age* (London, 1998), p. 77.

7 Charles Jarrott, letter to Filson Young (April 1904), in Young, *Complete*

Motorist, pp. 244–5; and Charles
Jarrott, *Ten Years of Motors and Motor
Racing* [1906] (London, 1956), p. 171,
cited in Joe Moran, *On Roads: A
Hidden History* (London, 2009),
p. 169.

8 Mike Breslin, 'Cover Story', *Circuit
Driver*, 94 (May 2007), p. 30.

9 Quoted in Young, *Complete Motorist*,
p. 274. See also G. Stewart Bowles, *A
Stretch Off the Land* (London, 1903).

10 Filippo Tommaso Marinetti, 'The
Founding and Manifesto of Futurism'
(1909), in *Marinetti: Selected
Writings*, ed. R. W. Flint, (New York,
1972), pp. 39–44. See also Jeffrey T.
Schnapp, 'Crash (Speed as Engine of
Individuation)',
Modernism/Modernity, VI/1 (1999),
pp. 1–49.

11 Emily Post, *By Motor to the Golden
Gate* (New York, 1916), quoted in
Warren James Belasco, *Americans on
the Road: From Autocamp to Motel,
1910–1945* (Cambridge, 1979), p. 88.

12 Lou Marinoff, 'Persistence Pays',
Times Higher Education Supplement,
1941 (1 April 2010), p. 47.

13 Melvin M. Webber, The Joys of
Automobility', in *The Car and the
City: The Automobile, the Built
Environment and Daily Life*, ed.
Martin Wachs and Margaret
Crawford (Ann Arbor, MI, 1992),
pp. 274–84.

14 Loren E. Lomasky, 'Autonomy and
Automobility', *The Independent
Review*, II/1 (1997), pp. 5–28. See also

Sudhir Chella Rajan, 'Automobility
and the Liberal Disposition',
Sociological Review, LIV/1 (2006),
pp. 113–29.

SELECT BIBLIOGRAPHY

BOOKS AND ARTICLES

Antonio Amado, *Voiture Minimum: Le Corbusier and the Automobile* (Cambridge, 2011)

Anon, 'German Myth 8: Hitler and the Autobahn', at www.german.about.com

Donald Appleyard, Kevin Lynch and John R. Myer, *The View from the Road* (Cambridge, 1964)

Umbro Apollonio, ed., *Futurist Manifestos* (London, 1973)

Vivien Arnold, 'The Image of the Freeway', *Journal of Architectural Education*, xxx/1 (1976), pp. 28–30

Michael Atkinson, *Blue Velvet* (London, 1997)

——, 'Crossing the Frontiers', *Sight and Sound*, iv/1 (1994), pp. 14–17

Marc Augé, *Non-places: Introduction to an Anthropology of Supermodernity* (London, 1995)

Margaret Baker, *Discovering M1* (Tring, 1968)

Reyner Banham, *Los Angeles: The Architecture of Four Ecologies* (Harmondsworth, 1973)

Stephen Barber, *Projected Cities: Cinema and Urban Space* (London, 2002)

T. C. Barker, 'The International History of Motor Transport', *Journal of Contemporary History*, xxix/1 (1985), pp. 3–19

Nick Barley, ed., *Breathing Cities: The Architecture of Movement* (Basel, 2000)

Gabrielle Barnett, 'Drive-by Viewing: Visual Consciousness and Forest Preservation in the Automobile Age', *Technology and Culture*, xlv/1 (2004), pp. 30–54

Roland Barthes, 'The New Citroën', *Mythologies* [1957] (London, 1973), pp. 95–7

——, *Oeuvres complètes* [1963] (Paris, 2002)

Jean Baudrillard, *America* [1968] (London, 1988)

——, *The System of Objects* [1968] (London, 1996)

Stephen Bayley, *Sex, Drink and Fast Cars: The Creation and Consumption of Images* (London, 1986)

John Beck, 'Resistance Becomes Ballistic: Vanishing Point and the End of the Road', *Cultural Politics*, iii/1 (2007), pp. 35–50

——, and Paul Crosthwaite, 'Velocities of Power: An Introduction', *Cultural Politics*, iii/1 (2007), pp. 23–34

Jörg Beckmann, 'Mobility and Safety', *Theory, Culture and Society*, xxi/4–5 (2004), pp. 81–100

Warren James Belasco, *Americans on the Road: from Autocamp to Motel, 1910–1945* (Cambridge, 1979)

Jonathan Bell, ed., *Carchitecture: When the Car and the City Collide* (Basel, 2001)

David Bellos, *Jacques Tati: His Life and Art* (London, 1999)

Richard Benson et al., *The Secret Life of Cars, and What They Reveal About Us* (London, 2007)

Todd Berliner, 'The Genre Film as Booby Trap', *Cinema Journal*, XL/3 (Spring 2001), pp. 25–46

Shane Birney, *A Nation on Wheels: Australia and the Motor Car* (Sydney, 1986)

Par Blomkvist, 'Transferring Technology-shaping Ideology: American Traffic Engineering and Commercial Interests in the Establishment of a Swedish Car Society, 1945–1965', *Comparative Technology Transfer and Society*, II/3 (2004), pp. 273–302

Steffen Böhm, Campbell Jones, Chris Land and Mat Paterson, 'Introduction: Impossibilities of Automobility', *Sociological Review*, LIV/1 (2006), pp. 1–16

——, eds, *Against Automobility* (Oxford, 2006)

Jennifer Bonham, 'Transport: Disciplining the Body that Travels', *Sociological Review*, LIV/1 (2006), pp. 57–74

Pieter Boogaart, *A272: An Ode to a Road* (London, 2000)

Iain Borden, 'Chinatown, Automobile Driving and the Unknowable City', *Urban Constellations*, ed. Matthew Gandy (Berlin, 2011), pp. 186–9

——, 'Machines of Possiblity' (2004), at www.issuu.com

——, 'Playtime: "Tativille" and Paris', *The Hieroglyphics of Space: Reading and Experiencing the Modern Metropolis*, ed. Neil Leach (London, 2002), pp. 217–33

——, *Skateboarding, Space and the City: Architecture and the Body* (Oxford, 2001)

——, Jane Rendell and Joe Kerr with Alicia Pivaro, eds, *The Unknown City: Contesting Architecture and Social Space* (Cambridge, 2001)

Scott Bottles, *Los Angeles and the Automobile: The Making of the Modern City* (Berkeley, CA, 1987)

G. Stewart Bowles, *A Stretch Off the Land* (London, 1903)

Ruth Brandon, *Auto Mobile: How the Car Changed Life* (London, 2002)

David Brodsly, *L.A. Freeway: An Appreciative Essay* (Berkeley, CA, 1981)

Clyde Brolin, *Overdrive: Formula 1 in the Zone* (London, 2010)

Mikita Brottman, ed., *Car Crash Culture* (London, 2002)

Fleda Brown, *Driving with Dvořák: Essays on Memory and Identity* (Lincoln, 2009)

Travis Brown, 'On an Aesthetic of Highway Speed', *Journal of Architectural Education* (*JAE*) XXX/1 (1976), pp. 25–7

Blaine A. Brownell, 'A Symbol of Modernity: Attitudes toward the Automobile in

Southern Cities in the 1920s', *American Quarterly*, XXIV/1 (1972), pp. 20–44

Giuliana Bruno, *Atlas of Emotions: Journeys in Art, Architecture and Film* (London, 2002)

——, 'Driven', *2wice*, V/2 (2001), pp. 56–64

Martin Buckley, *Cars in Films: Great Moments from Post-War International Cinema* (Sparkford, 2002)

Michael Bull, 'Automobility and the Power of Sound', *Theory, Culture and Society*, XXI/4–5 (2004), pp. 243–59

Helen J. Burgess, 'Futurama, Autogeddon: Imagining the Superhighway from Bel Geddes to Ballard', *Rhizomes*, 8 (Spring 2004)

Thomas J. Campanella, '"The Civilising Road": American Influence on the Development of Highways and Motoring in China, 1900–1949', *Journal of Transport History*, XXVI/1 (2005), pp. 78–98

Christy Campbell, *Mini: An Intimate Biography* (London, 2009)

Giles Chapman, *Chapman's Car Compendium: The Essential Book of Car Facts and Trivia* (London, 2007)

James Chapman, *War and Film* (London, 2008)

Ian Christie, *The Last Machine: Early Cinema and the Birth of the Modern World* (London, 1994)

David B. Clarke, ed., *The Cinematic City* (London, 1997)

Nigel Coates, *Guide to Ecstacity* (London, 2003)

Steven Cohan and Ina Rae Hark, eds, *The Road Movie Book* (London, 1997)

Jim Conley and Arlene Tigar McLaren, eds, *Car Troubles: Critical Studies of Automobility* (Abingdon, 2009)

Tom Conley, *Cartographic Cinema* (Minneapolis, 2007)

Timothy Corrigan, *A Cinema Without Walls: Movies and Culture after Vietnam* (London, 1991)

——, 'Wender's *Kings of the Road*: The Voyage from Desire to Language', *New German Critique*, XXIV/25 (1981), pp. 94–107

Jonathan Crary, *Suspensions of Perception: Attention, Spectacle and Modern Culture* (Cambridge, 2000)

Tim Cresswell, 'Mobility as Resistance: A Geographical Reading of Kerouac's "On the Road"', *Transactions of the Institute of British Geographers*, XVIII/2 (1993), pp. 249–62

——, *On the Move: Mobilities in the Modern Western World* (London, 2009)

Catherine Croft, ed., *On the Road: The Art of Engineering in the Car Age* (London, 1999)

Jesse Crosse, *The Greatest Movie Car Chases of All Time* (St Paul, 2006)

Barry Curtis, *Dark Places: The Haunted House in Film* (London, 2008)

Andrea Dahlberg, 'Film as a Catalyst for Social Change: Ousmane Sembene's Borom
　　Sarret', *Bright Lights Film Journal*, 42 (2003)
Sara Danius, 'The Aesthetics of the Windshield: Proust and the Modernist Rhetoric of
　　Speed', *Modernism/Modernity*,VIII/1 (2001), pp. 99–126
——, *The Senses of Modernism: Technology, Perception, and Aesthetics* (Ithaca, NY, 2002)
Tim Dant, 'The Driver-Car', *Theory, Culture and Society*, XXI/4–5 (2004), pp. 61–79
Mark Dery, '"Always Crashing in the Same Car": A Head-on Collision with the
　　Technosphere', *Sociological Review*, LIV/1 (2006), pp. 223–39
Kingsley Dennis and John Urry, *After the Car* (Oxford, 2009)
Cynthia Golomb Dettelbach, *In the Driver's Seat: The Automobile in American Literature
　　and Popular Culture* (Westport, 1976)
Carlo Di Carlo and Giorgio Tinazzi, eds, *The Architecture of Vision: Writings and
　　Interviews on Cinema* (New York, 1996)
Edward Dimendberg, *Film Noir and the Spaces of Modernity* (Cambridge, 2004)
——, 'The Will to Motorization: Cinema, Highways, and Modernity', *October*, 73
　　(Summer 1995), pp. 90–137
James Donald, *Imagining the Modern City* (London, 1999)
Lisa Dorn, ed., *Driver Behaviour and Training* (Aldershot, 2003)
Enda Duffy, *The Speed Handbook: Velocity, Pleasure, Modernism* (Durham, NC, 2009)
Michael Easton, *Chinatown* (London, 1998)
Steven Eastwood, 'The Eventless and the Event: Vincent Gallo and the *Brown Bunny*',
　　Vertigo, II/8 (2005), pp. 34–5
Tim Edensor, 'Automobility and National Identity: Representation, Geography and
　　Driving Practice', *Theory, Culture and Society*, XXI/4–5 (2004), pp. 101–20
——, 'Defamiliarizing the Mundane Roadscape', *Space and Culture*, VI/2 (2003), pp.
　　151–68
Ilya Ehrenburg, *The Life of the Automobile* [1929] (London, 1999)
Glenn Elert, Africa Belgrave, Stephanie Ma, Brittany Mejia and Bridget Ritter, 'Speed
　　of a Car: *C'était un Rendezvous*', at www.hypertextbook.com
Cliff Ellis, 'Interstate Highways, Regional Planning and the Reshaping of Metropolitan
　　America', *Planning Practice and Research*, XVI/3–4 (2001), pp. 247–69
——, 'Lewis Mumford and Norman Bel Geddes: The Highway, the City and the Future',
　　Planning Perspectives, XX/1 (2005), pp. 51–68
Christian Emden, Catherine Keen and David Midgley, eds, *Imagining the City*, vol. I:
　　The Art of Urban Living (Oxford, 2006)
Tim English, *Overlanding: The Ultimate Road Trip* (London, 2004)
Expositions Publications, *Official Guide Book* (New York, 1939)
Ron Eyerman and Orvar Lofgren, 'Romancing the Road: Road Movies and Images of

Mobility', *Theory, Culture and Society*, XII/1 (1995), pp. 53–79

Mike Featherstone, Nigel Thrift and John Urry, eds, *Automobilities* (London, 2005)

Peter Filby, *Amazing Mini* (Yeovil, 1981)

Matthew Field, *The Making of the Italian Job* (London, 2001)

Robert Fishman, *Urban Utopias in the Twentieth Century: Ebenezer Howard, Frank Lloyd Wright, and Le Corbusier* (Cambridge, 1982)

Tony Fitzmaurice, '*Chinatown* and the End of Classical Hollywood', *Irish Journal of American Studies*, VII (1998), pp. 149–61

James J. Flink, *America Adopts the Automobile, 1895–1910* (Cambridge, 1970)

——, *The Automobile Age* (Cambridge, 1988)

——, 'Three Stages of American Automobile Consciousness', *American Quarterly*, XXIV/4 (1972), pp. 451–73

R. W. Flint, ed., *Marinetti: Selected Writings* (New York, 1972)

Max Forsythe, *Drive by Shooting* (London, 2004)

John Foster, 'John Buchan's "Hesperides": Landscape Rhetoric and the Aesthetics of Bodily Experience on the South African Highveld, 1901–1903', *Ecumene*, V/3 (1998), pp. 323–47

Paul Mason Fotsch, 'The Building of a Superhighway Future at the New York World's Fair', *Cultural Critique*, XLVIII (2001), pp. 65–97

Greg Fountain, ed., *Epic Drives* (Peterborough, 2009)

Giampiero Frasca, *Road Movie: Immaginario, Genesi, Struttura E Forma Del Cinema Americano on the Road* (Turin, 2001)

Murray Fraser, *Architecture and the Special Relationship: The American Influence on Post-war British Architecture* (Abingdon, 2007)

Anne Friedberg, 'Urban Mobility and Cinematic Visuality: The Screens of Los Angeles – Endless Cinema or Private Telematics', *Journal of Visual Culture*, I/2 (2002), pp. 183–204

Lee Friedlander, *America by Car* (San Francisco, CA, 2010)

Leslie Gardiner and Adrian Gardiner, *The Best of British Motorways: Where to Eat, What to See and Where To* (London, 1987)

Simon Garfield, *Mini: The True and Secret History of the Making of a Motor Car* (London, 2009)

David Gartman, 'A History of Scholarship on American Automobile Design' (nd), at www.autolife.umd.umich.edu

——, *Auto Opium: A Social History of American Automobile Design* (London, 1994)

——, 'Three Ages of the Automobile: The Cultural Logics of the Car', *Theory, Culture and Society*, XXI/4–5 (2004), pp. 169–95

——, 'Tough Guys and Pretty Boys: The Cultural Antagonisms of Engineering and

Aesthetics in Automotive History' (2004), at www.autolife.umd.umich.edu

Norman Bel Geddes, *Magic Motorways* (New York, 1940)

David Gelernter, *The Lost World of the Fair* (New York, 1995)

General Motors, *Highways and Horizons: The General Motors Exhibit Building* (Detroit, MI, 1939)

——, *The Story of Firebird II* (General Motors, flyer produced for the Motorama exhibition, 1956)

Nick Georgano, ed., *The Beaulieu Encyclopedia of the Automobile* (London, 3 vols, 2001)

Grant Geyer, "'The" Freeway in Southern California', *American Speech*, LXXVI/2 (2001), pp. 221–4

R. J. Gibbens and Y. Saacti, *Road Traffic Analysis Using MIDAS Data: Journey Time Prediction* (Cambridge, University of Cambridge Computer Laboratory, Technical Report 676, December 2006)

Rob Golding, *Mini: Thirty-five Years On* (London, revd edn, 1994)

Paul Gormley, '*Crash* and the City', *Intellect Quarterly*, 3 (Winter 2006), pp. 24–6

Michael Grant, ed., *The Modern Fantastic: The Films of David Cronenberg* (Westport, 2000)

Suzanne Greaves, 'Motorway Nights with the Stars', *The Times* (14 August 1985), p. 8

Roger Green, *Destination Nowhere: A South Mimms Motorway Service Station Diary* (Twickenham, 2004)

Dominic Greyer, *Far from Dull: And Other Places* (London, 2004)

Lawrence Halprin, *Freeways* (New York, 1966)

Terry Harpold, 'Dry Leatherette: Cronenberg's *Crash*', *Postmodern Culture*, VII/3 (1997)

Jason Henderson, 'Secessionist Automobility: Racism, Anti-urbanism, and the Politics of Automobility in Atlanta, Georgia', *International Journal of Urban and Regional Research*, XXX/2 (2006), pp. 293–307

Tony Hiss, *In Motion: The Experience of Travel* (London, 2011)

P. Hogue, 'Radio On', *Film Quarterly*, XXXVI/2 (1982), pp. 47–52

Home Office, *Roadcraft: The Police Drivers' Manual* (London, 1960)

David Inglis, 'Auto Couture: Thinking the Car in Post-war France', *Theory, Culture and Society*, XXI/4–5 (2004), pp. 204–19

Ruth E. Iskin, 'Father Time, Speed and the Temporality of Posters around 1900', *KronoScope*, III/1 (2003), pp. 27–50

Mike Jackson, *The M4 Sights Guide: Find Out About Everything You Can See from Your Vehicle on the Motorway* (Worcester, 2005)

Steven Jacobs, 'From Flâneur to Chauffeur: Driving through Cinematic Cities', in *Imagining the City*: vol. I: *The Art of Urban Living*, ed. Christian Emden, Catherine Keen and David Midgley (Oxford, 2006), pp. 213–28

Sarah S. Lochlann Jain, 'Urban Errands: The Means of Mobility', *Journal of Consumer*

Culture, II/3 (2002), pp. 385–404

Geoffrey Jellicoe, *Motopia: A Study in the Evolution of Urban Landscape* (London, 1961)

——, 'Motorways', *Studies in Landscape Design* (Oxford, 1960), pp. 66–87

David Jeremiah, *Representations of British Motoring* (Manchester, 2007)

R. J. Johnston, Derek Gregory, Geraldine Pratt and Michael Watts, eds, *The Dictionary of Human Geography* (Oxford, 2000)

Jane Holtz Kay, *Asphalt Nation: How the Automobile Took over America, and How We Can Take It Back* (New York, 1997)

Louis Ward Kemp, 'Aesthetes and Engineers: The Occupational Ideology of Highway Design', *Technology and Culture*, XXVII/4 (1986), pp. 759–97

Stephen Kern, *The Culture of Time and Space, 1880–1918* (London, 1983)

Jack Kerouac, *On the Road: The Original Scroll* (London, 2007)

Ken Knabb, ed., *Situationist International Anthology* (Berkeley, CA, 1981)

Richard Koeck and Les Roberts, eds, *The City and the Moving Image: Urban Projections* (London, 2010)

James Howard Kunstler, *The Geography of Nowhere: The Rise and Decline of America's Man-made Landscape* (New York, 1993)

Soo Ah Kwon, 'Autoexoticizing: Asian American Youth and the Import Car Scene', *Journal of Asian American Studies*, VII/1 (2004), pp. 1–26

Brian Laban, *The Mini: Forty Years of Fun* (London, 1999)

Brian Ladd, *Autophobia: Love and Hate in the Automotive Era* (Chicago, IL, 2008)

David Laderman, *Driving Visions: Exploring the Road Movie* (Austin, TX, 2002)

——, 'The Road Movie Rediscovers Mexico: Alex Cox's *Highway Patrolman*', *Cinema Journal*, XXXIX/2 (2000), pp. 74–99

Pedro Juan Larrañaga, *Successful Asphalt Paving: A Description of Up-to-date Methods, Recipes and Theories, with Examples and Practical Hints, for Road Authorities, Contractors, and Advanced Students* (London, 1926)

Eric Laurier, 'Doing Office Work on the Motorway', *Theory, Culture and Society*, XXI/4–5 (2004), pp. 261–77

Henri Lefebvre, *Introduction to Modernity: Twelve Preludes, September 1959–May 1961* (London, 1995)

——, *The Production of Space* (Oxford, 1991)

——, *Rhythmanalysis: Space, Time and Everyday Life* (London, 2004)

Thomas Leitch, *Crime Films* (Cambridge, 2004)

David D. Lewis and Laurence Goldstein, eds, *Automobile and American Culture* (Ann Arbor, MI, 1983)

Peter J. Ling, *America and the Automobile: Technology, Reform and Social Change* (Manchester, 1989)

Phil Llewellin, *The Road to Muckle Flugga: Great Drives in Five Continents* (Sparkford, 2004)

Julia Loktev, 'Static Motion, or the Confessions of a Compulsive Radio Driver', *Semiotexte*, VI/1 (1993)

Loren E. Lomasky, 'Autonomy and Automobility', *The Independent Review*, II/1 (1997), pp. 5–28

Susan Luckman, 'Road Movies, National Myths and the Threat of the Road: The Shifting Transformative Space of the Road in Australian Film', *The International Journal of the Humanities*, VIII/1 (2010), pp. 113–25

Per Lundin, 'American Numbers Copied! Shaping the Swedish Postwar Car Society', *Comparative Technology Transfer and Society*, II/3 (2004), pp. 303–34

Alexander H. (Sandy) McCreery, 'From Moderne to Modern: An Ideological Journey Along London's Western Avenue from the 1930s to the 1970s', Masters dissertation, UCL Bartlett School of Architecture (1992)

——, 'Turnpike Roads and the Spatial Culture of London: 1756–1830', PhD thesis, UCL Bartlett School of Architecture (2004)

John McCrystal, *100 Years of Motoring in New Zealand* (Auckland, 2003)

Eliza Russi Lowen McGraw, 'Driving Miss Daisy: Southern Jewishness on the Big Screen', *Southern Cultures*, VII/2 (2001), pp. 41–59

Ewan McGregor and Charlie Boorman, *Long Way Round: Chasing Shadows across the World* (London, 2004)

Clay McShane, *The Automobile: A Chronology of Its Antecedents, Development and Impact* (London, 1997)

Jane Madsen, 'Marion's Death Drive: Psycho Driving and the Car', paper for MA in Architectural History, UCL Bartlett School of Architecture (2008)

Greil Marcus, 'Back Seat', *2wice*, V/2 (2001), pp. 35–7

Lou Marinoff, 'Persistence Pays', *Times Higher Education Supplement*, 1941 (1 April 2010), pp. 46–8

Andy Markowitz, 'Ceausecu's Folly', *The Guardian*, 'Travel' section (23 April 2005), at www.guardian.co.uk

Peter Marsh and Peter Collett, *Driving Passion: The Psychology of the Car* (London, 1986)

Marianne W. Martin, *Futurist Art and Theory, 1909–1915* (Oxford, 1968)

Richard Matheson, *Duel: Terror Stories by Richard Matheson* (New York, 2003)

David Matless, *Landscape and Englishness* (London, 1998)

Ewa Mazierska and Laura Rascaroli, *Crossing New Europe: Postmodern Travel and the European Road Movie* (London, 2006)

Richard Meaden, *Classic Motorsport Routes* (Basingstoke, 2007)

Barbara Mennel, *Cities and Cinema* (London, 2008)

Maurice Merleau-Ponty, *Phenomenology of Perception* (London, 1962)
Peter Merriman, 'Automobility and the Geographies of the Car', *Geography Compass*,
 III/2 (2009), pp. 586–99
——, 'Driving Places: Marc Augé, Non-places, and the Geographies of England's M1
 Motorway', *Theory, Culture and Society*, XXI/4–5 (2004), pp. 145–67
——, *Driving Spaces: A Cultural-Historical Geography of England's M1 Motorway*
 (Oxford, 2007)
——, '"Mirror, Signal, Manoeuvre": Assembling and Governing the Motorway Driver in
 Late 1950s Britain', *Sociological Review*, LIV/1 (2006), pp. 75–92
——, '"Operation Motorway": Landscapes of Construction on England's M1 Motorway',
 Journal of Historical Geography, XXXI/1 (2005), pp. 113–33
——, 'A Power for Good or Evil: Geographies of the M1 in Late-fifties Britain', in
 Geographies of British Modernity: Space and Society in the Twentieth Century,
 ed. David Gilbert, David Matless and Brian Short (Oxford, 2003), pp. 115–31
Jeremy Millar and Michiel Schwarz, eds, *Speed: Visions of an Accelerated Age* (London,
 1998)
Daniel Miller, ed., *Car Cultures* (Oxford, 2001)
Roger Miller, 'Selling Mrs Consumer: Advertising and the Creation of Suburban Social
 Relations, 1910–1930', *Antipode*, XXIII/3 (1991), pp. 263–301
Octave Mirbeau, *La 628-E8* (Paris, 1907)
László Moholy-Nagy, *Vision in Motion* (Chicago, IL, 1947)
Rowan Moore, 'Let's Celebrate the Westway', *Evening Standard* (Tuesday, 11 July 2000),
 p. 28
Joe Moran, *On Roads: A Hidden History* (London, 2009)
Henry Vollam Morton, *In Search of England* [1927] (Harmondsworth, 1960)
Kurt Möser, 'The Dark Side of Automobilism, 1900–30: Violence, War and the Motor
 Car', *The Journal of Transport History*, XXIV/2 (2003), p. 238–58
Chris Mosey, *Car Wars: Battles on the Road to Nowhere* (London, 2000)
Eric Mottram, *Blood on the Nash Ambassador: Investigations in American Culture*
 (London, 1989)
Marc Myers, 'Chasing the Ghosts of *Bullitt*', *Wall Street Journal* (26 January 2011), p. D7
Mark Nawrot, 'Depth from Motion Parallax Scales With Eye Movement Gain', *Journal of
 Vision*, III/11 (December 2003), pp. 841–51
Lynda Nead, 'Paintings, Films and Fast Cars: A Case Study of Hubert Von Herkomer',
 Art History, XXV/2 (2002), pp. 240–55
Chris Nixon, *Kings of the Nurburgring. Der Nurburg: A History 1925–1983* (Isleworth,
 2005)
Greg Noble and Rebecca Baldwin, 'Sly Chicks and Troublemakers: Car Stickers,

Nonsense and the Allure of Strangeness', *Social Semiotics*, XI/1 (2001), pp. 75–89

William F. Nolan, *Steve McQueen: Star on Wheels* (New York, 1972)

Phillip Novak, 'The Chinatown Syndrome', *Criticism*, XLIX/3 (Summer 2007), pp. 255–83

G. Nowell-Smith, 'Radio On', *Screen*, XX/3 (1979), pp. 29–39

Sean O'Connell, *The Car and British Society: Class, Gender and Motoring, 1896–1939* (Manchester, 1998)

——, *The Social and Cultural Impact of the Car in Interwar Britain* (Warwick, 1995)

W. Scott Olsen, *At Speed: Travelling the Long Road between Two Points* (Lincoln, NE, 2006)

Devin Orgeron, *Road Movies: From Muybridge and Méliès to Lynch and Kiarostami* (London, 2008)

Per Ostby, 'Educating the Norwegian Nation: Traffic Engineering and Technological Diffusion', *Comparative Technology Transfer and Society*, II/3 (2004), pp. 247–72

R. J. Overy, 'Cars, Roads, and Economic Recovery in Germany, 1932–8', *The Economic History Review*, XXVIII/3 (1975), pp. 466–83

Juhani Pallasmaa, *The Architecture of Image: Existential Space in Cinema* (Helsinki, 2007)

Ian Parker, 'Traffic', *Granta*, 65 (Spring 1999), pp. 9–31

Jacob Paskins, 'The Social Experience of Building Construction Work in and Around Paris in the 1960s', PhD thesis, UCL Bartlett School of Architecture (2011)

François Penz and Maureen Thomas, eds, *Cinema and Architecture: Méliès, Mallet-Stevens, Multimedia* (London, 1997)

Chris Petit, 'Dancing Alone on the Céline', essay in the accompanying booklet to the BFI DVD version of *Radio On* (2008)

——, 'Radio On', *Screen*, XX/3 (1979), pp. 29–39

Roy Phippen, *M25 Travelling Clockwise* (London, 2004)

Claude Pichois, *Littérature et progrès: Vitesse et vision du monde* (Neuchâtel, 1973)

Robert L. Pike, *Bullitt: The Original Novel of the Classic Film* (London, 2005)

Steve Pile and Nigel Thrift, eds, *City A–Z* (London, 2000)

Pistonheads, *Pistonheads: The Best Bits, 2009* (London, 2009)

William Plowden, *The Motor Car and Politics, 1896–1970* (London, 1971)

Emily Post, *By Motor to the Golden Gate* (New York, 1916)

Marcel Proust, 'Impressions de route en automobile', *Le Figaro* (19 November 1907)

——, *Remembrance of Things Past*, vol. I: *Swann's Way* (www.gutenberg.org, Project Gutenberg EBook, 2009)

Jon Pressnell, *Mini: The Definitive History* (Sparkford, 2009)

Lawrence S. Rainey, 'Selections from the Unpublished Diaries of F. T. Marinetti', *Modernism/Modernity*, I/3 (1994), pp. 1–44

Mitchell Schwarzer, *Zoomscape: Architecture in Motion and Media* (New York, 2004)

Cotten Seiler, *Republic of Drivers: A Cultural History of Automobility in America* (Chicago, IL, 2008)

Richard Sennett, *The Fall of Public Man: On the Social Psychology of Capitalism* (New York, 1974)

——, *Flesh and Stone: The Body and the City in Western Civilization* (London, 1994)

L.J.K. Setright, *Drive On!: A Social History of the Motor Car* (London, 2002)

——, *Long Lane with Turnings: Last Words of a Motoring Legend* (London, 2006)

——, *Mini: The Design of an Icon* (London, 1999)

Mimi Sheller, 'Automotive Emotions: Feeling the Car', *Theory, Culture and Society*, XXI/4–5 (2004), pp. 221–42

——, and John Urry, 'The City and the Car', *International Journal of Urban and Regional Research*, XXIV/4 (2000), pp. 737–57

Gerald Silk, ed., *Automobile and Culture* (Los Angeles, CA, 1984)

Georg Simmel, 'The Metropolis and Mental Life', in *Cities and Society: The Revised Reader in Urban Sociology*, ed. P. K. Hatt and A. J. Reiss (New York, 1951), pp. 635–46

Iain Sinclair, *Crash* (London, 2008)

——, *London Orbital: A Walk around the M25* (London, 2002)

Justin Smith, *Withnail and Us: Cult Films and Film Cults in British Cinema* (London, 2010)

Wilbur Smith, *Future Highways and Urban Growth* (New Haven, CT, 1961)

Alison Smithson, *AS in DS: An Eye on the Road* (Delft, 1983)

Edward W. Soja, *Postmodern Geographies: The Reassertion of Space in Critical Social Theory* (London, 1989)

Hilar Stadler and Martino Stierli, eds, *Las Vegas Studio: Images from the Archive of Robert Venturi and Denise Scott Brown* (Zürich, 2009)

Garrett Stewart, 'The Long Goodbye from Chinatown', *Film Quarterly*, XXVIII/2 (1974–5), pp. 25–32

Kristine Stiles and Peter Selz, eds, *Theories and Documents of Contemporary Art: A Sourcebook of Artists' Writings* (Berkeley, CA, 1996)

Christophe Studeny, *L'Invention de la vitesse: France, XVIIIe–XXe Siècle* (Paris, 1995)

Maria Sturken, *Thelma & Louise* (London, 2000)

Juan A. Suárez, 'City Space, Technology, Popular Culture: The Modernism of Paul Strand and Charles Sheeler's *Manhatta*', *Journal of American Studies*, XXXVI/1 (2002), pp. 85–106

Nigel Taylor, 'The Aesthetic Experience of Traffic in the Modern City', *Urban Studies*, XL/8 (2003), pp. 1609–25

Peter Thorold, *The Motoring Age: The Automobile and Britain, 1896–1939* (London, 2003).

Nigel Thrift, 'Driving in the City', *Theory, Culture and Society*, XXI/4–5 (2004), pp. 41–59

John Tomlinson, *The Culture of Speed: The Coming of Immediacy* (London, 2009)

John Urry, 'The System of Automobility' (2002), at www.its.leeds.ac.uk

Tom Vanderbilt, *Traffic: Why We Drive the Way We Do (and What It Says About Us)* (London, 2008)

Eduardo Alcântara De Vasconcellos, 'The Use of Streets: A Reassessment and Tribute to Donald Appleyard', *Journal of Urban Design*, IX/1 (2004), pp. 3–22

Robert Venturi, Denise Scott Brown and Steven Izenour, *Learning from Las Vegas: The Forgotten Symbolism of Architectural Form* (Cambridge, MA, 1972)

Paul Veysey, *Motor Movies: The Posters* (Dorchester, 2007)

Paul Virilio, 'Dromoscopy, or the Ecstasy of Enormities', *Wide Angle*, XX/3 (1998), pp. 11–22

——, *Negative Horizon: An Essay in Dromoscopy* (London, 2005)

Martin Wachs and Margaret Crawford, eds, *The Car and the City: The Automobile, the Built Environment and Daily Life* (Ann Arbor, MI, 1992)

Alistair Weaver, *A Drive on the Wild Side: Twenty Extreme Driving Adventures from Around the World* (Dorchester, 2007)

Andrew Webber and Emma Wilson, eds, *Cities in Transition: The Moving Image and the Modern Metropolis* (London, 2008)

E. B. White, *Farewell to Model T* (New York, 2003)

Raymond Williams, *Keywords* (London, 1988)

Peter Wollen and Joe Kerr, eds, *Autopia: Cars and Culture* (London, 2002)

Jason Wood, *100 Road Movies* (London, 2007)

World Health Organization (WHO), *Global Status Report on Road Safety* (Geneva, 2009)

Rudolph Wurlitzer. *Two-Lane Blacktop*, reprint of original first screenplay draft (1970)

A. B. Filson Young, *The Complete Motorist: Being an Account of the Evolution and Construction of the Modern Motor-Car, Etc.* (London, revd 5th edn, 1905)

Thomas Zeller, *Driving Germany: The Landscape of the German Autobahn, 1930–1970* (Oxford, 2007)

MAGAZINES

Autocar	*Autocar and Motor*
Autosport	*Car*
Circuit Driver	*Evo*
Octane	*Road and Track*
Top Gear	

WEBSITES

www.audiworld.com
www.autocar.co.uk
www.autolife.umd.umich.edu
www.axe-net.be
www.bbc.co.uk
www.bookatrack.com
www.bsm.co.uk
www.car-accidents.com
www.cbrd.co.uk
www.claude-lelouch.ifrance.com
www.cnn.com
www.easytrack.co.uk
www.en.wikipedia.org
www.fhwa.dot.gov
www.fiatmio.cc
www.hypertextbook.com
www.gameinformer.com
www.getawayinstockholm.com
www.ghostridermovie.net
www.grouchoreviews.com
www.gt40s.com
www.haloipt.com
www.imboc.com
www.imcdb.org
www.imdb.com
www.informationasmaterial.com
www.its.leeds.ac.uk
www.justball.net

www.lightsinthedusk.blogspot.com
www.lotus-on-track.com
www.miniworld.co.uk
www.nissan.co.uk
www.nissan-note.co.uk
www.nurburgring.org.uk
www.nytimes.com
www.paulsmithmini.co.uk
www.pistonheads.com
www.ponysite.de
www.radfordmini.free-online.co.uk
www.rendezvousdvd.com
www.rhizomes.net
www.rmatrackdays.co.uk
www.roblightbody.com
www.seloc.org
www.stevemcqueen.com
www.theworldsbestdrivingroads.com
www.theitalianjob.com
www.guardian.co.uk
www.timesonline.co.uk
www.trackdayusa.com
www.trackpedia.com
www.transportation.frost.com
www.vauxhall.co.uk
www.wreckedexotics.com
www.youtube.com

ACKNOWLEDGEMENTS

I wish to thank Vivian Constantinopoulos, Michael Leaman and everyone at Reaktion for commissioning and producing this book.

Over the course of researching and writing the book, many people have made helpful suggestions, provided vital information and generally helped out. Many thanks to everyone concerned, and particularly to Stephen Barber, Serena Chapman, Simon Chapman, Barry Curtis, Granville Kirkup, Sandy McCreery and Brian Stater.

Particular gratitude is also due to Jan Birksted, Matt Bowles, Ben Campkin, Adrian Forty, Murray Fraser, Jonathan Hill, Kevin Jones, Nadia O'Hare, Barbara Penner, Peg Rawes, Jane Rendell, Sue Robertson and Phil Steadman and other colleagues and students at the UCL Bartlett School of Architecture. This book would not have happened without the aid of the Architecture Research Fund at the Bartlett, which very generously provided three financial awards.

Sam Borden continues to remind me that cars and movies are cool, great and awesome. Above all, my greatest thanks are to Claire Haywood for her wonderful love and support during our many years of car-driving, film-watching and journey-taking. This book is dedicated to her.

INDEX